VICTORIA AND ALBERT MUSEUM YEARBOOK

Number three

1. The Grenville Cover. English: late sixteenth century. Linen embroidered with silks and silver-gilt thread in detached buttonhole, stem, satin, double-running, double chain and other stitches, with padded trellis stitch, spider knots and filling stitches. Bequeathed by Dr. Nathaniel Sampson Lucas. T.262–1968 (*see* AN ELIZABETHAN EMBROIDERED COVER, *p. 76*).

VICTORIA AND ALBERT MUSEUM YEARBOOK

Number three

PHAIDON

© CROWN COPYRIGHT 1972
PUBLISHED BY PHAIDON PRESS LTD, 5 CROMWELL PLACE, LONDON SW7

PHAIDON PUBLISHERS INC, NEW YORK
DISTRIBUTORS IN THE UNITED STATES: PRAEGER PUBLISHERS INC.
III FOURTH AVENUE, NEW YORK, N.Y. 10003
LIBRARY OF CONGRESS CATALOG CARD NUMBER: 77-83519

ISBN 0 7148 1509 8
MADE IN GREAT BRITAIN
PRINTED BY THE CAVENDISH PRESS LTD, LEICESTER

CONTENTS

John Irwin

The Sanchi Torso

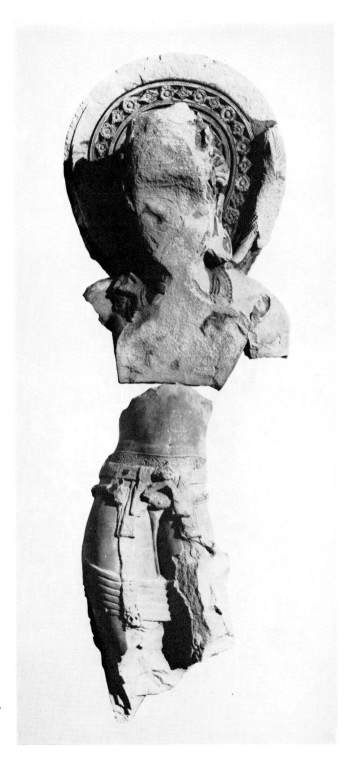

1. The Bodhisattva Maitreya (the "pair" to the Sāñchī Torso, recently discovered at Sāñchī). The plate is composed from two separate snapshots joined together. H. 167.5 cm.

A TURNING POINT in the appreciation of Indian art in the West was the purchase by the Museum, in 1910, of its first masterpiece of Indian sculpture, the Sāñchī Torso (colour plate). This unidentified male torso from the famous central Indian Buddhist site of Sāñchī has since been published a great many times and is still one of the most admired pieces of Indian sculpture outside India. Yet to the art historian it has always been a problem. During its eighty years in the Museum (the first twenty on loan), opinions about its age have differed by more than a thousand years. Only now has enough evidence come to light to settle its origin with some degree of finality.[1]

The most important new evidence is the recent discovery of the "pair" to this torso – a masterpiece apparently by the same hand, and carved in the same very fine-grained, purplish-brown sandstone (fig. 1). It was found in a *go-down* or warehouse at Sāñchī in November, 1970. Though in two pieces, incomplete, and even severely defaced, this second figure retains features of style and iconography missing in the Museum's torso. These, examined in relation to other sculptures at Sāñchī, give all the clues needed for precise attribution.

Both figures are Bodhisattvas (literally, "Buddhas-to-be" or "future Buddhas"). We shall show that they were carved in the late ninth or early tenth century A.D., and that they were designed to flank a large Buddha statue, composing a triad. The Museum's torso is an image of Avalokiteśvara – the Bodhisattva of mercy and compassion – and stood on the left as one faced the triad. The other is Maitreya – the next Bodhisattva due to appear on earth as Messiah – and stood on the right. There are strong grounds for supposing that the original centre-piece is the Buddha statue at fig. 11, now enshrined in a ruined temple on the eastern periphery of the site, known as Temple 45 (figs. 8 and 12). The triad was apparently designed for the narrow shrine of this temple, built at the same period on the foundations of an earlier, burnt-out temple and monastery.

The site of Sāñchī, which produced these sculptures, is an ancient monastic settlement situated on a hill-top about five miles from the historic mercantile city of Vidiśā, now disappeared except for its archaeological remains (see map, fig. 2).[2] The area owed its great prosperity in early times both to the fertility of its soil – still famous for grain-growing – and to its location on the *dakshināpatha* or "southern trade route" linking the

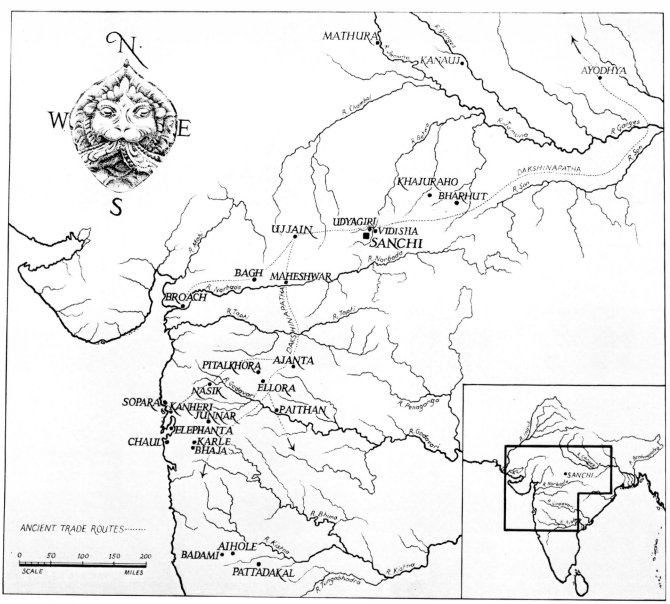

2. Map showing location of Sāñchī in relation to ancient trade routes and other historic Buddhist sites.

Ganges valley with southern India and the seaports of the west coast. The same route took the traveller southwards to the great cave sites of western India, including Ajantā, Elurā, Kārlī, Nāsik and Kanherī. Thus, Sāñchī occupied a key position in the exchange of cultural influences between north and south.

The earliest monuments are the three well-known stūpas, the largest of which – known as the Great Stūpa – dates at least from the reign of Aśoka in the third century B.C. During the next 1,500 years, more than forty other monuments, including many temples and monasteries, were added (see plan, fig. 20). The history of Sāñchī therefore corresponds to the whole period of the rise and decline of Buddhism as an independent religion in India. From the point of view of the art historian, the richest period was between 50 B.C. and 50 A.D. when the three main stūpas were given their famous carved stone railings and gateways, replacing

earlier wooden prototypes. The next major creative phase was the fifth century A.D., under the rule of the Gupta dynasty. The sixth century was one of confusion owing to the Hun invasions of northern India; but between the seventh and tenth century – the period with which we are here mainly concerned – prosperity came back, first under the Later Guptas, and then under the Pratihāras of Kanauj and their local feudatories, the Paramāras. Already by the seventh century, Hīnayāna Buddhism (which concentrated worship on the Buddha himself) had given way to the Mahāyāna cult, in which the worship of Bodhisattvas featured more conspicuously. These "future Buddhas" were reverenced as celestial beings or saviours who had renounced the opportunity of becoming Buddhas in order to remain accessible to earthly suppliants. In the Mahāyāna Buddhist art of Sāñchī, the influence of Hinduism becomes increasingly strong from the eighth century onwards; but the cult of

Tantrism,[3] which dominated northern Buddhism at this period, is very little evident. By the eleventh century, Hinduism was so successful in the surrounding area that Buddhism was gradually eclipsed as an independent religion, the Buddha himself now being reduced in status to an incarnation of the god Vishnu, thus illustrating another stage in the age-old Indian mythological process of assimilating-to-kill. As a result, the ancient stūpa-sites lost prestige and patronage. By the thirteenth century Sāñchī is said to have been deserted and its monuments already in decay – a process later hastened by Islāmic vandalism.

The rediscovery of Sāñchī in modern times dates from 1818, when a British officer, General Taylor, happened upon its ruins during a military campaign. Since the subsequent stages of research and restoration are important to the unravelling of the history of the Sāñchī Torso, they will here be summarized:

1819. Captain E. Fell published the first general description of Sāñchī in the *Calcutta Journal*, 11 July, 1819.[4]

1847. Captain J. D. Cunningham, political agent at Bhopal, published the first detailed plan of the monuments, together with a report, in the *Journal of the Asiatic Society of Bengal*.[5]

1849. Lieutenant F. C. Maisey, who had been selected for special duty investigating archaeological remains in the region, spent the winters of 1849–50 and 1850–1 at Sāñchī making descriptive notes, plans of the site, drawings of the monuments, and detailed drawings of the sculptures.

1851. Major Alexander Cunningham (brother of Captain J. D. Cunningham; later, as General, appointed first Director of Archaeology in India) excavated some of the stūpas jointly with Lieutenant F. C. Maisey. Results were published by Cunningham in *The Bhilsā Topes*, 1854, and in Maisey's *Sāñchī and its remains*, 1892, compiled after his death from the notes made in 1849–51.

1862. The first photographs of the monuments were taken by Colonel J. J. Waterhouse (see fig. 3).

3. First photograph of the Great Stūpa, Sāñchī, taken in 1862, before the site had been cleared of jungle growth. As published by James Fergusson in 1868.

1868. James Fergusson published the first art-historical study of the stūpa sculptures under the misleading title, *Tree and serpent worship*, 1868, using the photographs taken by Waterhouse in 1862, and drawings made by Maisey in 1849–51.[6]

1869. The central government had casts made from the Eastern Gateway of the Great Stūpa, full-size models being set up in London, Edinburgh, Dublin, Berlin and Paris.[7]

1875–77. General Alexander Cunningham, as Director of Archaeology, returned to Sāñchī to examine inscriptions. Among them was an inscription on the Swāmi-Gosura pillar, previously regarded as Aśokan, but now proved to be Gupta. His report was published three years later in *Archaeological Survey Reports*, x, accompanied by a lithographed plate of the pillar with the Museum's Sāñchī Torso shown (illogically and without explanation) leaning against the shaft (reproduced here at fig. 4).

1881. The central government allocated Rs.2,000 for initial restoration of the site, including the clearing of vegetation and the collecting together of the scattered "carved stone fragments".[8] This work was assigned to the local Superintendent of Public Works. The photograph reproduced at fig. 5 was taken while restoration was in progress. In the same year William Kincaid (later General) was appointed Political Agent to the state of Bhopal, which included Sāñchī.

1882. The central government allocated Rs.20,000 for further restoration, including re-erection of the two fallen gateways of the Great Stūpa. The work was planned by Major H. H. Cole as Curator of Ancient Monuments, and executed by military engineers.

1883. Cole's restoration, started the previous December was finished by April. The photograph reproduced at fig. 8 was probably taken in March.

1886. William Kincaid relinquished his post as Political Agent to the state of Bhopal and returned to England, taking with him the Sāñchī Torso.

Evidence of the torso reaching England in 1886 is contained in the following letter addressed to General Donnelly, Secretary of the Science and Art Department, Council on Education – the body at that time responsible for the South Kensington Museum, a decade later to give birth to the Victoria and Albert Museum:

> Radnor,
> Holmbury St. Mary,
> Dorking.
> 17th September, 1891.
>
> My dear General,
>
> Leaving England for a time I am desirous of finding a temporary home for a famous Torso of the Budha [*sic*] given to me by Her Highness the Begum of Bhopal. At the time of the re-erection of the Western and Southern gateways of Sanchi numerous carved stones were under my supervision unearthed and put together, but travellers British and Foreign were craving permission to take them away, so I thought it advisable to save the Torso which you will find engraved in Fergusson's *Tree and serpent-worship* among plates devoted to the Sanchi Topes. This Statue had been erected by order of King Asoka in the 3rd century B.C. and is considered by Fergusson a good specimen of Indo-Grecian art – it had been on the top of a column in front of the Western gateway. If the Indian Section of the South Kensington Museum will accept the Torso as a loan from me I think it may be thought worthy of a temporary resting place there. I could place it in the box in which it came from India 5 years ago and send it by rail to your care.
>
> Yours truly,
> W. Kincaid.

The offer to lend the torso to the Museum was accepted, and everything Kincaid had to tell about it was regarded as authoritative.

To-day, however, there is little information in Kincaid's letter we can accept as valid except his claim that the torso had been given to him by the Begum of Bhopal and brought to England in 1886. It could not, in fact, have been among the sculptures "unearthed" during the winter of 1882–3 (when the southern and western gateways were re-erected) because, as already noted, three years prior to this it had been photographed and published leaning against the broken shaft of the Swāmi-Gosura pillar (fig. 4).[9] Kincaid is also wrong in stating that the torso had been published by Fergusson. His claim that it had come from the top of an Aśokan column "in front of the Western gateway" is contradicted by the fact that no column of any kind had ever stood in this position. In short, Kincaid's evidence on all the main points is patently misleading.

The Museum authorities accepted Kincaid's story because at that time there was nobody on the staff with the knowledge to challenge it. Hitherto, interest in Indian art had been focused on handicrafts to the exclusion of "fine art". As recently as 1880 the official handbook to the Indian collections at the South Kensington Museum had warned its readers that "the monstrous

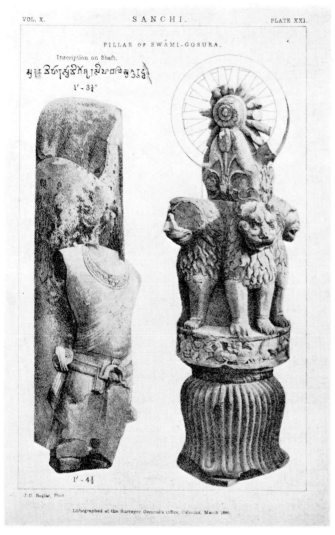

VOL. X. SANCHI. PLATE XXI.

PILLAR OF SWĀMI-GOSURA.

Inscription on Shaft.

1'-3¼"

1'-4⅝

J.D. Beglar, Phot.

Lithographed at the Surveyor General's Office, Calcutta, March 1880.

4. The Sāñchī Torso as first published in 1880 (*Archaeological Survey Reports*, vol. x). It is shown leaning against the Swāmi-Gosura pillar, the latter bearing a Gupta inscription of about the fifth century A.D.

shapes of the Puranic [Hindu] deities are unsuitable for the higher forms of artistic representation . . . [which] is possibly why sculpture and painting are unknown, as fine arts, in India".[10] In the case of the Sāñchī Torso, an extenuating factor was undoubtedly its recommendation to the Museum as "a good specimen of Indo-Grecian art". Not long before this, news had been reaching Europe of an Indo-Hellenistic school of Buddhist art which flourished in north-west India sometime after the invasion of Alexander the Great. Since the Sāñchī Torso had been attributed to the reign of

Aśoka – less than a century after Alexander – there seemed nothing *historically* implausible about the idea of Greek influence. *Stylistically*, too, its clear lines seemed to support such a possibility.

To the handicraft experts at that time directing the policy of the Indian Section, the main interest of the Sāñchī Torso was in its jewellery (fig. 7 (a)). This explains why the torso first came to be published in England in 1909, not in its own right as a sculptured work of art, but as an illustration to a series of articles on Indian jewellery.[11] (Not unexpectedly, the anonymous author of these articles concluded his praise of the jewellery with advice to the reader to look for parallels among the gold ornament of "the finest period of Greek art".) However, publication coincided with growing impatience among a certain section of the educated public towards official neglect of Indian "fine art". The Museum's records reveal that within a few months the Director was being petitioned – from undisclosed "private sources" and over the heads of the Indian Section staff – to acquire the Sāñchi Torso for the permanent collections. The identity of these sources may be inferred from the fact that the petitioning exactly coincided with the foundation of the India Society and a particularly relevant letter to *The Times*. The Society was founded "to further the study and appreciation of Indian culture in its aesthetic aspects", and, more especially, "to promote the acquisition by the authorities of our national and provincial museums of works representing the best Indian art".[12] The letter to *The Times* was signed by a group of artists and intellectuals prominent in the India Society, including Laurence Housman, Walter Crane, W. R. Lethaby, A. E. Russell and William Rothenstein. It was a protest against certain insulting remarks made about Indian sculpture by Sir George Birdwood, the Museum's former adviser on Indian art, at a meeting of the Royal Society of Arts. It concluded with the pious statement that "we find in the best art of India a lofty and adequate expression of the religious emotion of the people and of their deepest thoughts on the subject of the Divine".[13]

The choice of the Sāñchī Torso as a sculpture on which the Society could take issue was a good one. Its sculptural qualities were obvious for all to recognize. There was nothing too obviously alien about its conventions to disturb even the most westernized sensibility. The very fact that it was a "torso" provided, perhaps, another link – however fortuitous – with Greece and Rome.

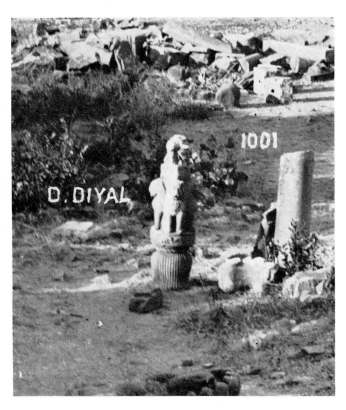

The Museum's recommendation to the Board of Education to buy the torso was reinforced at just the right moment by a rumour that "a leading Continental Museum was endeavouring to obtain information about this loan-object with a view to purchase".[14] This prompted the Board to act quickly lest (as one member recorded in a minute) they should "risk the rumpus that would ensue if it came out that Germany had bagged the torso". Kincaid had died recently. Agreement was reached with his widow to purchase the sculpture for the sum of £80.

The news was received with delight by members of the India Society, and when, in the following year, they published a book of plates to introduce to a wider public the best standards of Indian sculpture, the Sāñchī Torso featured as Plate 1.[15] E. B. Havell, in his notes on the plate, recorded a little acidly the hope that the Museum's purchase of the Torso might be "a first indication of a different view of Indian fine art from

5. A "blown-up" section of the photograph below showing the Sāñchī Torso still leaning against the shaft of the Swāmi-Gosura pillar (cf. fig. 4).

6 View of the Great Stūpa taken in 1881, during early stages of restoration. *India Office Library negative no. 1413.*

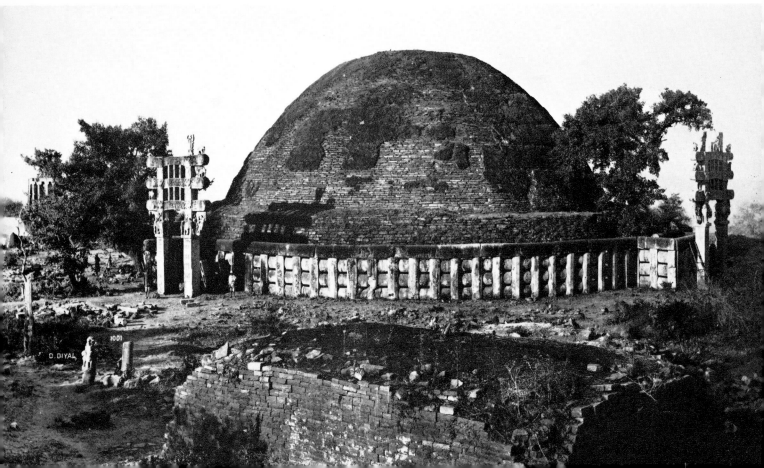

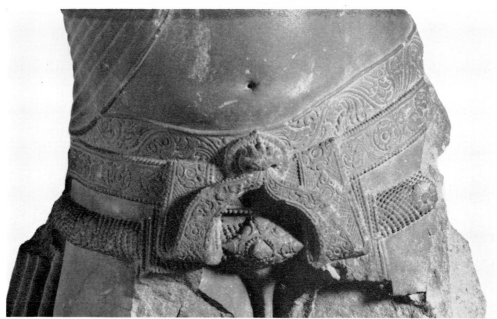

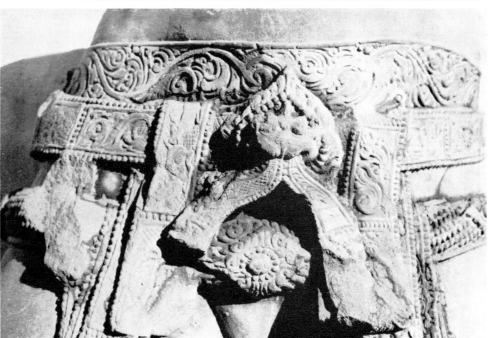

7. (a) and (b). Waist and girdle of the Sāñchī Torso (above) and of the recently discovered "pair" (below).

that which had hitherto prevailed in the management of the Indian Section". In the same context he challenged the attribution to the third century B.C. and suggested instead the fourth or fifth century A.D. This was the beginning of the torso's long reputation as a masterpiece of *Gupta* art. And since the Gupta dynasty ruled at a formative stage in the transition from ancient to mediaeval India, the term "classical" so often applied to it in the past with a Hellenistic connotation was now re-interpreted to denote a classic style within a purely *Indian* context.

Up till now, nobody had pointed out that the torso, brought to England in 1886 by Kincaid, was the same as the torso published in India in 1880 in the tenth volume of *Archaeological Survey Reports*, where it was shown leaning against the Swāmi-Gosura pillar (fig. 4). This was first recognized by K. de B. Codrington, who then assumed that torso and pillar, if not actually monolithic, were at any rate by the same hand. Since the pillar bore a Gupta inscription, this was taken by him as confirmation that the torso was the same.[16]

This Gupta attribution was not openly challenged until 1949, when Professor Benjamin Rowland of Harvard University argued in a paper that the torso was neither Gupta nor a product of Sāñchī. Instead he claimed it as an eighth- or ninth-century import from the north, relating its style to the art of the Pāla dynasty of Bihār and Bengal.[17]

In November, 1970, the controversy was still at this stage when the "pair" to the Museum's torso was found

in a warehouse adjoining the archaeological museum at Sāñchī.[18] In London, three months later, this fortunate discovery was followed by another. In searching for photographs taken at Sāñchī during the vital period of restoration in the 1870s and 1880s, there came to light in the photographic archives of the India Office Library[19] an old and faded print of the greatest significance. It was a view taken from the terrace of the Great Stūpa looking east (fig. 8). On the horizon are the ruins of Temple 45 (which is soon to play a major part in the story), and in the foreground to this temple are ranged a number of sculptured fragments which, on close scrutiny, were seen to include *both sections of the recently found "pair" to the Sāñchī Torso*. By lucky chance, the original glass negative was also traced in the Library archives. From a "blow-up" (fig. 9) we see that both halves of the sculpture were more complete then than they are now. The line-drawing at fig. 10 has been prepared to show how the two sections, as seen in the photograph, might have looked had they been joined together at that time. It is

clear from the enlarged photograph that the lower half of the sculpture was then complete with its lotus pedestal,[20] and that chest and halo were relatively un-damaged. We also recognize a clue to its identity in the broken fragment of a flower-stem showing in front of the left shoulder (no longer a feature of the sculpture in its present more damaged condition, though the scar remains). Originally this stem must have supported a flower-head at the level of the halo and joined to it. There is in fact a scar clearly visible at the lower segment of the halo where the flower-head has been broken off. Most significant of all, we can detect quite clearly that the shape of this flower-head was not round, like a lotus, but elongated, like the *nagapushpa* or *champaka* flower, which is the special symbol of the Bodhisattva Maitreya. At the left hip is the badly-damaged fragment of the left hand, the thumb with its decorative thumb-ring being visible both in the photo-graph (fig. 1) and in the reconstructed drawing (fig. 10). The lower end of the flower-stalk would have rested in the open palm of the hand.

8. View looking east from the terrace of the Great Stūpa, taken in March, 1883. In the background are the ruins of Temple 45. *India Office Library negative no. 1640.*

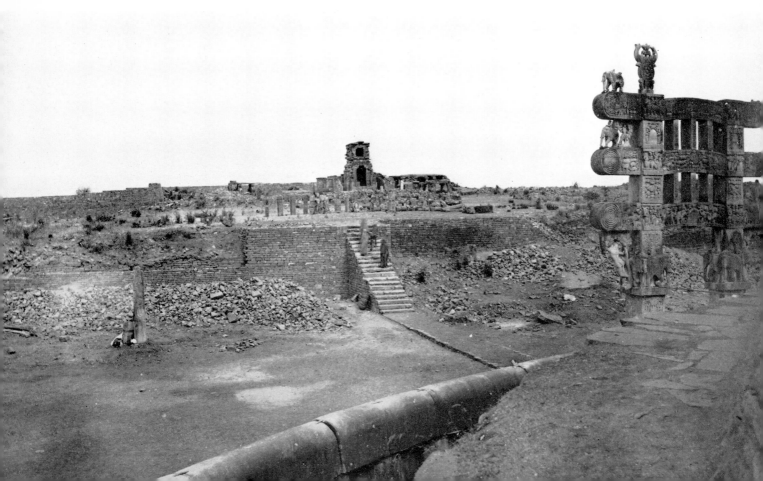

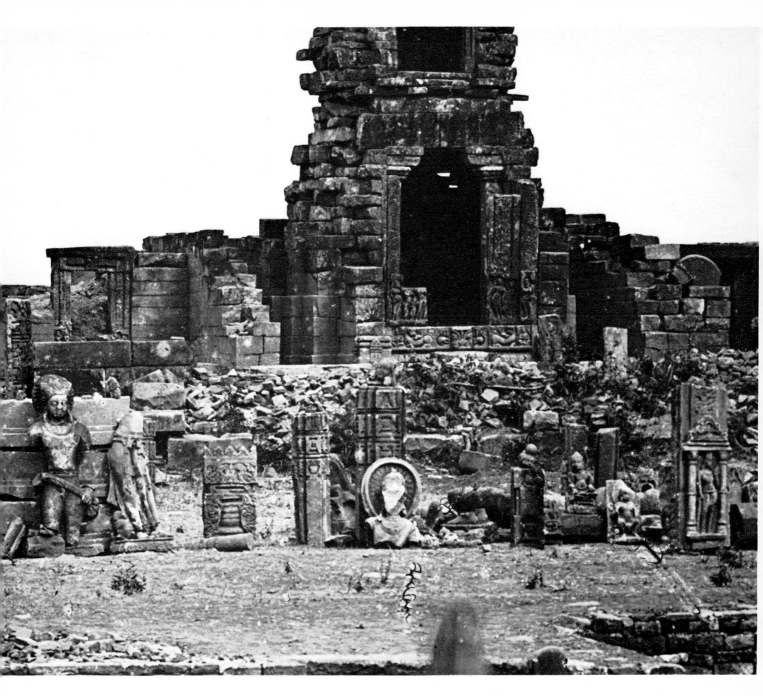

9. A "blown-up" section of the photograph on opposite page showing, in the foreground of Temple 45, various fragments of sculpture, including both sections of the "pair" to the Sāñchī Torso. The round object at the feet is the head of an earlier image.

Further examination of the sculpture reveals that on the right shoulder and the halo above it there are scars of what may have been a fly-whisk – an object commonly held by Bodhisattvas when in attendance upon the Buddha.[21] The 1883 photograph (fig. 9) shows a long curved bridging piece leading from the right ear to this broken object, but the details are too indistinct to ascertain whether this is part of the flywhisk or a long tress of hair or the remains of a hanging ear-ornament. A further possibility is that the fragment on the shoulder might indicate the point of contact of a miniature *stūpa*. Although this symbol of Maitreya usually appears only in the crown or head-dress, there are occasional precedents for its double-appearance – once in the head-dress and again adjacent to the halo on the proper right side.[22] Whatever the conclusion on this particular point, we still have a clear indication that the figure is Maitreya from the nature of the flower-head on the opposite side. We therefore have no difficulty in recognizing that the Museum's torso is Avalokiteśvara, on the strength of the *ajina* or antelope-skin worn across the left shoulder. Hitherto, the *ajina* alone had been insufficient evidence because, in mediaeval Buddhist iconography, the antelope-skin is

occasionally worn by Maitreya as well as by Avalo-kiteśvara.[23]

The two remaining problems are the date of the two Bodhisattvas and the position they originally occupied. Nobody familiar with mediaeval Indian sculpture is now likely to dispute that the two figures were carved somewhere in the ninth or tenth century A.D. The difficulties begin when we try to fix a more precise date within this rather wide margin of two centuries. Most of the vandalism at Sāñchī was concentrated on monuments of precisely this period, presumably because their greater profusion of images made them the most obvious targets for the iconoclast.

The most important of the surviving pieces for our purpose is the large seated Buddha now enshrined in Temple 45 (fig. 11). The details of its face have been almost completely expunged by hammer-blows, and the right arm, which was originally in the gesture of "calling the earth to witness (*bhūmisparśa mudrā*)", has been destroyed. Otherwise the damage is relatively superficial. The first thing to notice is that the halo of this statue matches in style that of our recently discovered Bodhisattva Maitreya (fig. 1), and that the diamond-and-rosette motif which features prominently in its ornament is found again in the necklace of the Sāñchī Torso. When we examine the "blown-up" photograph at fig. 9 with a magnifying glass, we see that the conventional lotus petals decorating the pedestal of the Maitreya match in style those of the Buddha's pedestal. All three images are of a stone similar in grain and colour (notwithstanding the fact that the Buddha shows traces of red pigment on its surface), and laboratory analysis suggests that the stones could well have come from the same quarry.[24] (There is no evidence that this extremely fine-grained sandstone was used at Sāñchī before about the seventh century A.D. – the earliest apparently being the seated Buddha in Temple 31, reproduced at fig. 15. After that it was used frequently, as the many fragments of post-Gupta and mediaeval images lying about the site testify).

There exists, therefore, a *prima facie* case for supposing that the three images, if not actually contemporary, were certainly carved within one or two generations by craftsmen of the same local caste or guild of stone

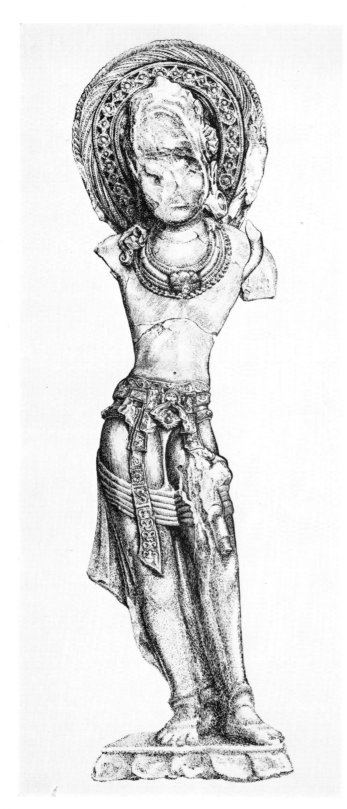

10. Drawing of the "pair" to the Sāñchī Torso as it would have appeared if the two sections had been joined in 1883 (cf. fig. 9). The overall height of the complete figure would have been approximately 210 cm.

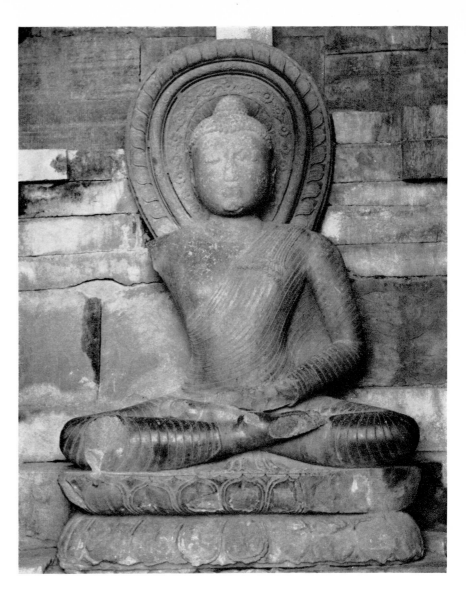

11. Close-up of Seated Buddha in Temple 45, Sāñchī. Probably 800 to 850 A.D. Height including lotus pedestal 306 cm.

masons. This attaches special importance to any clues we can find for the dating of the Buddha statue in Temple 45.

The first clue is an inscription on the pedestal in characters which Sir John Marshall and others have attributed to the ninth or tenth century.[25] On style alone, Marshall thought the sculpture might be older than its inscription, and older than Temple 45 itself, which he attributed to the tenth or eleventh century.[26] He thus inferred that the image did not originally belong to Temple 45 but to some other building.[27] Oddly enough, he did not take into account the fact (of which he may have been unaware) that this large statue was already in Temple 45 in 1819, when the site was "discovered" after many centuries of supposed abandonment.[28] Since this was so, it is difficult to escape the conclusion that the statue has been in Temple 45 at least since the thirteenth century, by which time Sāñchī is thought to have ceased functioning as a religious settlement.

The plain truth is that Temple 45 is a hotch-potch. The excavations of 1912–14 proved that, in its present form, it is a reconstruction on the foundations of an earlier temple and monastery destroyed by fire, and that old materials were mixed with new in the rebuilding. In design, the present temple consists of a square sanctum (*garbhagriha*) approached through a small antechamber and crowned by a hollow spire (*śikhara*), the upper part of which has collapsed. Round three sides runs a narrow procession path (*pradakshina-patha*) – so narrow that the photographing of sculpture on its walls is very difficult.

In spite of the problems of Temple 45, the question of the date of its rebuilding has to be faced, because, as we shall see, the answer is very relevant to the origin of the Buddha statue and to our two Bodhisattvas. In distinguishing old from new materials used in the rebuilding, Marshall made special mention of the reliefs decorating the threshold door-jambs (fig. 12) which, for structural reasons, he claimed were "manifestly executed expressly for this temple".[29] These particular sculptures are strongly Hindu in character and could well have decorated a Hindu temple, their main subject being the

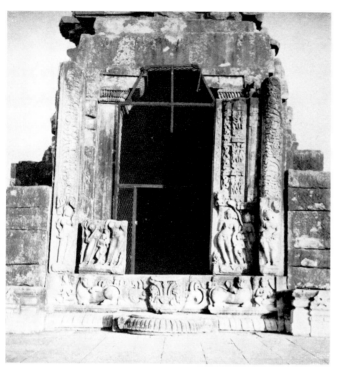

12. Threshold of Temple 45, Sāñchī, showing Gangā-Yamunā relief carvings contemporary with construction, c.900 A.D.

river-goddesses Gangā and Yamunā. Madame Odette Viennot of the Musée Guimet, who has made a specialized study of the Gangā-Yamunā theme in sculpture[30], is confident on one point: that these reliefs are only *slightly* later than those on the temple known as the Telika Mandir at Gwalior, known to have been finished about 800 A.D. On this basis she cannot admit to the threshold carvings of Temple 45 being later than 850 A.D.[31] On the other hand we are faced with the contradictory evidence of the sculptures on the outside walls, which Marshall also regarded as contemporary with the rebuilding, but which are difficult to reconcile with a date much earlier than 900 A.D. The walls concerned are plain except for three niches sunk in the middle of their south, east and north faces. In the south niche is an image of Mañjuśrī[32] seated on a peacock (fig. 13 (a)). In the East niche is a seated Buddha on a lotus throne supported by two lions (fig. 13 (b and c)). The niche on the north side is empty. As Marshall noted, these images are carved "*in the same purplish-brown stone and in the same style*" as the large Buddha in the inner shrine.[33] Therefore, if we accept the conclusions of both Marshall *and* Viennot, and also take into account the evidence of

the excavation reports of 1912–14, the history of Temple 45 may be summarized as follows. A combined temple and monastery was built on this site in the seventh or eighth century. This was subsequently burnt down, and re-erection of another temple-monastery complex, using some of the old materials, was started some time before 850 A.D. The new shrine was apparently designed to take a large standing image; but for reasons unknown building operations were delayed, and when finally the shrine itself was completed about 900 A.D. it was decided to install a seated image. The building of the rest of the complex was then again interrupted, as clearly indicated by the later construction of the flanking cells, which were apparently not completed until the eleventh century.

In light of this hypothesis, we next have to consider

13 (a), (b) and (c). Niche carvings on outside walls of Temple 45, Sāñchī, in sandstone similar to Sāñchī Torso. (a) Mañjuśrī, on south wall; (b) and (c) the Buddha, on east wall. Late ninth or early tenth century A.D.

(a)

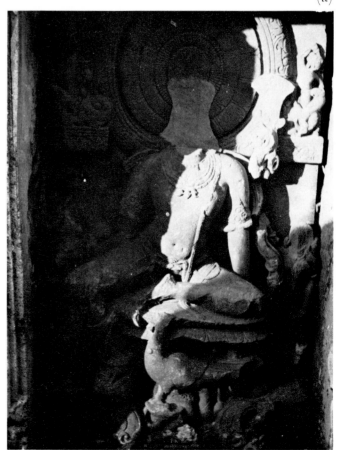

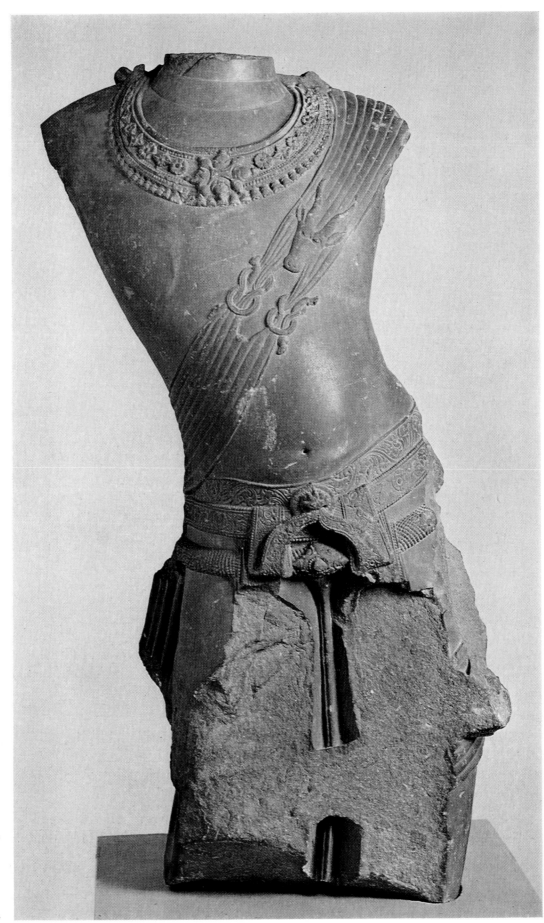

"The Sāñchī Torso".
An image of the
Bodhisattva
Avalokitesvara.
Sandstone. From
Sāñchī, Central
India, 800 to 850 A.D.

whether the seated Buddha at present installed could date from the completion of the shrine about 900 A.D. To answer this, we shall first have to examine the statue in relation to other Buddha images surviving at Sāñchī and see whether it fits into any kind of chronological pattern.

For this, the logical starting point is the Gupta Buddha at fig. 14. This is one of four steles carved in comparatively coarse-grained whitish sandstone which were placed inside each of the four gateways of the Great Stūpa. Their Gupta origin is proved by an inscription which records that they were already in position by the middle of the fifth century A.D.[34] A typical Gupta feature is the serene meditative pose (suggestive of the Yogic discipline of *prānasamyama* or breath control), which is thrown into greater focus by the crisp, light foliations of the circular halo.

The image at fig. 15 is somewhat dead in comparison. The halo suggests that it cannot be later than the eighth century. Yet, in spite of the comparatively early date, the uninspired, static treatment of the

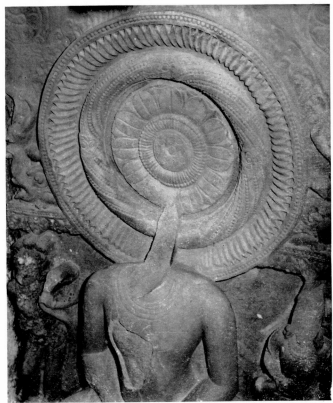

(c)

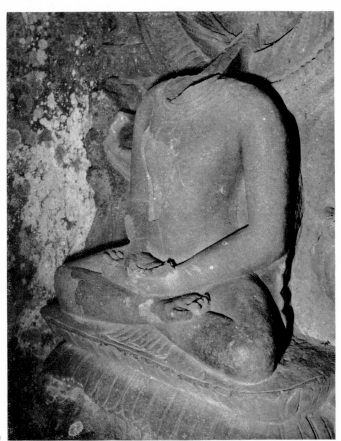

(b)

ornament, and the dull modelling of the torso (no longer suggestive of Yogic discipline) make it difficult to believe that the artist felt any personal identification with the Buddha or his original doctrine. This in fact corresponds with the stage when the Buddha was losing popularity as an object of worship in favour of his more human and approachable mediators, the Bodhisattvas. Next in sequence comes the Temple 45 Buddha (fig. 11). The halo is no longer quite circular but slightly elliptical. The poise of the body is more stylized and hieratic. Note, too, the exaggerated skull-protuberance (*ushnīsha*), and the tightly-curled hair like a wig (which contrasts absurdly with short, realistic, combed hair at the temples, not visible in the photograph). Though the carver of this image was in every way a better artist than the creator of the image at fig. 15, the result is a long step further away from the earlier humanistic vision, most strikingly expressed in the Gupta image at fig. 14. A final stage in the process is represented by the statue at fig. 16, carved in the eleventh century or later. By this time Buddhism in the Sāñchī region was losing spirit as an independent religion, in face of the advance of Hinduism. In describing this sculpture it is difficult

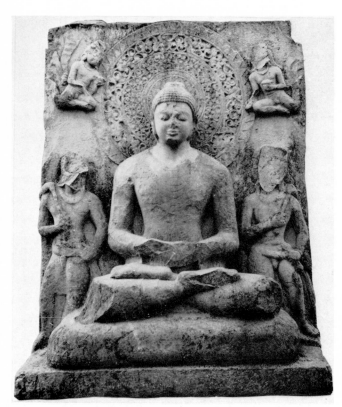

14. Seated Buddha located inside the eastern gateway of the Great Stūpa, Sāñchī. Coarse-grained, whitish sandstone. Gupta style, early fifth century A.D.

15. Seated Buddha, now in Temple 31, Sāñchī. Sandstone. Seventh or eighth century A.D.

to avoid the term "decadent". The figure entirely lacks tension. The composition is overweighted by the ponderous, oval halo, the true function of which as a nimbus is now lost. The conventional, curled hair sits more than ever like a wig on a plum-pudding. The shoulders lack vitality; the legs are weak. Details such as the lotus petals decorating the pedestal, and the pleated hem of the garment displayed in front, confirm a general lack of sensitivity.

Using this sequence as a framework for stylistic reference, one would logically expect the date of our key Buddha image (fig. 11) to fall about half-way between fig. 15 (seventh–eighth century) and fig. 16 (eleventh century or later). It could be argued that in this part of India, the ninth century is too early for an interpretation so hieratic and impersonal; and the tenth century too late for a Buddha invested with such obvious power and prestige. On this reckoning, a date around 900 A.D.,

coinciding with the completion of Temple 45, would be quite plausible.

Taking this date as a hypothesis, let us turn again to our two Bodhisattvas. We earlier suggested that, if not actually contemporary with the Buddha in Temple 45, they certainly seem to have been carved within a generation or two by the same local caste or guild of stonemasons. Can we now see them fitting logically into the late ninth or early tenth century?

The term "hieratic", which we applied to the Temple 45 Buddha, is of course a far cry from these intensely human Bodhisattvas. It is as though the Buddha had now become a figure remote in the popular imagination, and the humanistic feelings with which he was invested by the Gupta sculptor (fig. 14) were now reserved for his mediators, the Bodhisattvas. Such a deduction is in fact consistent with contemporary developments of the Mahāyāna cult.

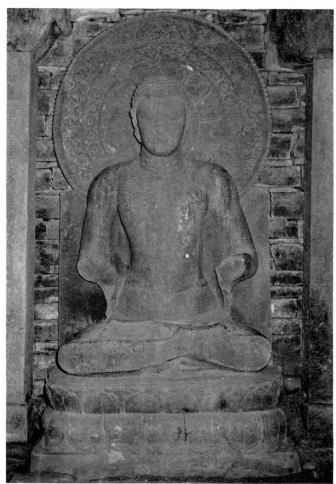

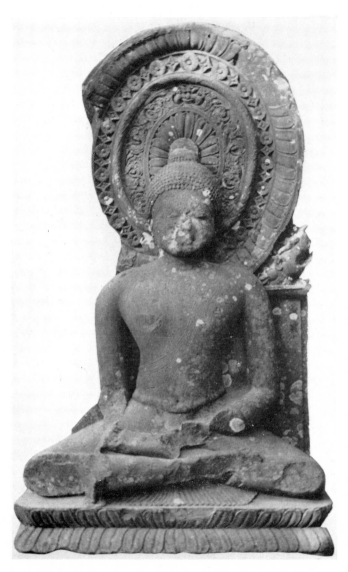

16. Seated Buddha, now adjoining Temple 45 (south wing), Sāñchī. Sandstone, much weathered. Eleventh century A.D. or later.

with the austere, awe-invoking Buddha. It follows therefore that the difference in treatment between the Buddha in Temple 45 and our two Bodhisattvas does not preclude the possibility of all three images being contemporary products of the same guild of craftsmen. The forerunners of our Avalokiteśvara and Maitreya are the Bodhisattvas so lovingly depicted in the great cave temples of Western India in the sixth and seventh century. One thinks of the well-known triad in Cave X at Ellorā (fig. 17), and the masterly paintings in Cave I

17. The Buddha, flanked by the Bodhisattvas Avalokiteśvara and Maitreya. Rock-cut sculptures in Cave X, Ellora. Seventh-eighth century A.D.

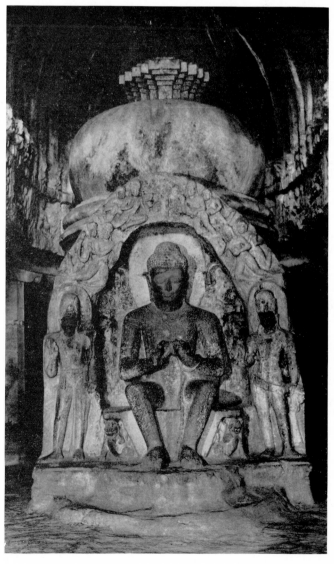

According to earlier doctrine, only a monk could attain Buddhahood. Now it was believed to be within the power of any mortal, simply by following the right disciplines. Artists therefore envisaged Avalokiteśvara and Maitreya as human like themselves. Moreover, these Bodhisattvas, unlike the Buddha, answered personal prayer, and their special power as mediators was matched by mercy and compassion. Hence the sculptor's feeling of personal identity, and his concern to make them seem accessible to mortals, in contrast

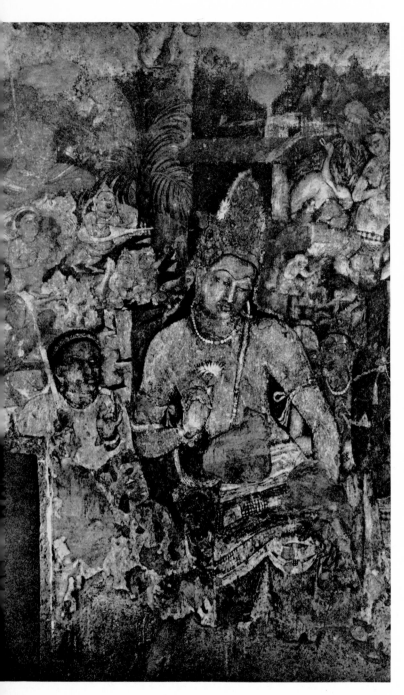

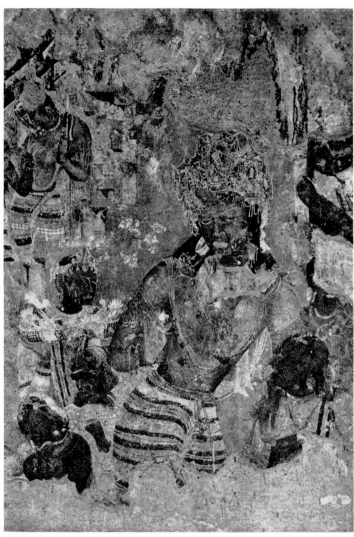

19. (*above*) The Bodhisattva Vajrapāni. Seventh century, first half. Cave I, Ajanta.

18. (*left*) The Bodhisattva Avalokiteśvara. Seventh century, first half. Cave I, Ajanta.

at Ajantā (figs. 18 and 19).[35] In the former case they are flanking a seated Buddha; in the latter, they serve as door-guardians to the inner shrine. This prompts us to ask the precise function of our two Sāñchī Bodhi-sattvas: did they form part of a triad, or were they door-guardians?

The vital clue is once again to be found in the "blown-up" photograph at fig. 9. A careful look at the lower section of the Maitreya shows that the image was designed to stand slightly to one side of its pedestal, instead of in the centre. (The vacant space on the opposite side happens to be occupied in the photograph by the head of another image which has no relevance in this context). This suggests the image had been de-signed as part of a triad – more particularly, to stand

on the proper left-hand side of a central Buddha image in a comparatively confined space. The special reason was to prevent the feet of the Bodhisattva being obscured by the folded legs and lotus pedestal of the central image, while at the same time giving it a stable base.

This now leads to the final question: could the seated Buddha in Temple 45 have been the original centre-piece in the triad with our two Bodhisattvas? Final proof on this point may never be forthcoming, but on aesthetic grounds a positive answer certainly seems likely, as the scale-drawing at fig. 21 shows. When arranged with shoulders approximately level, the three heads compose well together; and the feet of the Bodhisattvas adjust neatly with the folded legs and lotus-pedestal of the central image. The possibility of Temple 45 being the setting for which the triad was designed is strengthened by the narrowness of the shrine. This required the figures to be drawn as close together as possible – and hence the slight off-setting of the Bodhisattvas on their pedestals, as already noted. In the absence of any evidence to the contrary, we believe therefore that this triad was designed specifically for the shrine of Temple 45 at the time of its rebuilding.[36]

With the mediaeval origin of the Sānchī Torso now established, the old ideas of Greek inspiration must be recognized as absurd. Instead, we see the figure as characteristically Indian, especially the graceful sinuous pose, and the skilful balancing of masses against a curved central line (in iconographical treatises, this pose is called *tribhanga*, literally "thrice-bent"). Even more typically Indian is the sensuous rendering of flesh into stone. (Its present shiny surface – especially the area around the abdomen – is witness to the generations of museum visitors who have been tempted to caress it with their fingers). Also very Indian is the way in which sensuousness is stressed by deliberate contrast of sensitive flesh surfaces with the highly stylized girdle and waistcloth – a contrast which provides the basic aesthetic tension of so much of the best Indian sculpture of all periods. Although a torso, clear and simple in outline, we should recognize that it is essentially a *relief* carving, not sculpture in the round. This is another Indian feature. The harsh Indian sunlight kills the subtlety of *chiaroscuro* and makes free-standing sculpture in the open difficult to look at; on the other hand, the same strong vertical light helps high relief carving. This preference for relief extends even to the treatment of figures inside temples. If the effect of the Sānchī Torso on the observer is nonetheless that of a

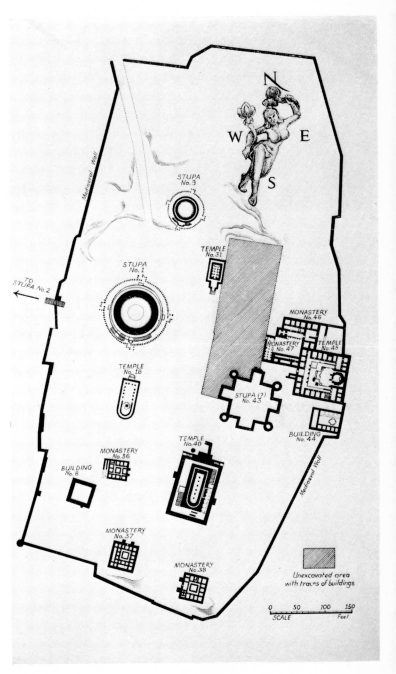

20. Plan showing the principal monuments at Sānchī and the area still unexcavated.

sculpture in the round, this is due to the artist's skill in contriving three-dimensional illusion – particularly evident in the treatment of the necklace and the way in which its bell-pendants, receding in size, are made to suggest depth. Only when we look at the torso

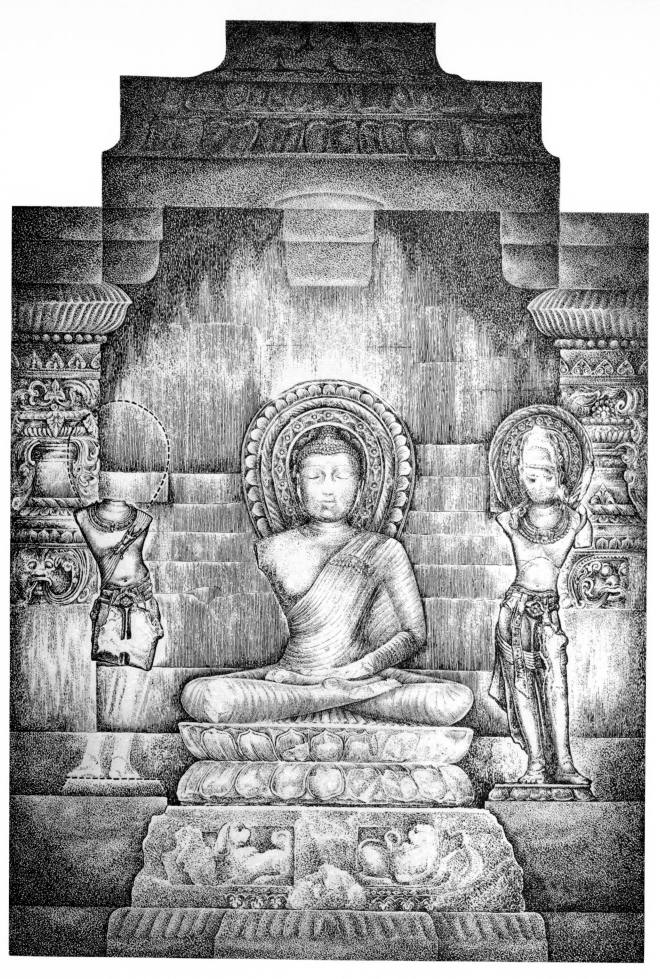

24

21. (*opposite*) Scale drawing showing the aesthetic relationship of the two Bodhisattva sculptures to the Buddha statue now in Temple 45, Sāñchī (cf. fig. 1). In view of alterations to the shrine, it is not possible to state their exact relationship.

22. Isometric sketch of the shrine, Temple 45, Sāñchī.

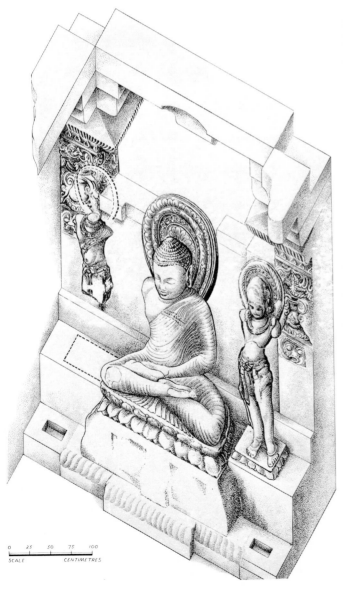

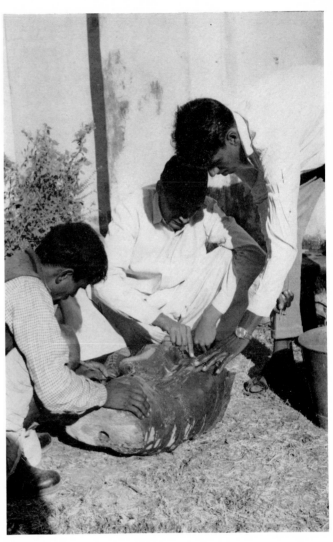

23. The first of the two fragments of the "pair" being cleaned immediately after discovery at Sāñchī on 28th November, 1970.

from the side are we aware that the actual depth of carving from back-to-front is little more than six inches. Four decades ago, when Marshall and Foucher reviewed the mediaeval sculptures at Sāñchī for their three-volume study of the site, they remarked that the few surviving fragments of Bodhisattvas had "too little artistic or documentary interest to be worth reproducing".[37] To-day, this judgement can no longer stand. In light of the mediaeval identification of the Sāñchī Torso and its recently discovered "pair", it will never again be doubted that masterpieces were being produced at Sāñchī as late as the end of the ninth century A.D.

Notes

1. In reaching the conclusions presented with this article, I have sought the help and advice of many colleagues in their own specialized fields. I should like in particular to acknowledge Mr. B. N. Misra, Assistant Archaeological Superintendent at Sāñchī, who gave me every possible facility and encouragement for my work on the site; Mme. Odette Viennot, Chargée de Mission au Musée Guimet, Paris, who not only helped me to sort out the problems of Temple 45 on the spot but also directed me to the particular warehouse at Sāñchī where the "pair" to the Sāñchī Torso was identified; Mr. Douglas Barrett, Keeper, Department of Oriental Antiquities, British Museum; Dr. James Harle, Keeper of the Oriental Department, Ashmolean Museum, Oxford; Professor Dr. J. E. van Lohuizen-de Leeuw, Director of the Instituut v. Zuid-Aziatische Archeologie, Amsterdam University; Mlle. Marie-Thérèse de Mallmann, Maître de Recherche au C.N.R.S. et Chargée de Mission au Musée Guimet; and Dr. U. P. Shah, Director of the Oriental Institute, Baroda University. At every stage I have received generous help from my Indian Section colleagues, Mr. Robert Skelton, Mr. John Lowry and Miss Hilary Moule. Finally, a special word of recognition is due to Miss Margaret Hall for the drawings published with this article and for her help in the solution of iconographical problems.

2. The standard work on Sāñchī is by Sir John Marshall and Alfred Foucher, *The monuments of Sāñchī*, 3 vols., Calcutta, 1939. Sir John Marshall also published a short *Guide to Sāñchī*, first edition, Delhi, 1918. The reports of his excavations conducted at Sāñchī between 1912 and 1914 are published by the Archaeological Survey of India in its Annual Report for 1914–15. I hope my disagreement with Marshall on some of the vital problems of Temple 45 will not be interpreted as disrespect for the overall achievement of his Sāñchī explorations, to which, in other respects, I am greatly indebted.

3. The aim of Tantrism is, by union of the individual with the cosmic soul, to achieve full enlightenment in this life and thus to escape rebirth. This can be gained by the acquisition of supernatural powers which are produced by special rituals, the use of magic, the casting of spells, and so on. Tantrism is therefore a fusion of indigenous beliefs and folk-cults with ideas already present in conventional Indian religions. As far as mediaeval Buddhist art in northern India was concerned, its main influence was to enlarge the pantheon of male deities and to provide them with consorts through whom they could be more easily approached. This introduction of goddess-worship into Buddhism corresponded with a philosophical emphasis on the energy-giving female principle and other expressions of sexual symbolism central to their mystical conception of the universe.

4. Captain E. Fell, "Description of an ancient and remarkable Monument, near Bhilsah", written on 31 January, 1819. Published in *The Calcutta Journal, or Political, Commercial and Literary Gazette*, vol. IV, no. 132, 11 July, 1819 (India Office Library shelf-mark 21–FF–4). The report was reprinted by James Prinsep in the *Journal of Asiatic Society of Bengal*, Calcutta, III, 1834, pp. 488–94.

5. Captain J. D. Cunningham, "Notes on the antiquities of the Districts within Bhopal Agency", *Journal of Asiatic Society of Bengal*, Calcutta, XVI, 1847, pp. 739–63.

6. James Fergusson, *Tree and serpent worship: or illustrations of mythology and art in India . . . from the sculptures of the Buddhist topes at Sanchi and Amaravati*, Indian Museum, London, 1868. Second edition, 1873.

7. One of these casts stood for nearly a century beside the main staircase of the old Indian Section building in Imperial Institute Road, South Kensington. When the building was demolished in 1956 to make way for extensions to London University, the cast was also destroyed. Of the five original casts, only the Berlin one survives, this having been recently re-erected in the courtyard of the Museums for Indische Kunst at Dahlem (West Berlin).

8. In order to piece together a complete record of restoration operations between 1881 and 1883 it is necessary to consult the first three reports of the Curator of Ancient Monuments in India published under the title *Preservation of national monuments*. The first report (for the year 1881–2) was published from Simla in 1882; the second and third, covering the next two years, from Calcutta in 1883 and 1885 respectively. Photographs taken after the re-erection of the stūpa gateways in 1883 are separately published by the Curator, Major H. H. Cole, under the title *Preservation of national monuments in India: Great Buddhist Tope at Sāñchī*, Calcutta, 1885.

9. A copy of the photograph on which the 1880 lithograph was based is fortunately preserved in the India Office Library (photo no. 1359). The photograph reproduced at fig. 6 was taken at least a year later and shows the torso in exactly the same position. The plan of the site which was published in the second report of the Curator of Ancient Monuments (see fn. 8) mentions "fragment of an image" in the same context as the Swāmi-Gosura pillar (nos. 9, 10, 11 and 12). This was almost certainly the Sāñchī Torso. According to Cole, writing in another context, this site plan was drawn in January 1881.

10. George C. M. Birdwood, *The industrial arts of India: South Kensington Museum Art Handbook*, 1880, p. 125.

11. *Journal of Indian Art*, Vol. XII, no. 106, April 1909. A special number on Indian jewellery.

12. *The India Society, report for the year ending December 31, 1910, with rules, list of members, and prospectus*, London, 1911, p. 13.

13. Letter to *The Times* dated 28 February, 1910.

14. Museum registered paper no. 1891-6373 I.M.

15. *Eleven plates, representing works of Indian sculpture chiefly in English collections*, The India Society, London, 1911. The notes to most of the plates, including the Sāñchī Torso, were by E. B. Havell.

16. K. de B. Codrington, *Ancient India from earliest times to the Guptas*, 1926. In his notes to Plate 39(c), Codrington says: "This torso was once described as 'Mauryan'. It was first published by Cunningham, CSI, vol. X pl. XXI, where it is shown as being attached to the base of a pillar. Cunningham also gives the capital. The pillar appears to be Marshall's no. 26 (*Sanchi Guide*, p. 96). It is post-fifth century. The beautiful jewellery and the modelling as a whole are reminiscent of Badami". In 1930 Codrington interpolated the same views into Vincent Smith's

text as editor of the second (revised) edition of *The history of fine art in India and Ceylon* (p. 84) but without making clear that they were his views, not Vincent Smith's. Sir John Marshall, who assumed them to have been Vincent Smith's views, commented as follows: "The torso (now in the South Kensington Museum) figured in Cunningham's report as leaning against this pillar, had nothing whatever to do with it, and there is no evidence, as Vincent Smith supposes, that it stood at the base of the column". Sir John Marshall and Alfred Foucher, *The monuments of Sānchī*, I, p. 50, fn. 4.

17. Benjamin Rowland, Jr., "The Sanchi Torso: iconography and style", *Art Quarterly*, Detroit Institute of Arts, XII, 1949, pp. 170–6. The only published comment on Rowland's views was made by Douglas Barrett, "A group of Bronzes from the Deccan", *Lalit Kala* (Journal of Lalit Kala Akadami, New Delhi) nos. 3 and 4, 1957, p. 45, fn. 4: "An interesting example of Deccani influence in Malwa is provided by the so-called Sanchi torso . . . formerly called Gupta, and, more recently, Pala of the seventh to ninth century A.D. The Gupta date and the Pala attribution are both unacceptable. That the torso belongs to the ninth century A.D. or rather later, hardly admits of argument. That it fits uneasily in the body of Pratihāra or Paramara sculpture – whichever label is preferred – is merely due to the fact that it owes its style to such Deccani sculptures as the famous *chauri*-bearer from Patancheru (*The art of India and Pakistan*, pl. 46, no. 284)."

18. At the time of discovery it was noted that the fragments bore two separate numbers: 2728 and 61582. In 1922, when the Archaeological Survey of India published its *Catalogue of the Museum of Archaeology at Sanchi* by Maulvi Muhammad Hamid, Pandit Ram Chandra Kak and Ramaprasad Chandra, our figure was not apparently considered worthy of inclusion in the main body of the catalogue. However, at Appendix 'D', under the heading "Inventory of Sculptures and Minor antiquities in the godown or lying about the site", between two and three thousand fragments are very summarily listed. Under a sub-heading, "In the cells south of Temple 45", the list includes no. 2728, described simply as "Damaged figure". There can be little doubt that this refers to the 'pair'.

19. The India Office Library, formerly in the original India Office building in Whitehall, is now at 197 Blackfriars Road, SE1.

20. Careful study of the photograph with a magnifying glass shows signs of a fracture at the ankles which may be taken as an indication that this lower section was already in two parts. The round object by the feet is clearly the severed head of another image, apparently of earlier date.

21. In the cave temples of Western India, the Bodhisattvas Avalokiteśvara and Maitreya are quite often depicted with fly-whisks. R. D. Banerji, *The Eastern school of medieval sculpture*, Archaeological Survey of India, New Imperial Series, vol. XLVII, 1933, p. 89, quotes one of the iconographical texts of north-eastern India as saying that when Maitreya is depicted in attendance on the Buddha "he has two hands and holds a fly-whisk in his right and a branch of the Nāgakeśara in his left hand".

22. For instance, see R. D. Banerji, *op. cit.*, plate X (a).

23. I am much indebted to Mlle. Marie-Thérèse de Mallmann both for advice in correspondence and for her valuable work, *Introduction à l'étude d'Avalokiteçvara*, Annales du Musée Guimet, Bibliothèque d'Études, tome 57, 1948. Her remarks on the iconographical significance of the *ajina* are especially interesting (pp. 219–20).

24. I am indebted to Mr. E. A. Jobbins, Principal Geologist, Geological Survey and Museum, South Kensington, for much painstaking work on the analysis of these and other stones. Among samples brought back were some from a quarry about 18 miles north-east of Bhilsa, on the road to Basoda. These were similar in grain and colour to the Sānchī Torso. Mr. Jobbins agreed after analysis that the two Bodhisattvas and the Buddha in Temple 45 could have come from that particular quarry.

25. Sir John Marshall and Alfred Foucher, *The monuments of Sanchi*, I, 1939, p. 73. The inscription, incomplete and much damaged, records the Buddhist creed. The legible characters read as follows: *ye dharrmā he . . . bhavā he . . . ñca yo . . .*
The full creed would have read: *Ye dharrmā hetuprabhavā hetum tesām tathāgato hyavadattesāñca yo nirodha evamvādī mahāśramanah.* Translation: "Of all phenomena sprung from a cause the Tathagata has told the cause and also their cessation. Thus spoke the great mendicant". I am grateful to Professor Dr. J. E. van Lohuizen-de Leeuw for having examined this inscription from a cast sent to her, and from which she independently confirmed that the characters were attributable on palaeographic grounds to the ninth or tenth century.

26. Sir John Marshall, *Guide to Sanchi*, first edition, 1918, pp. 120 and 124. See also the same author's article, "The monuments of Sanchi, their exploration and conservation," published in the Annual Report of Archaeological Survey of India, 1913–14, Calcutta, 1917, p. 35.

27. Marshall gave three other reasons in support of the possibility that this Buddha statue did not originally belong to Temple 45: (1) high up above the statue in its present position, there is a projecting architrave which has been cut away, seemingly to accommodate a taller image; (2) the plinth or lion throne on which the statue and its lotus-pedestal now rest does not belong to it and is clearly of earlier date; and (3) the statue is buttressed from behind by an extra wall of stones which obliterate part of the decoration of the pilasters (also noted as being of earlier date than the image). The first of these points is certainly valid, yet it cannot by itself be taken as conclusive evidence. The second is weakened by his separate admission that the pilasters in the corners were also earlier. The third is unconvincing because it is clear from the 1883 photograph (fig. 9) that the rear wall of Temple 45 was then in a ruinous state with daylight showing through: it must therefore have been rebuilt, or at least radically restored, between 1883 and 1912 when Marshall first saw the temple. F. C. Maisey, in his 1849–50 ms. notes on the shrine (now in India Office Library), mentions seeing "fragments of a richly carved framework, or niche, which once surrounded the principal image." In his posthumous book, *Sanchi and its remains*, published forty years later, the wording is revised. He describes the Buddha image as having "once had a rich canopy or niche over it, as is evident from existing fragments." There are no fragments of this kind in the temple today.

28. The description is unmistakable in Captain Fell's report (fn. 4), and also in subsequent reports.

29. Sir John Marshall, *Guide to Sanchi*, first edition, 1918, p. 123.

30. Odette Viennot, *Les Divinités fluviales Ganga et Yamuna aux portes des sanctuaires de l'Inde*, Publications du Musée Guimet, Paris, 1964.

31. Quoted from a personal letter to the author dated 13 April, 1971.

32. The iconography of this particular image is discussed by Marie-Thérèse de Mallmann, *Étude iconographique sur Mañjuśrī*, École Française d'Extrême Orient, 1964, pl. VIII.

33. Marshall and Foucher, *op. cit.*, I, p. 74. In the same context Marshall adds that some of the ordinary construction stones in the wall are carved with names (supposedly those of stone-masons) in characters of the tenth century; and since some of the names are upside down he concludes that they were carved prior to construction. (This had also been noted by Maisey in 1849.)

34. J. F. Fleet, *Corpus inscriptionum indicarum*, III, Calcutta, 1888, pp. 260–2; also Marshall and Foucher, *op. cit.*, I, pp. 389–90.

35. Among the Avalokiteśvaras depicted in Ajantā wall-paintings, the one most appropriate to this context is the figure in Cave II (see G. Yazdani, *Ajanta*, 1933, Part II, plate XXVIII b), since this wears the antelope-skin (*ajina*) like our Sāñchī Torso. But unfortunately its condition has so much deteriorated since the 1870s when James Burgess wrote his description in *Bauddha rock-temples of Ajanta*, Bombay, 1879, p. 35.

36. Anyone disagreeing with this conclusion would have to ask himself: if not Temple 45, from what other structure at Sāñchī could the triad have come? No other temple of the ninth or tenth century is known, nor is there trace of any other Buddha image which could possibly have matched our two Bodhisattvas as a centre-piece. Yet, in view of the size of image involved, it is difficult to believe that it could have been so smashed up by vandals as to disappear without trace. As the many remains of Buddha images on the site testify, the vandal was usually content to destroy head and arms. It is true, of course, that the area between Temple 45 and the Great Stūpa has not been fully excavated (see hatched section of the plan at fig. 20). Marshall was aware that beneath this area were remains of "various earlier structures . . . mainly monastic dwellings similar in character to those already brought to light in other parts of the enclave and unlikely, therefore, to add much to our present knowledge of the monuments" (Marshall and Foucher, *op. cit.*, I, p. 9). By "earlier", he meant pre-mediaeval. The possibility of any building contemporary with our Bodhisattvas being still below ground is now remote.

37. Marshall and Foucher, *op. cit.*, I, p. 253.

Anthony Radcliffe

Bronze Oil Lamps by Riccio

I. *The Cadogan lamp in the Museum*

ON 30 MARCH, 1865, after viewing the works of art put up for sale at Christie's by the heirs of Lord Cadogan, John Charles Robinson, Art Referee to the South Kensington Museum, reported to the Director, Henry Cole, that the collection was "as a whole mediocre". But about two pieces he was enthusiastic: ". . . the two most important specimens", he wrote, "are the cinquecento bronze lamp, lot 1066, and the iron casket, lot 267; these are unique and beautiful works of art, and I am prepared to advise their acquisition, if need be, at a considerably higher price than I have put on them". He valued them at £100 each, and asked for a total sum of £1,000 to spend at the sale.[1]

The Cadogan sale came at an awkward time financially for the Museum. Only the previous month Robinson had spent a large sum at the Pourtalès sale in Paris and the Museum had just paid off a long-standing debt to the dealer John Webb for an expensive collection of ivories; furthermore it was due to pay the final instalment on its purchase of the great Soulages collection, which had been held on trust for it since 1859. Consulted by the Director, Robinson's senior co-referee, Richard Redgrave, stressed the financial straits of the Museum and recommended that half the sum requested by Robinson should be put at his disposal for purchases at the sale. The Director was obliged, he felt, to leave the selection of objects for purchase to Robinson, "but", he added, "I think the bronze lamp, 1066, among the least desirable".

In the event, on the second day of the sale[2] the casket reached an unexpectedly high figure, and Robinson was obliged to let it go, but on the final day, 7 April, the lamp was secured for the sum of £163, a high price for a small bronze at that date. The casket in question

1. Bronze oil-lamp (the Cadogan lamp), by Riccio (right flank).
Height 13·2 cm; length 21 cm. Victoria and Albert Museum (no. 137–1865).

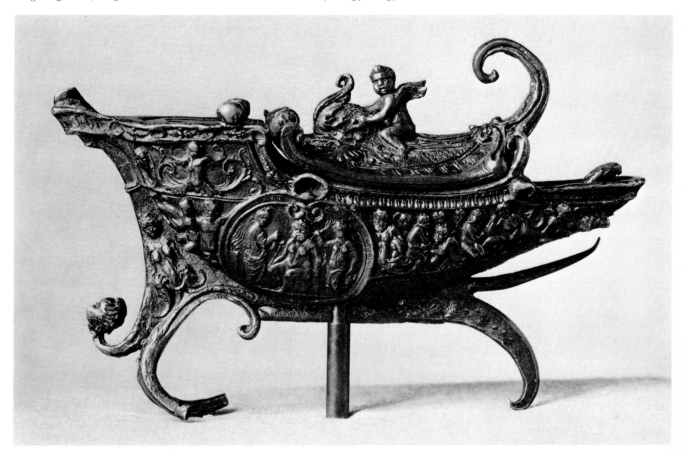

was the superb early seventeenth-century steel casket with the Medici arms which eventually entered the collections of the Museum in 1960.[3] The lamp was the well-known lamp in the form of a galley which has generally been attributed to Riccio (figs. 1–7). We may well feel that Robinson was justified, and it should be said that Redgrave's judgement might have been impaired by the bad relations which already obtained at this time between Robinson and his superiors.

Unlike the casket, the lamp cannot be traced before it was in the collection of Lord Cadogan. It is first recorded in 1857 at the Manchester *Art Treasures Exhibition*, to which Cadogan lent it together with the casket. In common with the other small bronzes shown there it received no specific mention in the official catalogue, but it was selected by Waring for reproduction in his illustrated souvenir.[4]

As is the case with most small bronzes at that time, early descriptions of the lamp are in the vaguest terms. No classification was attempted by Waring, and it was registered at the Museum with the classification which it had borne in the sale catalogue: "Italian cinquecento". But in 1876, in his catalogue of the bronzes at South Kensington, Fortnum was predictably more precise. With his seldom erring flair for dating, remarkable at a time when so little was known about Renaissance bronzes, he placed it firmly in the "end of 15th or first quarter of 16th century".[5]

The attribution of the lamp to Riccio was first advanced by Bode in 1907.[6] Bode's judgement was characteristically intuitive, and is expressed in the form of a brief but authoritative asseveration without argument, but it is nevertheless so manifestly correct, in view of the close correspondence with Riccio's known works, that it has never been challenged. Twenty years later, in his monograph on Riccio, Planiscig concurred without hesitation, but his passage concerning the lamp, although much lengthier than Bode's, is scarcely more satisfactory and is based in part on an inaccurate reading of the details of the lamp's decoration.[7] Since the lamp has never been fully described, it will be as well at this point to give a complete account of it.

The Cadogan lamp, as most authorities have noted, is in the general form of a ship, but so highly stylized a ship that it is far from easy to determine immediately which end is to be considered the prow and which the stern. Fortnum understood it as representing a classical war-galley with built-up forecastle and high, incurving stern-post: the flat-sided projection at the opposite end from the spout would in this case read as the stem-post of the ship, developed at its lower end into a ram. The direction implied by the putto riding a dolphin which forms the hinged cover of the lamp would at first sight tend to lend support to this reading. But in both classical and Renaissance lamps in the form of ships the prow is invariably formed by the nozzle for the wick (the Latin word *rostrum* is used both for the prow of a ship and the spout of a lamp), and, if we may assume that the present lamp is no exception, it becomes perfectly intelligible read in the alternative sense as a representation of a Venetian galley of about 1500 with a low overhanging bow with projecting "beak" and high poop. In this case the flat-sided projection at the opposite end from the nozzle can now be seen as forming the rudder, while the cover on which the dolphin now moves in the reverse direction must be understood as forming, as indeed it logically does in any case, a separate decorative element unrelated to the scheme of the lamp insofar as it represents a ship. The high incurved element behind the spout, which suggested to Fortnum the stern-post of a classical galley, represents, of course, nothing more than the tail of the dolphin, performing the function of a handle for the cover. It is in this latter sense that the lamp is undoubtedly to be read, and in this article, both in this case and that of the lamps described below, the spout will invariably be taken as forming the front end of the lamp, and the flanks will be termed left and right accordingly.

2. Cover of the Cadogan lamp.

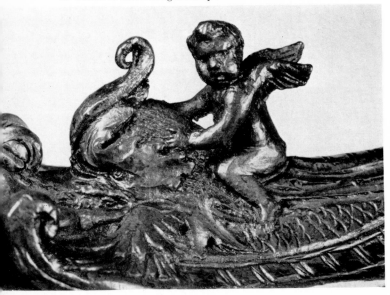

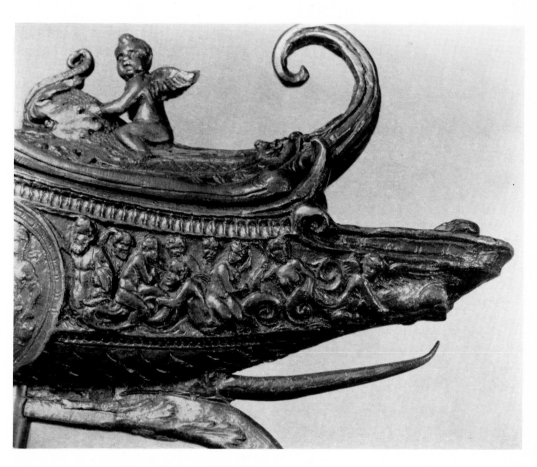

3. The Cadogan lamp:
nereid frieze on the right
flank.

Originally the lamp stood on three incurved legs, one under the spout echoing the shape of the dolphin's tail above, and two forking outwards from a common stem below the rudder. These latter, which were apparently originally widely splayed, are now broken off short, with the result that the lamp can no longer stand by itself and is supported today by a modern brass pin fixed under its centre. Another breakage is at the top of the rudder just above the poop, at which point a tiller might originally have been attached. Possibly this was decorated, since the deck surface over which it would have projected is void of decoration. A hole drilled at the forward end of this surface, otherwise inexplicable, may have provided the fixture for another lost element, possibly the figure of a helmsman. Further damage is to be found directly under the lip of the nozzle, where there are the truncated ends of two projecting spikes analogous to that which is preserved intact below the body of the spout. Presumably these features derive from the ram of the contemporary war galley. The lower extremity of the rudder is developed downwards

in a curved element terminating in a head with inflated cheeks and rounded mouth, presumably the head of a wind-god, which is now bent sharply inwards towards the body of the lamp. The cover of the lamp (fig. 2), hinged where it abuts the poop, is modelled in the form of a dolphin, so highly stylized as to be scarcely recognizable as such, and composed largely of acanthus leaves, other vegetable ornament, bird wings and areas of scale pattern, with a shell set into the tail and a small nude winged boy riding on top.

Along each side of the lamp runs a frieze of nereids and putti riding on ichthyocentaurs (figs. 3, 4), based in a generalized way on antique nereid sarcophagus reliefs, but comprising some idiosyncratic elements, such as a winged boy with a fish-tail. Each frieze is broken just to the rear of its centre by an oval medallion carrying an allegorical scene in shallow relief, the frame of each medallion being supported by the ichthyocentaurs which flank it in the frieze. The scene on the right-hand side of the lamp (fig. 5) shows an obese female (or possibly androgynous) figure seated naked in the centre

flanked by two draped female figures. At the left of this group is a flaming altar. Attention has been drawn to a correspondence between the central figure in this medallion and the obese naked female in Mantegna's drawing of *Virtus Combusta*, which was engraved soon after 1490 by Zoan Andrea together with a complementary scene of *Virtus Deserta*.[8] The relief on the lamp is on a minute scale (width: 45 mm.) and the details are somewhat sketchy, but a close examination proves that still further correspondences can be found between the group on the lamp and the group at the right-hand side of the engraving. Like the fat figure in the engraving, the central figure in the medallion also proves to be seated on a sphere, in this case smaller and partially hidden by her legs, and the object which she grasps in her left hand emerges as a rudder attached to the sphere by pintles, corresponding in function with the detached classical rudder in the engraving and in form with the contemporary rudder with pintles which appears on the relief of *Prudentia* on Riccio's Paschal Candelabrum

in the Santo.[9] Although she does not wear a crown as in the engraving, she carries in her right hand what appears to be a sceptre. The standing figure on the left of the medallion holds out a money-bag analogous to that held in the right hand of the hag on the right of the group in the engraving and to those which lie on the pavement in the foreground. The standing figure on the right of the medallion, who holds in her left hand a vase with a bucket handle, holds in her right an object resembling a scourge which may perhaps be seen as in some way analogous to the object held by the blindfold figure on the left of the group in the engraving.[10] We might also possibly read the flames on the altar in the medallion as having a reference to the burning laurel branches in the engraving.

The observable correspondences would appear to be sufficient to indicate that Riccio was aware of the engraving when he made the lamp, and it is to be inferred that the medallion illustrates substantially the same theme. The complete allegory, as represented in

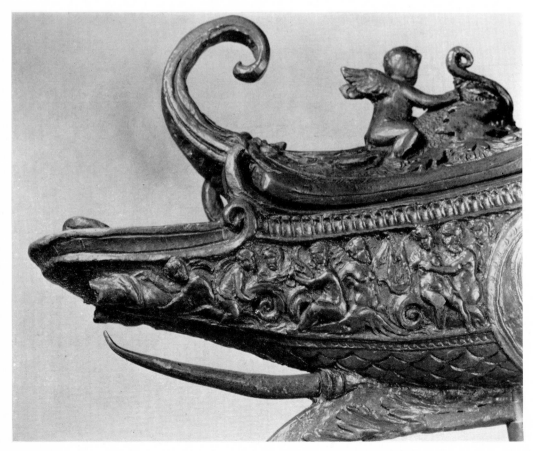

4. The Cadogan lamp: nereid frieze on the left flank.

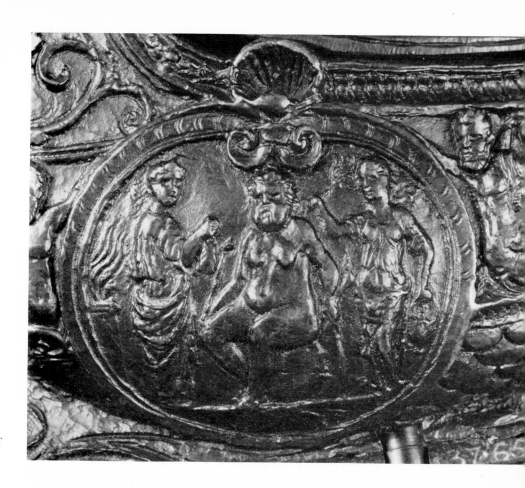

5. The Cadogan lamp: allegorical relief on the right flank.

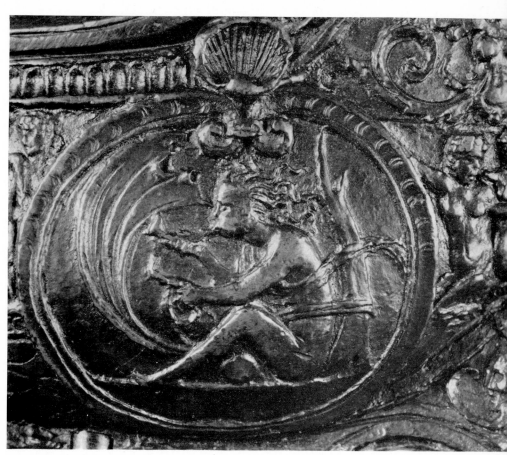

6. The Cadogan lamp: allegorical relief on the left flank.

against a tree-stump and blowing through a horn into a billowing sail. The bottom end of the sail is secured by a rope passed around the tree-stump and the end of the rope is held in the youth's left hand. Beneath the knees of the youth is a small sphere. Like the reverse of Pisanello's well-known medal of Lionello d'Este with a billowing sail attached to a column,[12] this clearly represents an allegory related to the general theme of *festina lente*. However, its precise meaning is obscure, although some clue to its interpretation may be provided by reference to a drawing by a German artist in the Universitäts-Bibliothek at Erlangen with which it has certain obvious correspondences. The drawing, which shows a winged naked youth standing on a globe and blowing into a sail the bottom of which is secured to his waist, has been interpreted by Wind as a representation of *Fortuna Amoris*.[13]

It seems fairly clear that the view expressed by Pope-Hennessy that the two medallions are designed to be read in conjunction as having contrasted or complementary meanings is correct,[14] but their precise meaning in the present context can only be guessed at as yet. It may be noted, however, that in each medallion one of the principal attributes is appropriate to a ship, in the one a rudder and in the other a sail, relevant respectively to the guidance of a ship and to its means of propulsion, and that both of these are attributes of *Fortuna*.

It would be dangerous to impute too complex an iconographical programme to a small decorative object, and it seems that, apart from the medallions, the decorative features of the lamp are unlikely to have any programmatic significance. Planiscig cites a boxwood relief of a putto riding on two dolphins with attendant putti inscribed AMOR OMNIA VINCIT. A. CRIS. OP. in connection with Riccio's representations of putti.[15] He saw in this relief a later copy of a lost bronze relief by Riccio, and Buddensieg has recently drawn attention to the reproduction of the same scene by Montfaucon without the inscription and has suggested that Montfaucon's engraving represents this lost original.[16] If this were indeed the case, one would perhaps have a clue to the symbolism which the emblem of the putto on a dolphin, of which there are several possible interpretations, held for Riccio, and one might suppose that the putto on a dolphin on the cover of the lamp might also signify *Amor omnia vincit*. However, Montfaucon gives no information about the original of his engraving beyond the fact that his source was the Cavaliere

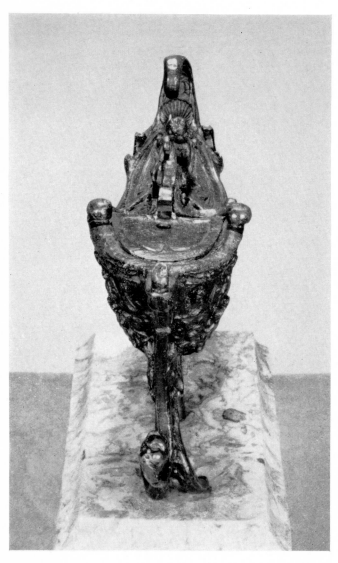

7. The Cadogan lamp seen from the back.

both sections of the engraving, has been convincingly elucidated by Förster as one of *Virtuti semper adversatur ignorantia*, and the section of the engraving to which the medallion relates is explained by him as representing Ignorance (the obese female figure) slothfully relying on Fortune (the sphere and the rudder), rather than on the learning of an art, to attain wordly prosperity (the proffered money-bag).[11]

The corresponding medallion on the left-hand side of the lamp (fig. 6) shows a youth seated with his back

Maffei, the Vatican antiquarian with whom he corresponded. Consultation of Maffei's work on antique gems reveals that the original is in fact a chalcedony cameo reproduced there from an old plate by Enea Vico.[17] The cameo, in the Medici collection, is also reproduced by Gori.[18] The boxwood relief, which is in any case not noticeably related in style to any of Riccio's known works, could have been copied either from the original gem or from one of the engravings of it, and is unlikely to have anything to do with Riccio.

The remainder of the decoration of the lamp does, however, relate very closely at several points to the decorative repertory of Riccio's Paschal Candelabrum and thus serves to endorse Bode's attribution. The sphinxes on the sides of the rudder enclose in their scroll-shaped extremities two grotesque masks in profile. Both sphinx and mask are of a type which recurs in grotesque ornament of the early sixteenth century, notably in the engraved candelabra of Giovanni Antonio da Brescia and Nicoletto da Modena, but the combination of the mask in profile with the sphinx in a single motif appears to be peculiar to Riccio and finds a close parallel in the sphinxes at the bottom corners of the Paschal Candelabrum. The upper edge of the poop is decorated with a band of swags between scallop shells, and further larger scallops, a recurring feature not only in the Candelabrum but throughout Riccio's work, are to be found above each medallion and inside the curve of the dolphin's tail. The upper rim of the lamp where it abuts the lid carries a feature found on the Candelabrum which forms part of the decorative repertory of Mantegna and which in sculpture appears to be peculiar to Riccio, a band incised at intervals with parallel vertical lines. Finally, at the extreme after end of the poop (fig. 7), directly in front of the rudder in the position of the two stern ports of a contemporary galley, are two classical busts in oval frames of the exact type which is to be found between the projecting rams' heads on the upper register of the Candelabrum.

In view of these correspondences with the Paschal Candelabrum it would seem reasonable to suppose that the lamp was produced fairly close to it in time, but it is possible to obtain a clearer picture of the place which this lamp occupies in Riccio's development by reference to a group of lamps with which it is closely related.

II. *The Fortnum lamp and other closely related lamps*

Fortnum concluded his catalogue entry on the Cadogan lamp with the sentence: "One, less elaborate and unfortunately less perfect, is in the writer's collection".[15] This is today in the Ashmolean Museum at Oxford (figs. 8–11), to which it was presented by Fortnum in 1888 along with the rest of his superb personal collection of bronzes. In the manuscript catalogue which he himself prepared for his collection in the year following his gift to the University, Fortnum went further and ventured that the two lamps were by the same hand, and in a later marginal note to his entry he added a third lamp to the group which he described as ". . . the lamp bought for Berlin in 1892".[20] This is identifiable with the small lamp of exceptionally high quality with a frieze of nereids and ichthyocentaurs which was actually acquired by the Kaiser-Friedrich Museum in

8. Bronze oil-lamp (the Fortnum lamp), by Riccio. Length 16·5 cm. Ashmolean Museum, Oxford (Fortnum collection).

9. Left flank of the Fortnum lamp.

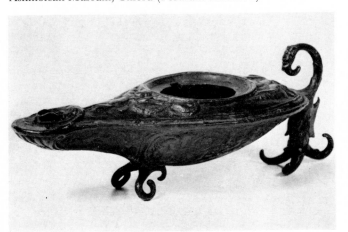

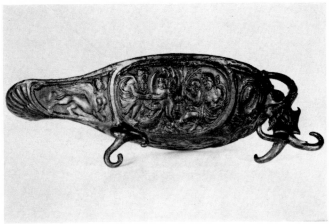

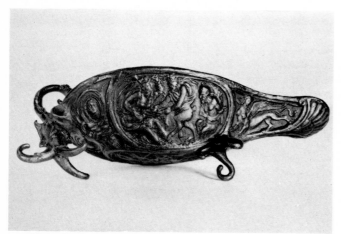

10. Right flank of the Fortnum lamp.

1893 and is sadly missing since the last war[21] (fig. 13). The same grouping was later arrived at by Bode, who firmly ascribed all three lamps to Riccio and added a fourth lamp in the collection of Gustave de Rothschild, which will be fully described later in this article.[22] Both grouping and ascription were accepted by Planiscig in his monograph,[23] and there can be no doubt that this judgement is correct.

Unlike the Cadogan lamp, the Fortnum and Berlin lamps are based in their general form, as Planiscig noted, on the standard classical oil-lamp, but it seems to have escaped both Bode and Planiscig that in the case of the Fortnum lamp this shape forms an ingenious compromise with that of a stylized boat. The lamp has a sharply V-shaped underside, and at the back is a clearly-defined rudder. Unlike the Berlin lamp, which stands on a ring-shaped moulding on its own bottom, the Fortnum lamp is supported in the same way as the Cadogan lamp on hook-shaped legs. On either flank of the Fortnum lamp, as in the Cadogan lamp, are oval medallions with allegorical scenes. On the left flank (fig. 9) is an embarkation for the underworld: a winged child welcomed by Charon into his boat, in the centre a vase followed by a palm tree sprouting sprigs of laurel clasped by a second child, and to the right of this a reclining female figure. On the right flank (fig. 10) is a scene of a satyr uncovering a nymph with a child; behind him on the right a bound satyr. To the rear of these medallions, just forward of the rudder, are the same two classical portrait busts in ovals related to those on the Candelabrum which I have noted above in an analogous position on the Cadogan lamp. In this case they are framed in the scrolls emanating from a

centrally placed grotesque mask, which is in effect a full-faced version of the masks in profile enclosed in the scrolls of the sphinxes at the corners of the bottommost register of the Candelabrum. Below the mask is a shell of precisely the same form and dimensions as the shells directly above the medallions on the Cadogan lamp. Flanking the spout of the lamp are two walking sphinxes. As in the Cadogan lamp, three hook-shaped features project downwards from the bottom of the rudder, although in this case all three perform the function of supports. Above the rudder rises a further hook-shaped element forming the handle of the lamp. This is decorated with a satyr-mask, and may perhaps be seen as providing a clue to the possible shape of the element which is missing at this point on the Cadogan lamp. The upper surface of the lamp (fig. 11), which is cast separately and soldered to the body, like the surface of the poop in the Cadogan lamp, has in its centre a large circular aperture, the sides of which are cut by two rectangular segments showing that originally this aperture received a lid which was designed to be secured by twisting. An old photograph in Fortnum's manuscript catalogue shows the lamp fitted with a lid surmounted by a crude figure of a cock, of the type reproduced by Planiscig on a dragon inkwell from the workshop of Severo da Ravenna.[24] This lid, which is quite inconsistent with the style of the lamp, is correctly not exhibited with it today. The raised moulded rim surrounding the aperture is supported as if it were a medallion by a figure of a nude boy, standing on the rim around the nozzle, who is closely reminiscent of the boys who support the medallions with the busts of Emperors on the ceiling of the Camera degli Sposi. Around the shoulders of the boy are looped swags, the outer ends of which are secured to rams' heads. Above the aperture are on the left a seated figure of Pan holding the syrinx in an attitude which recalls that of the statuette of Pan in Oxford, and on the right a group of Nessus and Deianira closely related in pose to figures in the nereid friezes of the Cadogan lamp.

The Fortnum lamp is currently condemned as a workshop production in view of the lack of definition in its relief decoration, but a classification of this nature is not illuminating. It is indeed blunt, but the definition is in general no poorer than in certain areas of the Cadogan lamp, and is in fact not so poor that one cannot see that the modelling in the wax was of the most astonishing brilliance and vitality, superior indeed in many respects to that of the Cadogan lamp. The typical

brutalizing of the detail which is noticeable in aftercasts from a bronze original is not in evidence here, and there seems to be every indication that this is an indifferent cast from an autograph wax and has not been worked up with the chisel. In terms of composition the lamp is a masterly work, more successful perhaps on its simpler level than the much more ambitious Cadogan lamp.

The Berlin lamp (fig. 12) exhibits the same superb quality in the modelling with only very slightly better definition in the casting.[25] In general this lamp is constructed on the same principle as the Fortnum lamp, but is less fanciful in shape and adheres more closely to the standard type of classical lamp. Its upper surface

has a smaller opening, not adapted to receive a cover, and the relief decoration around this is intimately related to that of the Fortnum lamp. Flanking the opening in half-medallions are what appear to be complementary sacrificial scenes. Above these are a pair of tritons holding a vase, and below, seated on a candelabrum from which sprouts a palm tree, a pair of addorsed bound satyrs of the type which appears on the medallion on the right-hand flank of the Fortnum lamp. Beneath the nozzle is a superb grotesque male mask. The most remarkable feature of this lamp is the beautiful frieze of nereids and ichthyocentaurs with musical instruments and masks which runs around the body, continuing uninterrupted around the back of the lamp

11. The Fortnum lamp seen from above.

12. Bronze oil-lamp, by Riccio. Length 13·5 cm. Formerly Kaiser-Friedrich Museum, Berlin.

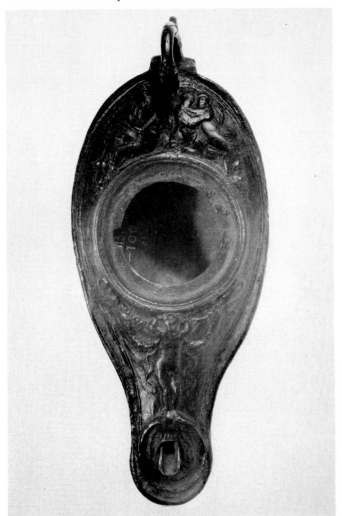

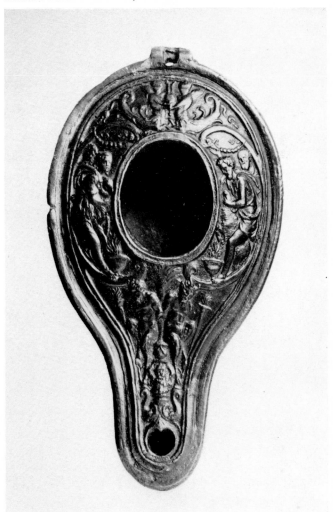

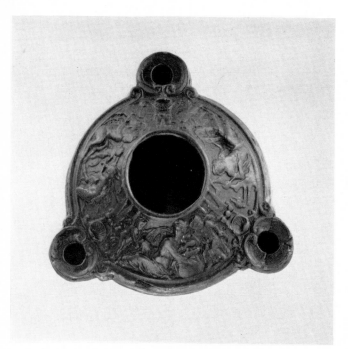

13. Bronze three-wick oil-lamp, by Riccio. Width 11 cm. National Gallery of Art, Washington, D.C. (Kress Collection).

known in four examples. The lamp in its complete form, as in a good version in the Museo Cristiano at Brescia and another of poor quality formerly in the Morgan collection, stands on three legs terminating at their upper ends in projecting rams' heads placed directly below the nozzles. The finest known cast, which, however, now lacks the legs, is in the Kress Collection in the National Gallery at Washington (formerly Dreyfus collection) (figs. 13, 14), and another version without the legs is also in Washington in the Widener Collection.[27] The Widener lamp, which is of notably bad quality, is apparently a modern aftercast from the Kress version.[28] An ascription to Riccio was advanced by Bode in 1897 in respect of the Widener lamp, at that time in the Hainauer collection. This has found support recently with Pope-Hennessy in the case of the Kress version, but was generally ignored in the intervening literature. The ascription is undoubtedly correct. The six scenes in relief on these lamps are intimately related both in style and facture to those in the two medallions in the Fortnum lamp, while the three grotesque masks under the nozzles are identical to that under the nozzle of the Berlin lamp.

It is worth mentioning here, in passing, an object of superb quality in the Louvre (fig. 15), which, although not itself a lamp, finds a natural place here by virtue of

14. Three-wick lamp seen from below.

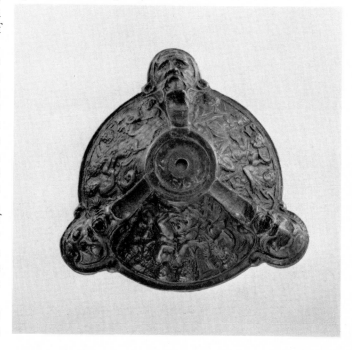

under the fixture for the handle. This is related to the similar friezes on the Cadogan lamp, but is perhaps more sophisticated in form. Whereas in the case of the friezes on the Cadogan lamp it is not possible to do more than indicate a general dependence from the reliefs on the many nereid sarcophagi available in the lifetime of Riccio, in this case a precise source can be proposed. It is the famous nereid sarcophagus now in the Louvre which was formerly in the church of S. Francesco in Trastevere and was drawn there in about 1490 by one of the artists who contributed to the *Codex Escurialensis*.[26] This is strongly suggested by the presence on the lamp of a ram-headed sea-monster, a peculiar feature of this sarcophagus, although it also appears on gems. By a process of hindsight it is now possible to see that this sarcophagus was probably also the primary source from which the friezes of the Cadogan lamp were developed, as it was also for the relief of *Cosmography* at the base of the Paschal Candelabrum. The same sarcophagus may also have provided the source for the putto riding a dolphin on the cover of the Cadogan lamp, since his apparent prototype appears just to the left of centre in the foreground of the sarcophagus relief.

Closely associable with the Berlin and Fortnum lamps is a type of three-wick lamp of classical form which is

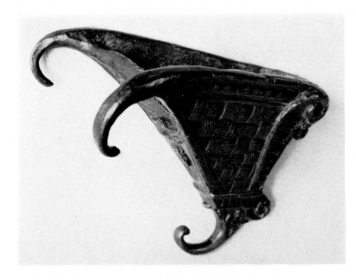

15. Bronze bracket, by Riccio. Height 9 cm; length 11 cm. Musée du Louvre, Paris (Carle Dreyfus bequest).

its close affinity with the Fortnum and Cadogan lamps. Its precise function is difficult to determine, but it appears to be some kind of bracket, perhaps for the suspension of a hanging lamp. It has the familiar hook-shaped projections and bears on its forward surface a bust in an oval frame and a shell identical in form with those which have been noted on the Fortnum and Cadogan lamps. Its flanks are decorated with an interwoven pattern resembling wicker-work, framed by bands incised with paired vertical lines such as are to be found on the Cadogan lamp and the Paschal Candelabrum.[29]

The lamps thus far described form so closely interrelated a group that we are possibly entitled to infer that they were produced in fairly close proximity to each other in time, and the many close correspondences between features of the decoration of the lamps in London and Oxford and features of the Paschal Candelabrum would appear to indicate that the date of these two lamps cannot be too far removed from that of the Candelabrum. Work on the Paschal Candelabrum was begun in 1507 and it was installed in the Basilica of S. Antonio in January 1516. It is known from the inscription on lead which was found under its base that the work was interrupted by the war between the Emperor and Venice, and that, but for that, it would have been completed in only three years. It may perhaps be inferred that this interruption could have begun in June 1509 with the occupation of Padua by the Imperial army after just over two years' work had been done, and that work could have been resumed by Riccio at a much later date, possibly little more than a year before it was installed in the Basilica.

The chronological sequence of Riccio's work on the Candelabrum has never been worked out, and there has been no attempt to assign the various sections of this complex structure to the two campaigns: indeed it would probably not be possible to complete such a task satisfactorily. It is nevertheless possible to see that certain sections are markedly more developed stylistically than certain others. While it would be dangerous to be too categorical, it might for instance be hazarded that the four reliefs on the cylindrical drum which forms the middle register of the Candelabrum represent a considerably earlier stage in the development of Riccio's style than do the four reliefs of the Cardinal Virtues on the square-sectioned register directly below them, and that the former, which are notably closely related to the relief of the *Story of Judith* which Riccio completed in 1507, were modelled at an early stage of the work, while the latter were modelled at a much later stage.

In general it may be noted that, where significant correspondences are to be found between features on this group of lamps and features on the Candelabrum, it is with the less sophisticated sections of the Candelabrum that the affinities lie. It may be observed, for

16. Bronze plaquette of *Fame*, by Riccio. Diameter 6 cm. National Gallery of Art, Washington, D.C. (Kress Collection).

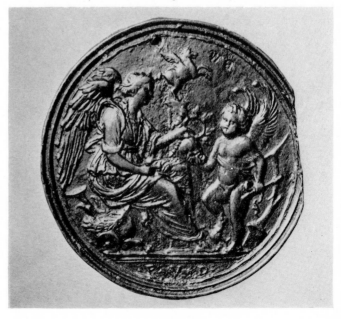

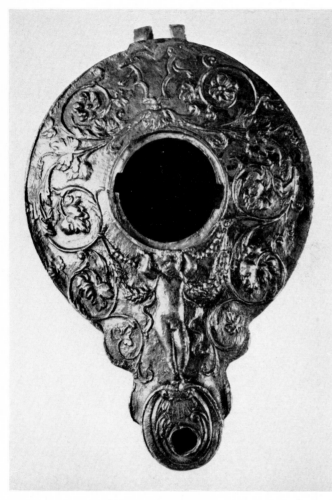

17. Bronze oil-lamp, by Riccio (seen from above).
Height 3·8 cm; length 11·5 cm. Musée du Louvre, Paris.

18. Left flank of the Louvre lamp.

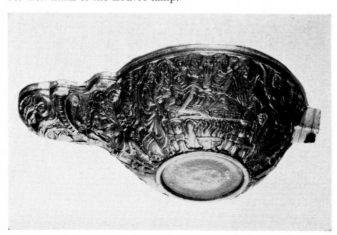

instance, that the satyr types in the medallion on the Fortnum lamp (fig. 10) are intimately related to the two satyrs on the relief of the middle register generally identified as *Simplicitas* and markedly different from what I take to be the more developed satyr type in the relief of *Temperantia* below. The inference would appear to be that this group of lamps is likely to have been produced somewhere in the vicinity of the earlier stages of work on the Candelabrum: one might say, for the sake of argument, before about 1510.

Support for such a conjectural dating in the first decade of the sixteenth century can be obtained by making another comparison. In cataloguing his own lamp Fortnum gave it as his opinion that the reliefs in the medallions were in the style of Moderno,[30] but it is in fact to plaquettes by Riccio himself that these medallions are related. The relationship is with the closely coherent group of circular plaquettes with scenes which Planiscig has described as allegories of humanist virtue.[31] The only complete set of the plaquettes which form this group exists in the Kress Collection in Washington, and it will be convenient here to refer to individual plaquettes by the numbers which they bear in Pope-Hennessy's catalogue of the bronzes in the Kress Collection of 1965.[32]

Comparing the medallion on the left-hand side of the Fortnum lamp (fig. 9) showing Charon welcoming a winged boy into his boat with the plaquette representing *Fame* (*Kress* No. 221: fig. 16) we can see that the boy entering the boat on the lamp is virtually identical with the putto representing *Virtue* on the right of the plaquette. The palm frond which he carries reappears in the hands of the female figures in the plaquettes *Kress* 222 and 226v. The tree in the centre of the medallion on the lamp, a palm sprouting two sprigs of laurel, is found again in closely similar form in the centres of plaquettes *Kress* 222, 223 and 226v. The vase to the left of the tree on the lamp finds parallels in plaquettes *Kress* 224 and 226, while the child to the right of the tree on the lamp is notably close in type to the child in the plaquette *Kress* 224.

Beyond the implication inherent in Planiscig's comparison of them with the reliefs from the Della Torre tomb which has little force, no attempt has been made to place this group of plaquettes in the chronology of Riccio's work. Stylistic considerations, however, preclude their having been produced at a date very far removed from that at which the plaquette with the inscription ΣΕΜΝΗΚΛΟΠΙΑ was made.[33] For this a

terminus ante quem is provided in 1511 by the fact that it appears as the reverse of a medal of Girolamo Donati, who died in that year, and indeed the probability is that this medal was produced quite some years earlier than Donati's death.[34]

At this point it will be useful to introduce a further lamp with close affinities to those discussed above. This is a small lamp in the Louvre which is modelled closely on the form of a classical oil lamp (figs. 17, 18). Although published by Migeon as a work by Riccio in 1904,[35] it was ignored by Planiscig in his monograph and has received no attention since. This lamp is directly related to the Fortnum lamp by the use of the identical motif on its upper surface of the naked child between swags supporting the rim of the central aperture while standing on the moulding surrounding the nozzle, which is again of similar form. It is also related to the lamp formerly in Berlin and to the three-wick lamps in that it has the same grotesque mask beneath the nozzle. Another version of this same lamp was published in 1652 by the Paduan antiquarian, Fortunius Licetus, in the sixth book which he added to the second edition of his work on antique lamps (fig. 19).[36] The version published by Licetus, apart from the fact that its upper surface was missing, was in every respect identical with the Louvre lamp. At the time at which Licetus wrote it was in a Paduan collection, that of Giovanni Galvani, who appears to have possessed a large collection of similar objects, and was understood to be an antique with an alleged history of having been excavated.

19. Plate from Licetus, *De lucernis . . .* , 1652, showing a lamp of the same type as the Louvre lamp.

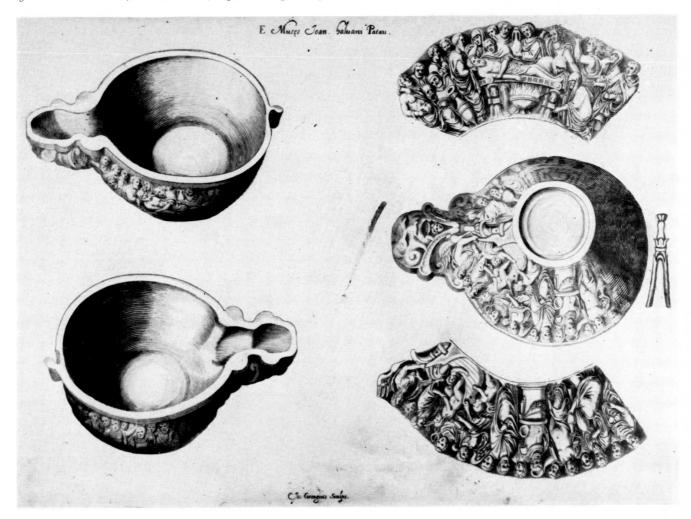

20. Bronze tabernacle doors, by Riccio. Ca'd'Oro, Venice.

The body of the Louvre lamp is decorated with a frieze with successive scenes in relief, carried as in the Berlin lamp in a continuous band, which passes around the back of the lamp under the fixture for the missing handle. In this case it is clearly designed to be read in

a sequence beginning at the left-hand side of the spout and ending at the right-hand side of the spout. First, occupying the whole of the left-hand side of the lamp, is a funeral scene with a corpse, surrounded by mourners, laid out on a table beneath which burns a brazier tended by a crouching hooded woman (fig. 18). A mourner at the left holds a grotesque mask and two others hold vases. This scene is joined at the back of the lamp under the handle fixture by a sacrificial scene centring on a herm, which stands on a cylindrical pedestal. At the left of this scene a veiled kneeling figure offers a vase, while the herm is flanked by two standing figures carrying bowls: to the left a semi-nude female, strongly reminiscent of the figure in Riccio's plaquette of *Prudentia*,[37] who pours a libation over the head of the herm, and to the right a male figure in a toga who rests his empty bowl on the pedestal. Although this latter figure holds in his left hand what appears to be a knife, no victim is visible. To the right of this scene ensues a scene of the embarkation for the underworld. A naked child is ushered into the boat by a winged figure and is received by an elderly bearded man (misunderstood by Licetus as Charon). Behind this group stands Mercury with the caduceus, and below it are a winged putto seated on the ground holding the prow of the boat (misunderstood by Licetus as the stern) and a child already in the boat. To the right of this group appears a grotesque face, possibly that of a Fury, and at the extreme right of the scene is the typical representation of Charon, semi-draped, seated in the stern with his hand on the rudder.

Licetus' commentary, although lengthy and in parts ingenious, is not particularly helpful for an understanding of the programme of the frieze, many features of which are difficult of interpretation. It does, however, seem clear that in general terms the frieze can be understood by reference to Saxl's reading of the reliefs from the Della Torre tomb.[38] Certain features of the frieze are strikingly like those on the Della Torre reliefs: one might cite, for instance, the woman stoking the brazier in the funeral scene, which is closely akin to the feature of the woman stoking the brazier on the right of the relief of the *Sickness of Della Torre*.[39] But here again, as with the circular plaquettes which Planiscig compared in subject with the Della Torre reliefs, stylistic considerations must take precedence over those of subject matter, and the disparity of style is such that a dating of the lamp anywhere in the vicinity of the Della Torre tomb is out of the question.

The closest point of reference for the style of the frieze on the lamp is to be found in the two reliefs of the *Entombment* and the *Lamentation over the Dead Christ* at the bottom of the tabernacle doors, now in the Ca'd'Oro, which Riccio made for the church of the Servi in Venice in connection with the presentation to the church by Girolamo Donati in 1492 of the relic of the Holy Cross (fig. 20).[40] The most obvious correspondence with these is, of course, to be found in the funeral scene on the lamp, which is allied to them not only in its general compositional scheme but also in the poses of individual figures. To cite a work more nearly allied to it in scale, the funeral scene on the lamp can be seen again to be intimately related to an early plaquette by Riccio in Berlin of the *Entombment* which both Bange and Planiscig correctly recognized as being itself inseparable from the reliefs on the Servi tabernacle doors.[41] The case for the correct dating of the Servi tabernacle doors between 1495 and 1500 has been convincingly argued by Pope-Hennessy.[42] Furthermore, a clear account of the progression in Riccio's handling of the subject of the *Entombment* has been given by Pope-Hennessy in terms of the respective influences upon him of Bellano and of Mantegna and of comparisons with the Paschal Candelabrum and the Della Torre reliefs, and by reference to this a dating before 1500 for the relief on the lamp would be mandatory.[43] If such a dating can be accepted for the lamp it acquires a special interest as a prefiguration in rudimentary form of the programme of the Della Torre reliefs, predating them by, at the most cautious estimate, more than a decade.

We therefore have to do here with a group of lamps which are all closely interrelated, for one of which I have proposed a dating before 1500, the others of which I conceive to have been made probably before about 1510. One of them, that in the Museum, is in the form of a stylized ship, and owes nothing in its form to any known classical type of lamp, one, that in Oxford, appears to represent a compromise in shape between that of a boat and that of the standard form of classical oil lamp, while the remainder all derive their shapes directly from classical prototypes. It would be rash to attempt to place these lamps in any rigid sequence of development – the lamp formerly in Berlin, while comparatively simple in its design, might be felt by some to be, in the handling of its decorative detail, the most sophisticated of the group, and has features, such as the addorsed satyrs, which are generally considered to belong to a fairly advanced stage of the

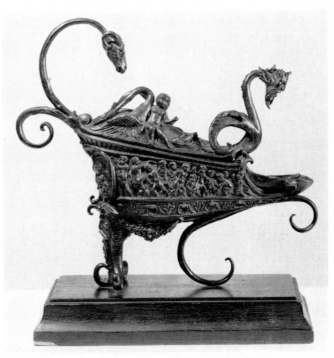

21. Bronze oil-lamp (the Rothschild lamp), by Riccio. Height 19·4 cm; length 23·3 cm. Private collection.

decorative repertory of the Renaissance – but it may be observed that the lamp which I have supposed to date from before 1500, that in the Louvre, is the most directly classicizing of the group, and that the lamp in the Museum is the most ambitious and original in design. It may also be noted that it is in the least directly classicizing of the lamps, those in the Museum and at Oxford, that the most direct correspondences with the decorative repertory of the Paschal Candelabrum are to be found. It could be argued that the group of lamps in general shows a development in design which takes as its starting point the hint of a boat-form inherent in the standard classical type of oil-lamp (it is interesting in this connection to note that Licetus read the Louvre lamp as being in the form of a boat), and that in this development the lamp in Oxford performs a transitional role, while the lamp in the Museum represents the culminating point.

That this view might in fact be justified is suggested by the existence of another lamp by Riccio, more sophisticated in design and handling than any of the lamps so far discussed, and again based on the form of a ship. It is interesting that in the case of this further lamp one can see a trend away from naturalism towards a greater degree of stylization.

III. *The Rothschild lamp and the Carrand vase*

The lamp in question is a large oil-lamp in private possession which was formerly in the collections successively of Barons James, Gustave and Robert de Rothschild in Paris (fig. 21). Its history can be traced back no farther than 1865, when it was lent by Baron James de Rothschild to an exhibition in Paris.[44] It was subsequently exhibited in Paris in 1913 and again, for the last time, in 1935.[45]

The Rothschild lamp was closely associated by Bode and Planiscig with the Cadogan lamp under an ascrip-tion to Riccio,[46] and, like the Cadogan lamp, it was understood by them, as also later by Venturi[47] and Ricci, to represent a ship. This view is certainly correct, although here the representation is much more stylized, and the distinctive ship-like features of the Cadogan lamp, such as the clearly defined poop-deck and rudder, are no longer in evidence. It is as if an entirely new shape, still nevertheless subtly echoing the form of a ship, had been evolved by Riccio from the basic shape of the Cadogan lamp.

A detailed comparison of the two lamps demonstrates not only that they are intimately interrelated, but that

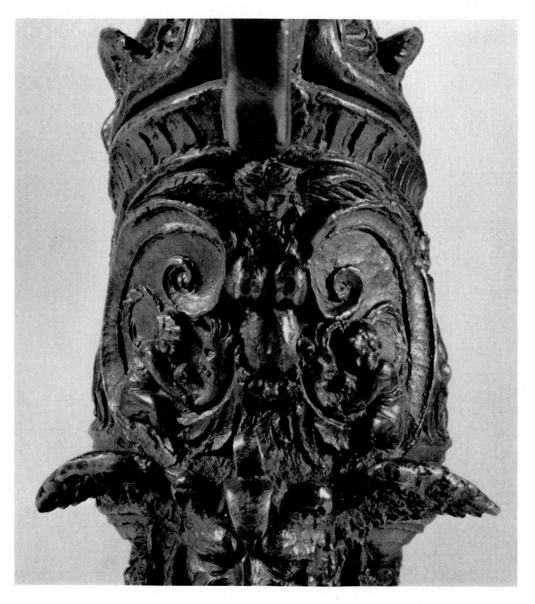

22. The Rothschild lamp: detail of back.

the Rothschild lamp indeed represents in every respect a sophisticated development from the Cadogan lamp. The lamps consequently afford valuable evidence of Riccio's creative process.

The naturalistic raised poop of the Cadogan lamp is developed forward in the Rothschild lamp to the point from which the spout begins, and the hinged lid now covers the whole of this length. The decorative band with incised vertical lines, which appears in the Cadogan lamp where the body of the lamp abuts the lid, is accordingly carried in the Rothschild lamp right to the back of the body. The medallions which cut the friezes on the flanks of the Cadogan lamp are omitted in the Rothschild lamp and the frieze, in this case a bacchanale of boys, is carried uninterrupted the whole length of the flank. Below the frieze, where the body is less sharply incurved, a decorative band carrying shells interspersed with a leaf motif somewhat resembling an anthemion echoes the band of shells and swags which borders the poop on the Cadogan lamp. The total effect of the decoration of the flanks is here much more unified and fluent. At the back of the lamp the four harpies which decorate the sides of the poop and the rudder on the Cadogan lamp have, as it were, been combined in

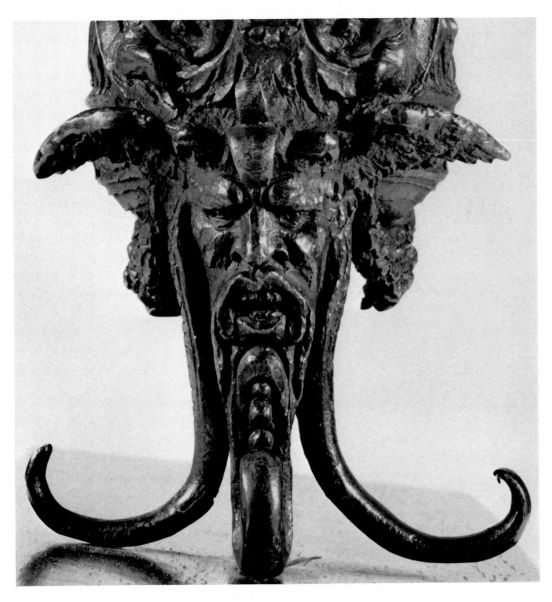

23. The Rothschild lamp: detail of back.

45

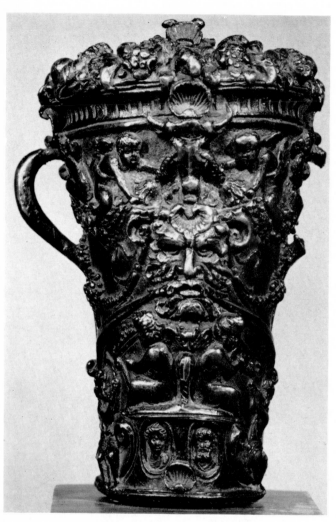

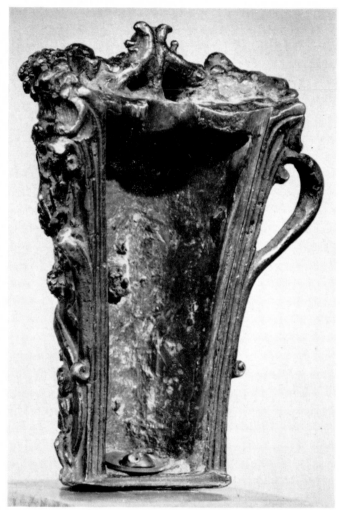

24. Bronze vase (the Carrand vase), by Riccio. Height 10 cm. Museo Nazionale, Florence (Carrand collection).

25. The Carrand vase seen from the back.

a single, greatly enlarged figure which, like the harpies on the rudder in the Cadogan lamp, encloses in its scrolls two masks in profile of closely similar type (fig. 22). Also enclosed in the scrolls are two nude boys seated in a pose recalling that of the putto on the lid of the Cadogan lamp who support the masks. Below this, in the position of the lower part of the rudder, is a superb winged grotesque head (fig. 23) of which the small head of a wind-god which terminates the rudder on the Cadogan lamp was perhaps the germ. From the head spring three hook-shaped legs, which recall the triple support of the Fortnum lamp, the lateral ones being decorated with an imbricated pattern, which echoes that on the underside of the Cadogan lamp. In

place of the rather awkward hook-shaped leg and spike beneath the spout of the Cadogan lamp are two slender hooks which form a single curve. Whereas on the cover of the Cadogan lamp the putto on a dolphin creates an unhappy directional trend at variance with the general movement of the lamp, here the movement implied is in the same direction. Acting as the handle for the cover in place of the tail of the dolphin is a grotesque figure facing forwards, the bearded head of which recalls the mask on the handle of the Fortnum lamp. The putto on a dolphin is itself replaced by two boys with their arms around the necks of two stylized swans. The surface of the cover in front of these is covered with an imbricated pattern and acanthus

attitude which Riccio himself reproduced in the sacrifice in his relief of the transport of the Ark, in the sacrifice to Christ on the Candelabrum and in the sacrifice to Aesculapius for the Della Torre tomb. It seems probable that, like the frieze on the Candelabrum, which shows boys leading a goat to an altar for sacrifice, those on the lamp also represent preparations for a sacrifice, although here no altar is visible.

Directly related in style and handling to the Rothschild lamp is an object recognized by Bode as a work by Riccio which came to the Bargello with the Carrand collection (fig. 24).[49] It is generally described as a vase, although its true function remains unexplained. The most striking correspondences with the Rothschild lamp occur in the central grotesque mask, which, although it differs somewhat in general form from the mask at the back of the Rothschild lamp (fig. 23), is identical with it in facial type and handling; in the two putti riding swags above this, which compare with those flanking the harpy above the mask in the lamp (fig. 22); and in the putti blowing horns at either side of the lower part, which recall those at the rear end of the friezes on the lamp. Further close correspondences can be found in the minor decorative features. At the bottom of the vase at the front there figure prominently the busts in oval frames which have been noted on the Fortnum and Cadogan lamps and on the Paschal Candelabrum. This object is modelled in the form of a vase filled with fruit resembling closely the fruit which emerges from the tops of the cornucopias on the Paschal Candelabrum. It was originally provided with two lateral handles, one of which is now broken off. At the back (fig. 25), which is cut off flat, there is a large aperture surrounded by a rebated moulding, into which there must have slid at one time a cover, which is now no longer with the vase.

What is undoubtedly the missing cover exists today in the Victoria and Albert Museum (fig. 26). It was acquired by the Museum in 1861 at the sale of the Baron Boissel de Monville, whose punched collector's mark it bears,[50] and was thus, like the vase, in a mid-nineteenth century Parisian collection. In the catalogue of the sale it bore an ascription to Riccio remarkable for the time, which was subsequently ignored in the Museum. Acquired as a plaquette, it was recognized later by Fortnum as the lid of a lamp,[51] and was thus ignored by Maclagan in his catalogue of plaquettes. For many years it has formed part of the travelling collections of the Museum and has received no atten-

26. The cover of the Carrand vase. Height 8·4 cm.
Victoria and Albert Museum (no. 7436–1861).

foliage, constituting the same fantastic combination of organic decorative motifs from which the dolphin on the Cadogan lamp is fabricated.

Like that of the Cadogan lamp, the decoration of the Rothschild lamp corresponds at many points with the Paschal Candelabrum, and the most striking correspondence is that which exists between the friezes of putti on the flanks of the lamp and that on the circular drum in the upper section of the Candelabrum. The two friezes on the lamp, which are virtually mirror images of each other,[48] represent nude boys dancing to the music of a boy playing a pipe around a recumbent ram held down by a boy who crouches over it in the attitude familiar from classical sacrificial scenes; an

27. Pair of engraved candelabra, by Nicoletto Rosex da Modena. British Museum.

tion. It will be seen at once that this cover is of the same high quality as the vase. The dimensions conform precisely, and the edge of the cover is filed on a bevel so as to fit exactly into the rebated moulding around the aperture of the vase. The shell at the top of the cover may be seen to correspond precisely in type, size and position with the shell in the centre of the upper decorative band on the vase.

Confirmation of the connection of the cover with the vase is provided by two paired engraved candelabra by Nicoletto da Modena (fig. 27), which also conceivably provide an approximate *terminus post quem* for them. In one of these appear addorsed putti analogous to those on the lower part of the front of the vase. Below these is a mask, which, although smaller and less prominent, is generically closely allied to the mask in the centre of the vase, and above this are the letters s.c. (*Senatus consulto*), which recur beneath the addorsed satyrs on the cover. In the second of the pair of engravings are to be found two addorsed bound satyrs analogous to those seated on a candelabrum on the cover.

The engraved designs of Nicoletto were widely circulated, and the correspondences noted would appear to indicate that Riccio knew of these two plates when he designed the vase. These plates are dated by Hind[52] in "the later period" of Nicoletto, which we may take to be roughly around 1510. They reflect the influence of the decorations of the *Volta gialla* in the *Domus Aurea*, and the date of Nicoletto's visit to the *Domus Aurea* is known from the fact that he scratched his name on the fabric together with the date 1507.[53] It has been reasonably argued by Enking that works by Riccio which reflect the influence of designs by Nicoletto inspired by the decorations of the *Domus Aurea* are to be dated after that year.[54]

Bode wrote of the Carrand vase ". . . I should say it is in its decoration the finest of all Riccio's known works. It gives one the impression of having been originally executed in gold".[55] It is indeed perfectly true that in the vase, as also in the Rothschild lamp, we can see Riccio's skill in working metal, which in fact derived from his training as a goldsmith, at its most accomplished. Perhaps a little less so in the vase than in the lamp, we can also see here his powers of design at a high stage of development: in terms of organization the Rothschild lamp is an infinitely more fluent and sophisticated piece than the Cadogan lamp which prefigures it.

I have suggested that the Cadogan lamp might be

dated somewhere in the vicinity of the earlier stages of work on the Paschal Candelabrum, and I put forward the suggestion here that the Rothschild lamp, which the inherent evidence would appear to reveal as a more advanced work, is to be associated with the more advanced stages of work on the Candelabrum. It may be noted that the feature of the Candelabrum which finds the most striking analogy on the lamp, the circular relief of boys taking a goat to sacrifice, is one of the most accomplished sections, and is perhaps the point at which the Candelabrum approaches most closely the method of organization and type of handling found in the reliefs for the Della Torre tomb. What I take to be the next stage in the development of Riccio's treatment of the oil-lamp was to represent a move in the direction of even greater elaboration and correspondingly less fluency in design, compensated by an increased finesse in the handling of the details.

IV. *The Frick lamp*

The culminating point in Riccio's treatment of the oil-lamp is almost certainly to be seen in the elaborately decorated lamp which is today in the Frick Collection (figs. 28, 29). This lamp came into the London art market in January, 1910, from an unrecorded source, and was bought by J. Pierpont Morgan.[56] But it has in fact a much earlier history, since, as has been noted by Buddensieg,[57] it was published in 1652 by Fortunius Licetus as being in the collection of Girolamo Santasofia, Professor of Medicine at the University of Padua, and a member of the famous Paduan medical family.[58]

In a letter dated 1646, printed by Licetus, Santasofia gives the names of two previous Paduan owners: Petrus Campesius and Hyacinthus Fagnanus. The lamp is reproduced by Licetus in two engravings (fig. 30), which leave no room for doubt that it is the identical lamp which is depicted and not another version of the same model, since the breakages (in the severed foot in front of the opening for the cover, and in the handle directly above the mask at the back) can be observed to correspond exactly. The engravings include an element which has since been lost from the lamp, a child with a lyre seated on a wide scroll on the forward side of the handle, and the fixture for this proves to exist on the Frick lamp in the form of a hole drilled in the scroll.

On its re-appearance in London in 1910 the lamp was recognized by Bode as an autograph work by Riccio and a constituent of the same group as the Cadogan, Fortnum and Rothschild lamps,[59] and all subsequent writers have concurred in this judgement. Bode never doubted that, like these other lamps, the lamp represented a galley, and this view was never questioned until Maclagan, who, when the lamp was exhibited in London in 1912, had classified it as "in the form of an ancient galley", came to describe it for the second time in the folio catalogue of the Frick Collection.[60] On this occasion he cited analogies with classical lamps in the form of sandalled feet which caused him to classify it as being "in the form of a galley or shoe", giving it as his opinion that "in the present example the form of a shoe is more immediately suggested". For Licetus, of whose work Maclagan was unaware, there had been no problem of identification; he described it as "constructam in formam fere calcei" (that is, of a half-boot, as distinct from a *caliga*, or sandal).[61] This view is undoubtedly correct, both on the strength of comparison with the general shape of classical lamps of the sandalled-foot type and Renaissance copies of them, and in view of the complete departure from the form of the Cadogan and Rothschild lamps (particularly in the shape of the spout) and the total absence of any ship-like features.

A notable departure in construction is to be seen in the method of support. Unlike the other lamps, the Frick lamp stands, not on its own hook-shaped projections, which are still however present in a more restrained form, but on a separately cast triangular pedestal, analogous in shape to, although different in function from, the bracket in the Louvre described above.

The decoration of the lamp is exhaustively described in the new catalogue of the sculpture in the Frick Collection,[62] so that it will not be necessary here to do more than cite those elements of the decoration which have a meaningful reference to the other lamps under discussion and to relevant documentary works by Riccio.

It is immediately apparent that in the Frick lamp the frieze of putti, which is carried uninterrupted around the back, is even more directly linked to the frieze on the drum of the Paschal Candelabrum than are those on the Rothschild lamp. Like that on the Candelabrum it represents (as Licetus noted, but Maclagan failed to recognize) a sacrificial scene. This can be seen quite clearly in the centre of the right-hand side of the lamp (fig. 28), where the altar with flames on top appears in minute form with, to its left, a group of a boy holding a bowl beneath the head of a recumbent goat held down

by a boy who crouches over it in the regular classical posture which occurs in Riccio's sacrificial scenes and which has been noted in the frieze of the Rothschild lamp. Maclagan read this scene as representing the boy offering a drink to the goat, but Licetus correctly understood the boy to be holding the bowl to catch the blood from the cut throat of the goat in the manner familiar from classical sacrificial scenes. Although this particular group is not paralleled on the drum of the Candelabrum, where the goat is seen still being led to the sacrifice, it occurs in a closely analogous form in the relief of a sacrifice to Christ on the lower part of the Candelabrum. Some striking correspondences can be found in individual figures. On the left-hand side of the lamp (fig. 29), for instance, occurs the boy crouching with one hand on the severed head of a ram which is one of the most memorable features of the frieze on the Candelabrum. On the same side again is a group closely reminiscent of the putto carried pick-a-back on the Candelabrum frieze: a satyr-like figure carried on the back of a boy. This figure is identified by both Licetus and Maclagan as Silenus, but it is more likely to represent Pan in view of its classical source, the scene of the chastisement of Pan on the right-hand end-panel of a Bacchic sarcophagus today in the British Museum.

This well-known sarcophagus was in the Renaissance in the basilica of S. Maria Maggiore in Rome, where it was drawn in the mid-fifteenth century by Michele di Giovanni di Bartolo.[63]

Correspondences with the Cadogan lamp include the lateral cartouches surmounted by shells under the belly of the lamp, which are identical in form with those which frame the medallions with allegorical scenes, and the classical portrait bust in an oval frame which has also been noted in the Fortnum lamp, the Louvre bracket, the Carrand vase and the Paschal Candelabrum. In the Frick lamp this occurs on the front of the lamp and on the back of the pedestal. The winged mask on the handle is closely similar to that on the handle of the cover of the Rothschild lamp.

Maclagan noted that the ornament on the lamp "with its profusion of shells and masks" was "closely related to that on the Paschal Candlestick", and this is, as we have seen, in general true, but the lamp possesses one decorative feature for which no close analogy can be found on the Candelabrum or on any of the other lamps. This is the band of decoration which runs around the rim of the aperture carrying a very complex design of grotesque masks alternating with shells. The shells are well known to us, but the very beautiful masks

28. Bronze oil-lamp (the Frick lamp), by Riccio (right flank). Height 16·9 cm; length 21·6 cm. The Frick Collection, New York.

29. The Frick lamp: left flank.

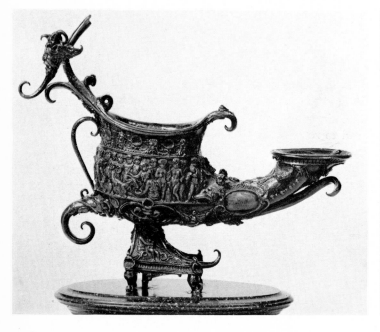

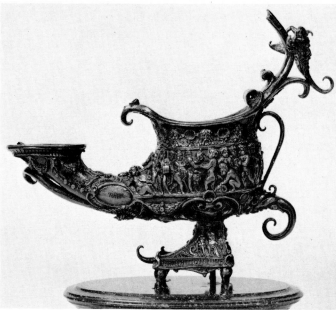

are of a type for which no precise parallel can be found in Riccio's other decorative work, and the design as a whole is of a refinement and precision which goes beyond the friezes of roughly analogous character on the Candelabrum and on the other lamps. It seems that we are bound to see this frieze as representative of a very high stage of development in the evolution of Riccio's decorative style. This view is borne out by an examination of the decoration of the rest of the lamp, for in the other areas too where we have noted ornament directly related in type to that on the other lamps or on the Candelabrum we find a marked increase in finesse of handling. One might cite as an example the motif of swags slung between bucrania around the rim of the spout which seems to show a distinct advance in handling when compared with the same motif on the surface of the drum between the four putti who sit at the angles of the middle register of the Candelabrum.

The refinement visible in the handling of the detail seems also to be reflected in the design of the lamp as a whole. One of the most immediately striking aspects of this is the way in which every effort seems to have been made to give the frieze of putti, which forms the main feature of the decoration, not only the maximum prominence but also the maximum space so that it can be developed in a fully sculptural manner. This is in signal contrast to the way in which the analogous friezes are presented on the Rothschild and Cadogan lamps, where they are fitted into awkward shapes and subordinated to a greater extent to the general decorative scheme.

Maclagan felt that ". . . the lamp in the Frick Collection is undoubtedly the most elaborate and by general consent the loveliest of the three". The technical refinement of the Frick lamp is indeed notably greater than that of any of the other pieces discussed here, but one might perhaps feel that there is a corresponding loss of vitality when it is compared with the superbly vigorous Rothschild lamp, and there is certainly a loss of clarity in the design. Although the more sculptural treatment of the frieze may indicate a higher stage of development, one might be forgiven for feeling that this is less appropriate to the decoration of an object of this nature. However that may be, all the indications seem to lead to the conclusion that the Frick lamp is indeed the culminating point in the development, and we may suppose it to have been produced at a fairly advanced stage in Riccio's career.

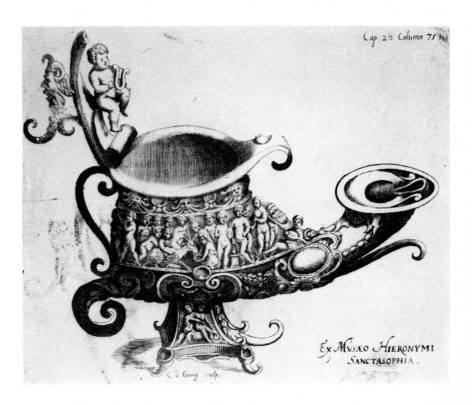

30. Plate from Licetus, *De lucernis . . .* , 1652, showing the Frick lamp.

V. *A related piece wrongly ascribed to Riccio*

Closely associated by Bode with the Cadogan, Rothschild and Frick lamps is an object in the Louvre (figs. 31, 32), described by Bode as a lamp,[64] a second version of which was at that time in the Bayerisches Nationalmuseum in Munich, but now no longer forms part of the Munich collections.[65] Planiscig reproduced both versions as lamps.[66] However, as had already been demonstrated by Migeon,[67] the Louvre version is identifiable with an item in the inventory of 1684 of the bronzes of Louis XIV described as *"Une lampe antique sur une manière de tripier* (i.e. *trépied*), *ornée de bas-reliefs et de harpies"*[68] which recurs in similar terms in the inventory made after the Revolution in 1791.[69] Migeon inferred that the object in the Louvre was in fact therefore a pedestal made to support a lamp, possibly antique, which had been lost. The absence of any of the functional features of an oil-lamp and the fact that it resembles in form the pedestal of the Frick lamp would appear to confirm this view.

The Louvre pedestal was first ascribed to Riccio by Migeon in 1904, and the ascription was followed by Bode. Both of these writers appear to have looked upon it as an autograph work, but Planiscig noted that the handling was not of the highest quality and refused to accept either version as autograph. Bode had noted, without making any inference, that the handles and legs of the two pedestals were "stronger and thicker" than the corresponding features of the lamps with which he linked them, and indeed it can be seen that the decorative detail throughout has a grosser quality here than on any of the lamps discussed above. This might perhaps just be explained by Planiscig's formula that they are workshop replicas, were it not for the fact that, although the repertory of motifs employed is at every point closely allied to Riccio's repertory, not one single decorative element on the pedestals corresponds with analogous features on the lamps in the same precise way in which the features of the lamps have been observed to correspond with one another. Furthermore, while the general form of the pedestals is quite consistent with those of the lamps to which Bode allied them, the way in which the various decorative elements are marshalled on the pedestals is not only quite inconsistent with Riccio's practice in design as exhibited on the lamps but infinitely less sensitive and accomplished. Technically speaking, the pedestals are far from being poor casts. Although the style of modelling

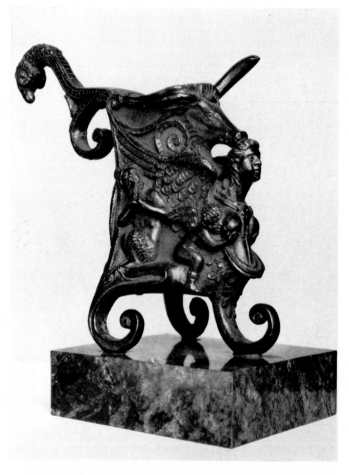

31. Bronze pedestal, North Italian, middle of the sixteenth century. Height 15 cm; length 17·5 cm. Musée du Louvre, Paris.

is coarse, the execution is fresh and vigorous, and the definition is in fact much superior to that on some of the lamps, such as the Fortnum and Berlin lamps. What we miss here are the sensitivity and finesse in handling and the sure command of design which are always in evidence in any genuine work by Riccio. The correct inference would appear to be that the pedestals represent a pastiche of Riccio's style.

That this view is in fact correct can be confirmed by reference to the oval plaquettes set into the backs of the pedestals below the handles. On the Louvre pedestal, as can be seen in the photograph reproduced here, there is a plaquette of a grotesque bearded male mask (fig. 32). The photographs reproduced by Bode purport to be of the Louvre pedestal, but in fact show a different plaquette with a scene of Mars, Venus and Cupid.[70]

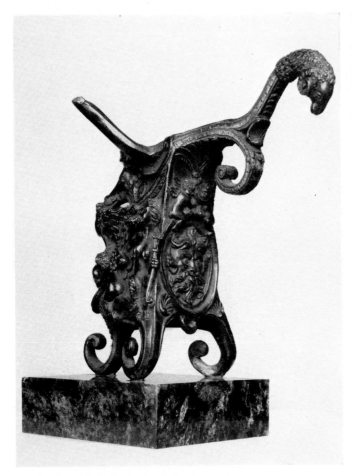

32. The Louvre pedestal seen from the back.

33. Bronze pedestal formerly in the Bayerisches Nationalmuseum, Munich, seen from the back. After a plate in *Hirth's Formenschatz*, 1906.

Actually, as is proved by a reproduction of the Bayerisches Nationalmuseum pedestal in the *Formenschatz* of 1906 (fig. 33), Bode's plate shows in error the bronze formerly in Munich.[71]

Bode himself wrote in describing the pedestal that "on the back of the lamp is a plaquette which is frequently met with by itself", but he failed to make any inference from this. The plaquette shown in Bode's plate does in fact recur in an identical detached version in the Berlin collections. It was classified by Bange as "after the antique", following Molinier's classification of a variant version without the Cupid which exists in a fairly large number of examples.[72] Maclagan, however, when he catalogued the variant version in the Victoria and Albert Museum, doubted the correctness of this classification and drew attention to the close correspondence between the plaquettes and a fine sardonyx cameo in the Museum in the style of Giovanni Bernardi da Castelbolognese.[73] Although Maclagan himself was not prepared to venture further, a comparison of the plaquettes in Berlin and on the Munich pedestal with the known plaquettes after Giovanni Bernardi suggests strongly that, if not actually cast from a gem cut by him, they are directly under his influence. It is thus possible to state that the Louvre and Munich pedestals are unlikely to have been made much before about 1540, and cannot have been made before Riccio's death in 1532.

53

VI. *Conclusion*

All of the lamps described above are perfectly capable of functioning as a practical means of lighting. Whether they were in fact used as such cannot now be determined, but that the rush-wick oil lamp was used as a regular means of lighting in the Renaissance at least as much as the candle is attested by the survival of numerous examples of purely functional spout-lamps. Those of Riccio's lamps which possess, like the Rothschild lamp, or almost certainly once possessed, like the Frick and Cadogan lamps, the singular high curved handles might well, although they are also capable of standing, have been suspended from a bronze lampstand such as that reproduced by Licetus, which supports two classicizing lamps of the sandalled-foot variety with analogous high curved handles (fig. 34). An example of the base of this lamp-stand was in the former Figdor collection,[74] and two examples of its central vase-shaped element were formerly in Berlin.[75] Although on grounds of style it must be ruled out as a work by Riccio, it would appear to have been a North Italian production of the early sixteenth century, and may perhaps be seen as representative of a forgotten Renaissance type, variants of which could conceivably have been produced by Riccio himself.

But, whether or not these lamps were actually used as a means of lighting, this consideration is of secondary importance to their role as works of art which, like the Renaissance bronze statuette, the medal and the cameo, recreated for the collector the antique world. It is interesting to note in this connection that all of these lamps of which notices exist before the nineteenth century came to be believed at some time to be actual antiques (we may remark that the same confusion arose in the case of some Renaissance statuettes, medals and gems). Those published by Licetus also carried spurious histories of excavation. Thus Licetus' version of the lamp in the Louvre with scenes of funeral rites is stated to have been found in the year 1589 *"in vallo fodiendo prope Castrum Sulpherini"*[76] (in excavations on the site of the amphitheatre at Solferino?). The place and date of the excavation of the Frick lamp were not known, but it was stated that it had been found *"sub terris ardentem"*.[77] A still more fantastic account is given of the origin of the lamp-stand described above, which was stated by its then owner, Giovanni Galvani, in a letter to Licetus[78] to have been brought to Padua many years ago by an old Jew from Illiberis (i.e. Granada) who

came to be cured by the Paduan doctor, Emilio Campilonghi. According to the Spanish Jew, it had been brought to Granada from Africa by his ancestors in the distant past. To this Licetus responded with the learned gloss that it had therefore doubtless come originally from a shrine of Minerva at Athens, whence it had been transported by Moors to Africa before being carried thence to Granada. This archetypal instance of a dealer's fanciful provenance and the willing gullibility of the antiquarian is only the most fantastic of many which abound in Licetus' book. They are in accord with those to be found in other seventeenth-century works on antiquities: Paul Petau, for instance, states of a version of one of the signed medals of Lysippus that it had been found inside an ancient Roman ash-urn excavated from a tomb at Amiens.[79] This has a special irony in view of Petau's punning motto: *"Cum nova tot quaerant non nisi prisca peto"*.

The pedestal now in the Louvre was in the collection of Louis XIV as an antique, together with other Paduan sixteenth-century bronzes.[80] Buddensieg has given an account of the many Paduan bronzes which were published as antiques by Montfaucon in 1719,[81] and typical bronzes by Riccio and Severo da Ravenna are to be found reproduced as antiques by Santi Bartoli in 1691, by La Chausse in 1699, by de Wilde in 1700, by Leplat in 1733, by Piranesi in 1778, by Lasinio in 1814 and by Disney as late as 1849.[82] Even at the end of the nineteenth century Renaissance bronzes of all types still abound as antiques in Reinach's *Répertoire*.

The misapprehension is more explicable in the case of these later and non-Paduan writers than it is in the case of Licetus writing in Padua itself little more than a century after most of the lamps had been made there. The much-discussed question of forgery is inevitably raised. That forgery of this kind was indeed practised in the Renaissance there is no shortage of evidence.[83] Amongst bronze statuettes an almost certain example of a deliberate forgery is the *Venus* today in Vienna which in the mid-sixteenth century was in the famous collection of antiques of Cardinal Granvella at Besançon, and came later as an antique into the possession of the Emperor Rudolf II. It was believed to be a genuine antique bronze until unmasked by Schlosser in 1919 as a production of the early sixteenth century.[84] In the case of lamps the Vienna collection possesses two strictly classicizing examples which are perhaps only to be explained as Renaissance forgeries,[85] and it seems more than likely that many of the Renaissance

examples of the common classical type of sandalled-foot lamp also fall within this category. That it was possible for a modern forgery to receive credit even in the informed Paduan circle which Riccio frequented is proved by the fact that his friend, the Paduan philosopher Niccolò Leonico Tomeo, possessed in the full belief that it was antique a cunningly distressed marble panel which is undoubtedly of Renaissance origin.[86]

But these are all pieces which at a first encounter would still considerably exercise a modern expert, and it would appear that in fact the connoisseurs of the nineteenth century like Courajod, writing at a period when for the first time the bronzes and medals of the Renaissance were being weeded out from the genuine works of antiquity in the great collections, somewhat over-stated their case on the score of forgeries: perhaps it was a sense (for the most part fully justified) of their own powers of discrimination which led them to over-estimate the deceptiveness of many classicizing pieces. As we come to know more about the circumstances in which Renaissance bronzes were made, it becomes apparent that fewer pieces can actually have been made to deceive than was at one time supposed.

That the lamps by Riccio described above could have been produced as forgeries is inconceivable. Their imagery is so closely linked to that of the Paschal Candelabrum and the sculpture of the Della Torre tomb that they could not possibly have passed for anything but modern works in the close-knit Paduan humanist circle of which Riccio appears to have been a member: that circle which included Leonico, Giambattista del Leone, Girolamo Fracastoro and the brothers Della Torre, the very scholars who themselves devised that imagery. So much are they in the current of Paduan academic thought of the time that it seems most likely that they were in fact produced in the full light of day by Riccio for that circle.

When in the mid-sixteenth century Basilius Amerbach, as a young Swiss student in Padua, was sold his famous *Venus* as an antique,[87] it may be that such a deception could only have been perpetrated on a foreigner, but on Licetus' evidence it was already possible before the end of the century for bronzes by Riccio to be passed off as antiques on Paduan academics. The memory of that brilliant circle of humanists surrounding Leonico and Del Leone which had nourished Riccio's art, and of its ideas, faded, even in Padua, surprisingly quickly. As Enking has shown, already in 1590 Valerio Polidoro was ignorant of Giambattista del Leone's programme

for the Paschal Candelabrum and was obliged to work out its iconography afresh in his own somewhat confused terms.[88] For Polidoro there was at least no doubt about the origin of the Candelabrum, whereas the lamps, as we know to have been the case with the Frick lamp, may well have changed hands several times before Licetus encountered them. Like Polidoro with the Candelabrum, he was obliged to look at them with fresh eyes, but with the added difficulty that they had all in the meantime lost their true provenances and acquired misleading ones. And to Licetus, writing in an age when artefacts were no longer made in so directly classicizing a style, the lamps must have appeared much more classical than they would have done to Leonico or Del Leone at the time of production or than they do to us viewing them in our long perspective.

34. Plate from Licetus, *De lucernis . . .*, 1652, showing a bronze lamp-stand.

There is also the possibility that Licetus and his correspondents, no more avid for antiques than earlier Paduan collectors, saw them with a less cool and discriminating eye: that they were in fact more willing to be deceived. The strong hint of obscurantism implicit in the story that the Frick lamp was found still burning under the earth is foreign to the way of thought of Leonico as we know it from his writings, and there emerge from Licetus' commentaries a love of mystery for its own sake and a confusion of allegorical myth with historical fact which is out of tune with the genuine spirit of enquiry of the earlier generation of Paduan academics.

Made originally as re-creations of the antique, only to be classified later as antiques themselves, it was not until the second half of the last century that these bronzes came to be recognized again for what they actually were. For most of them we do not know the actual moment of recognition, but it is recorded that the Louvre pedestal was removed from the *Département des Antiquités* in 1895. Throughout the last quarter of the nineteenth century and the early years of the twentieth the process of weeding the Renaissance bronzes out of the great collections of antiques went relentlessly on: in Paris with Courajod and Migeon, in Vienna with Ilg and Schlosser. But realization had dawned much earlier and with surprising swiftness. In 1849 the generally well-informed John Disney had believed all of his Renaissance bronzes without exception to be antique, but in 1855 John Charles Robinson, compiling the first full catalogue of what was later to become the Victoria and Albert Museum, was able to classify the Museum's newly-acquired version of the lamp with the plaquette of a sacrifice to Priapus as "Italian, cinque-cento period" and to discuss its relationship to the antique.[89] In 1861 Baron Boissel de Monville, compiling the sale catalogue of his own superb collection of Renaissance bronzes and plaquettes, was already able to make some extremely discerning judgements, including the ascription of the cover of the Carrand vase to Riccio, and some of Robinson's entries of the following year on the bronzes included in the great loan exhibition at the South Kensington Museum still make fruitful reading today.[90] In 1865 at the Cadogan sale, as we have seen, Robinson had a very clear idea of what he was buying, and when a decade later Charles Drury Fortnum brought the fine discrimination acquired as one of the most distinguished collectors of his time to bear on the already comprehensive collection of bronzes amassed by Robinson at South Kensington, his judgements showed in general a quite extraordinary degree of accuracy. By this time Bode was already laying the first foundations of the great Berlin collection of bronzes, and with his first catalogue of 1888 there begin to emerge the attributions which still compose the basic framework within which the modern student of bronzes makes his minor adjustments. Much can still be learned from the judgements of these comparatively uncluttered minds, and I make no apology for the fact that I have been at pains to record, wherever I have been able to trace them, the opinions of all previous connoisseurs who have studied these lamps.

Notes

1. *J. C. Robinson's reports*, II (MS. in Victoria and Albert Museum archive), minutes of 30 March, 1 April, 8 April, 1865.

2. *Catalogue of the valuable collection . . . formed by the late Right Hon. Earl Cadogan*, London, Christie's, 3–7 April, 1865.

3. R. W. Lightbown, "A Medici casket", in *Bulletin of the Victoria and Albert Museum*, III, 1967, pp. 81–89.

4. J. B. Waring, *Art treasures of the United Kingdom, from the Art Treasures Exhibition, Manchester*, London, 1858, II, "Metallic art", p. 31, pl. VIII.

5. C. Drury E. Fortnum, *A descriptive catalogue of the bronzes of European origin in the South Kensington Museum*, London, 1876, p. 163, no. 137–1865 (hereinafter cited as "Fortnum, *S.K.M.*").

6. W. Bode, *The Italian bronze statuettes of the Renaissance*, I, London, 1907, p. 29, pl. LIII (hereinafter cited as "Bode, *I.B.S.R.*").

7. L. Planiscig, *Andrea Riccio*, Vienna, 1927, pp. 273–4.

8. J. Pope-Hennessy, *Meesters van het brons*, Amsterdam, Rijksmuseum, 1961–2, no. 60. For the drawing see A. Popham and P. Pouncey, *Italian drawings in the . . . British Museum, the fourteenth and fifteenth centuries*, London, 1950, pp. 95–7, no. 157, pl. CXLVII: for the engraving see A. Hind, *Early Italian engravings*, V, London, 1948, pp. 27, 28, no. 22, VI, pl. 520.

9. Planiscig, *op. cit.*, fig. 348.

10. This object has not been satisfactorily identified: it is explained by Popham and Pouncey as a distaff, by Hind as two ropes and by Förster as two fans.

11. R. Förster, "Studien zu Mantegna und den Bildern im Studien-

zimmer der Isabella Gonzaga, I, *Virtus Combusta*", in *Jahrbuch der königlich preussischen Kunstsammlungen*, XXII, 1901, pp. 78–87. Mantegna's drawing appears to have been based on an antique cameo recorded in an engraving by Enea Vico (Bartsch, no. III), but Riccio's medallion is likely to have been derived from Mantegna, rather than direct from the cameo.

12. G. Hill, *A corpus of the Italian medals of the Renaissance before Cellini*, London, 1930, no. 530 (hereinafter cited as "Hill, *Corpus*").

13. E. Bock, *Zeichnungen in der Universitätsbibliothek Erlangen*, Frankfurt, 1929, no. 224; E. Wind, *Pagan mysteries in the Renaissance*, London, 1967, p. 105.

14. Pope-Hennessy, *loc. cit.*

15. Planiscig, *op. cit.*, p. 322, fig. 369.

16. T. Buddensieg, "Die Ziege Amalthea von Riccio und Falconetto", in *Jahrbuch der Berliner Museen*, n.f., V, 1963, p. 148, n. 76; Montfaucon, *L'antiquité expliquée*, I, pt. 1, Paris, 1719, pl. CXVII, no. 1.

17. *Gemme antiche figurate date in luce da Domenico de' Rossi colle sposizioni di Paolo Alessandro Maffei*, III, Rome, 1707, pl. 16. For an early state of the plate by Vico (Bartsch, no. 127) see *Ex antiquis cameorum et gemmae delineata. Liber secundus et ab Enea Vico Parmen. incis. D. Francisco Angelono devotionis ergo Philippus Thomassinus D. D.*, n.d. (Rome, 1618?), pl. 28. For an account of the different states of the plate see E. Bruwaert, *La vie et les oeuvres de Philippe Thomassin*, Troyes, 1914, p. 94, no. 402.

18. Gori, *Museum Florentinum*, I, *Gemmae antiquae*, II, Florence, 1732, pl. LI, no. II.

19. Fortnum, *loc. cit.*

20. *A descriptive and illustrated catalogue of his collection of works of Antique, Renaissance and Modern Art by C. Drury E. Fortnum*, II, *Bronzes*, Great Stanmore, 1889 (MS. in Ashmolean Museum archive), p. 75, no. 1100 (hereinafter cited as "Fortnum, *Oxford catalogue*").

21. Inv. 2092; Staatliche Museen zu Berlin, *Bildwerke des Kaiser-Friedrich-Museums, die italienischen Bildwerke der Renaissance und des Barock*, II, W. von Bode, *Bronzestatuetten, Büsten und Gebrauchsgegenstände*, 4 ed., Berlin/Leipzig, 1930, p. 57, no. 272 (hereinafter cited as "Bode, *Bronzestatuetten*, Berlin, 1930").

22. Bode, *I.B.S.R.*, *loc. cit.*

23. Planiscig, *op. cit.*, p. 274.

24. Planiscig, *op. cit.*, p. 108, fig. 111.

25. For a full reproduction of the lamp see Staatliche Museen zu Berlin, *Beschreibung der Bildwerke der christlichen Epochen*, 3 ed., II, *die italienischen Bronzen der Renaissance und des Barock*, pt. 2, E. Bange, *Reliefs und Plaketten*, Berlin/Leipzig, 1922, pl. 43 (hereinafter cited as "Bange, *Plaketten*, Berlin, 1922").

26. Robert-Rosenwaldt, *die antiken Sarkophagreliefs*, V, 1, A. Rumpf, *die Meerwesen*, Berlin, 1939, no. 132; H. Egger, *Codex Escurialensis*, Vienna, 1906, II, fol. 5v.

27. For the lamp in Brescia see G. Nicodemi, "Bronzi veneti del rinascimento nel Museo dell' Età Cristiana a Brescia", in *Dedalo*, I, 1920–1, p. 473: for the former Morgan lamp see Bode, *The J. Pierpont Morgan Collection. Bronzes of the Renaissance and subsequent periods*, I, Paris, 1910, pp. 12, 13, no. 42 (wrongly classified

as an inkstand): for the Kress (formerly Dreyfus) lamp (Inv. No. A.219.60C) see J. Pope-Hennessy, *Renaissance bronzes from the Samuel H. Kress Collection*, London, 1965, p. 130, no. 481 (hereinafter cited as "Pope-Hennessy, *Kress*"): for the Widener (formerly Hainauer) lamp (Inv. No. A.1472) see Bode, *die Sammlung Oscar Hainauer*, Berlin, 1897, p. 99, no. 237.

28. A detailed report kindly provided for me by Dr. C. Douglas Lewis Jr., shows that the Widener lamp reproduces precisely all the genuine flaws, damage and peculiarities of the Kress lamp.

29. Inv. No. OA.9559; H. Landais, Musée du Louvre, *Collection Carle Dreyfus léguée aux musées nationaux*, Paris, 1953, no. 4 (as by Riccio). I am indebted to Mons. Bertrand Jestaz for drawing my attention to this object.

30. Fortnum, *Oxford catalogue*, *loc. cit.*

31. Planiscig, *op. cit.*, pp. 455–9, figs. 559–63.

32. Pope-Hennessy, *Kress*, pp. 66–8. For a general account of the group of plaquettes see Pope-Hennessy, "The Italian plaquette", in *Proceedings of the British Academy*, L, 1964, pp. 80–1.

33. Planiscig, *op. cit.*, pp. 453–4, fig. 558; Pope-Hennessy, *Kress*, no. 219.

34. Hill, *Corpus*, no. 530.

35. Inv. No. 3861; G. Migeon, Musée du Louvre, *Catalogue des bronzes et cuivres*, Paris, 1904, pp. 76, 77, no. 51.

36. Fortunius Licetus, *De lucernis antiquorum reconditis libb. sex*, Udine, 1652, cc. 599–657.

37. Planiscig, *op. cit.*, p. 439, fig. 528.

38. F. Saxl, "Pagan sacrifice in the Italian Renaissance", in *Journal of the Warburg Institute*, II, 1938–9, pp. 355–9.

39. Planiscig, *op. cit.*, fig. 486.

40. Planiscig, *op. cit.*, pp. 231–3, figs. 262–4.

41. Bange, *Plaketten*, Berlin, 1922, no. 370.

42. Pope-Hennessy, "Italian bronze statuettes, I", in *Burlington Magazine*, CV, 1963, p. 18.

43. Pope-Hennessy, in *Proceedings of the British Academy*, L, 1964, pp. 78, 79.

44. *Union Centrale des Beaux-Arts appliqués à l'industrie: exposition de 1865*, *Musée rétrospectif*, Paris, 1867, p. 114, no. 1230.

45. S. de Ricci, *Exposition d'objets d'art du moyen âge et de la renaissance tirés des collections particulières de la France et de l'étranger organisée par la marquise de Ganay à l'ancien Hôtel de Sagan, mai-juin, 1913*, Paris, 1914, pl. XVII; *Exposition de l'art italien de Cimabue à Tiepolo*, Paris, Petit Palais, 1935, p. 349, no. 1219.

46. Bode, *I.B.S.R.*, I, p. 29, pl. LII; Planiscig, *op cit.*, p. 273, fig. 313.

47. A. Venturi, *Storia dell' arte italiana*, X, 1, Milan, 1935, p. 346.

48. For a reproduction of the left flank of the lamp see Bode, *I.B.S.R.*, I, pl. LII. I am indebted to the present owner of the lamp for the photographs reproduced here. For correspondences between the horn-playing boys on the friezes of the lamp and other works by Riccio, including a statuette in the Museum, see Planiscig, *op. cit.*, pp. 273, 332.

49. Ed. Sangiorgi, *Collection Carrand au Bargello*, Rome, 1895, p. 19, pl. 46; Bode, *I.B.S.R.*, I, p. 30, pl. LIV.

50. *Catalogue de la précieuse collection de bronzes italiens . . . composant la collection de M.B. de M. . . .*, Paris (Hôtel Drouot), 24, 25 January, 1861, no. 104: "Moyen relief. Elégant ornement. Probablement de Riccio. Seul connu."

51. Fortnum, *S.K.M.*, pp. 42, 43, no. 7436–1861.

52. Hind, *op. cit.*, v, p. 109, vi, pl. 695, nos. 116, 117.

53. F. Weege, "Das Goldene Haus des Nero", in *Jahrbuch des kaiserlich deutschen archäologischen Instituts*, xxviii, Berlin, 1913, p. 145.

54. R. Enking, "Andrea Riccio und seine Quellen", in *Jahrbuch der preussischen Kunstsammlungen*, lxii, 1941, p. 98.

55. Bode, *loc. cit.*

56. Invoice of Durlacher Bros. to Morgan of 3 January, 1910, in the archives of the Pierpont Morgan Library, New York.

57. Buddensieg, *op. cit.*, p. 148.

58. Licetus, *op. cit.*, cc. 755–68. For the Santasofia family see B. Scardeone, *De antiquitate urbis Patavii*, Basel, 1560, pp. 203–5.

59. Bode, *The collection of J. Pierpont Morgan, Bronzes of the Renaissance and subsequent periods*, I, Paris, 1910, pp. xv, xvi, 12, no. 39; Bode, *I.B.S.R.*, iii, London, 1912, p. 22, pl. ccxlv.

60. E. Maclagan, in Burlington Fine Arts Club, *Catalogue of a collection of Italian sculpture and other plastic art of the Renaissance*, London, 1913, p. 66, no. 31; *The Frick Collection*, v, *Sculpture of the Renaissance and later periods*, New York, 1953, pp. 35, 36, no. 18.

61. Licetus, *op. cit.*, c.756.

62. *The Frick Collection; an illustrated catalogue*, iii, J. Pope-Hennessy, *Sculpture, Italian*, New York, 1970, pp. 72–9.

63. B. Degenhart, "Michele di Giovanni di Bartolo: disegni dall' antico e il camino 'della Iole'," in *Bollettino d'arte*, xxxv, 1950, pp. 208–15. For a full account of the sarcophagus and for other early drawings from it see P. Bober, *Drawings after the antique by Amico Aspertini*, London, 1957, p. 47, and F. Matz, *Die dionysischen Sarkophage*, Berlin, 1968, i, pp. 204 ff., ii, Beilage, pp. 34, 35, pl. 114.

64. Bode, *I.B.S.R.*, i, London 1907, p. 29.

65. It was sold by the museum in 1930 to the Munich dealer, A. S. Drey (personal communication from Dr. Hans R. Weihrauch). It does not appear in the catalogue of the clearance sale of the firm of Drey (Berlin, June 17–18, 1936) and remains untraced.

66. Planiscig, *op. cit.*, p. 273, figs. 310, 311.

67. G. Migeon, Musée du Louvre, *Catalogue des bronzes et cuivres*, Paris, 1904, pp. 79, 80, no. 52.

68. J. Guiffrey, *Inventaire du Mobilier de la Couronne sous Louis XIV*, ii, Paris, 1886, p. 42, no. 164. (The object bears the engraved number 164.)

69. *Inventaire des diamants de la Couronne*, Paris, 1791, p. 259, no. 164.

70. Bode, *I.B.S.R.*, i, London, 1907, pl. liv.

71. *Hirth's Formenschatz*, 1906, no. 77 (as an inkstand by Riccio). I am indebted for this reference to Dr. Weihrauch.

72. Bange, *Plaketten*, Berlin, 1922, no. 60; E. Molinier, *Les plaquettes*, Paris, 1886, no. 129.

73. E. Maclagan, Victoria and Albert Museum, *Catalogue of Italian Plaquettes*, London, 1924, p. 13. For the cameo, Inv. No. A.25–1921, see Burlington Fine Arts Club, *Illustrated catalogue of a collection of Italian sculpture and other plastic art of the Renaissance*, London, 1913, p. 139, no. 8.

74. Bode, *I.B.S.R.*, ii, London, 1908, pl. cxxxi; Planiscig, *Piccoli bronzi italiani del rinascimento*, Milan, 1930, pl. xciii (height 13 cm).

75. Bode, *Bronzestatuetten*, Berlin, 1930, nos. 279, 280 (height 22 cm).

76. Licetus, *op. cit.*, c.600.

77. Licetus, *op. cit.*, c.754.

78. Licetus, *op. cit.*, c.666.

79. Paulus Petavius, *Antiquariae supellectilis portiuncula*, Paris, 1610, pl. 16 of the Museum's copy.

80. Guiffrey, *loc. cit.*

81. Buddensieg, *op. cit.*, pp. 148, 149.

82. P. Santi Bartoli, *Le antiche lucerne sepolcrale figurate*, Rome, 1691, pt. iii, pl. 18, p. 6; "Michaelis Angeli Causei de la Chausse Parisiensis de aeneis antiquorum lucernis dissertatio", in J. Graevius, *Thesaurus antiquitatum Romanorum*, xii, Leyden, 1699. cc. 989, 990, pls. x, xi; J. de Wilde, *Signa antiqua e museo Jacobi de Wilde per Mariam filiam aeri inscripta*, Amsterdam, 1700, pls. xiv, xvi, xlii, xliv, xlv, xlvi, xlvii; B. Leplat, *Recueil des marbres antiques qui se trouvent dans la galerie du Roy de Pologne à Dresde*, Dresden, 1733, pls. 185, 186, 192; G.-B. Piranesi, *Vasi, candelabri, cippi, sarcophagi, tripodi, lucerne ed ornamenti antichi*, Rome, 1778, pls. 8b, 9i; P. Lasinio, *Raccolta di sarcophagi, urne e altri monumenti di scultura del Campo Santo di Pisa*, Pisa, 1814, pl. xxiv; J. Disney, *Museum Disneianum*, London, 1849, pls. lxxv, lxxvi, lxxviii.

83. L. Courajod, *L'imitation et la contrefaçon des objets d'art antiques*, Paris, 1887, passim.

84. Planiscig, *Bronzeplastiken*, Vienna, 1924, pp. 65, 66, no. 114.

85. Planiscig, *Bronzeplastiken*, Vienna, 1924, p. 34, nos. 54, 55.

86. For the full history of this panel, later in the collection of Cardinal Grimani and from 1586 in the Biblioteca Marciana, see Anonimo Morelliano, *Notizia d'opere di disegno*, ed. Frizzoni, Bologna, 1884, pp. 37, 247, 248; A. Zanetti, *Antiche statue che nell'antisala della Libreria di S. Marco si trovano*, ii, Venice, 1743, pl. xxxii; Courajod, *op. cit.*, p. 19; Planiscig, "Del giorgionismo nella scultura Veneziana all'inizio del cinquecento", in *Bollettino d'arte*, xxviii, 1934–5, p. 148.

87. For the *Amerbach Venus*, now in the Historisches Museum, Basel, see H. Weihrauch, *Europäische Bronzestatuetten*, Brunswick, 1967, p. 52.

88. Enking, *op. cit.*, p. 78; Valerio Polidoro, *Le religiose memorie . . .*, nelle quale si tratta della Chiesa del glorioso S. Antonio Confessore di Padova, Venice, 1590, caps. xv, xvi, xvii.

89. J. C. Robinson, *Catalogue of the Museum of Ornamental Art at Marlborough House*, i, London, 1855, p. 36, no. 171.

90. J. C. Robinson, *Catalogue of the special exhibition of works of art on loan at the South Kensington Museum, June, 1862*, revised ed., London, 1863, pp. 27–35.

John Carswell

Some Fifteenth-century Hexagonal Tiles from the Near East

In 1881 the Victoria and Albert Museum purchased for six shillings a pair of hexagonal tiles of Near Eastern origin, painted in underglaze blue.[1] In 1898, a group of thirty-three hexagonal tiles and fragments were amongst various tiles bought for £33 17s od from Mr. Henry Wallis.[2] And in 1900 the Museum acquired seventy-one similar tiles for £18 7s 10d from Habra Brothers, the London dealers.[3] Over the years all these tiles have come to be considered as a single group,[4] believed to have been originally in the Great Mosque in Damascus before it was severely damaged by fire in 1893. One aim of the present study is to decide whether this provenance is correct; the other is to publish the tiles in detail and to relate them to what is known so far about fifteenth-century Near Eastern tilework as a whole.

First, it is worth considering by what means these tiles arrived in South Kensington in the late nineteenth century, and how the story of their Damascene origin arose. A study of the Museum archives reveals some interesting details;[5] immediately Mr. Henry Wallis springs on to the stage. He first appears in a letter dated 7 September, 1880, offering to lend his collection of "Hispano Mauresque, Italian Majolica, Persian-ware and Greek vase" for exhibition in the Museum galleries, and after inspection by one of the Museum officers, his offer was accepted. This was the beginning of a close relationship between Wallis and the Museum. From then on until 1901 there was a vigorous exchange of correspondence on various topics, not least important of which was the acquisition of objects which he had for sale. Wallis himself was an artist – a latter-day Pre-Raphaelite painter – and interested in art in all its forms.[6] He travelled widely in Europe and the Near East, and apart from some notoriety gained a few years earlier by running away with George Meredith's wife, established himself as a connoisseur of Islamic ceramics. He was, in fact, a sort of gentleman-dealer. His transactions with the Museum followed a consistent pattern. First, Wallis would write to the Museum describing what he had for sale, and this would in turn become the subject of a memorandum circulated among the Museum officers for comment. After recording their remarks, the file would then be passed to the Director for his final approval. For instance, in 1886 the Museum purchased from Wallis a valuable collection of Egyptian textiles for £300, after Mr. (later Sir) Alma-Tadema, R.A., had pronounced them to be "a real addition to the specimens its already possesses" [sic]. Wallis was also associated with the Museum in other ways. He

helped to obtain from the Louvre plaster-casts of the newly-discovered Susa friezes; by special dispensation he was allowed to have his monographs on pottery on sale in the Museum; and in 1888 he was busy writing to the Director from Egypt drawing his attention to the destruction of antiquities in Egypt.

In 1890 he wrote from Cairo that he had found a medieval panelled room for sale. The Museum sent him £500 on account so that he could negotiate the sale, but Wallis was unable to get the Mufti, its owner, to agree to a price. The Ambassador, Sir Evelyn Baring, was asked to talk to the Khedive about the matter, in the expectancy that he would bring pressure to bear on the Mufti. But Baring did not rise to the occasion. As Wallis crossly comments, "the French or German Consul-General would have at once put the screw on . . . unfortunately Lord Salisbury cares nothing about art—and still more unfortunately none of the Royal Family care about it either, and they are the people who keep ministers up to the mark abroad". But in the same letter we learn that he was luckier in the purchase of a panel of Damascus tiles, and in due course these tiles entered the Museum collection.[7] On 18 January, 1898, Wallis sent 113 objects from Cairo to South Kensington on approval. These included three carpets, two Persian books, six book-covers, glass paste, faience and alabaster bowls, terracotta vases, earthenware and hardstone bowls, a table, and

2 hexagonal tiles (chipped)	*(inventory nos. 37, 38)*
4 fragments of tiles	*(39)*
10 square tiles	*(40–49)*
30 small hexagonal tiles	*(50–79)*
20 hexagonal tiles	*(80–99)*
14 cut hexagonal tiles	*(100–113)*

From Museum records we learn that the following selection was recommended for purchase,

Tiles	*(37–49 except 48)*	
		£12 0s 0d
30 small hexagonal tiles	*(50–79)*	£10 0s 0d
20 hexagonal tiles	*(80–99)*	£30 0s 0d
14 cut hexagonal tiles	*(100–113)*	

The tiles were duly bought[8] and catalogued as nos. 408–440/1898. The printed catalogue describes them simply as "SYRIAN (DAMASCUS) 14th or 15th century", which seems odd if they were purchased in Cairo. However, a note in the catalogue in the late Arthur

Lane's writing states that the tiles were "said to have been in the Great Mosque at Damascus; about 1425. *cf.* 295–1900. These tiles are of the same kind as those in the Mosque et-Turuzi and Turbeh of Sheik Turuzi at Damascus . . . the label now (1937) on the frame saying that the tiles came from the Great Mosque appears to rest on a verbal statement of the late Henry Wallis and nothing else. The provenance is not mentioned on the R.P."[9]

In fact, Wallis believed that the tiles were from Damascus, and said so in a study he published in 1900 on the influence of oriental ceramics on Italian ceramics, in which he illustrated seven of the tiles.[10] Discussing a pottery jar in his own collection decorated in underglaze blue[11] he says it "is an example of the Chinese influence on Syrian faience and perhaps the earliest which has yet been identified . . . evidence as to the date and locality of the fabric where the vase was produced is supplied by the wall-tiles (figs. 21–27). These have all come from Damascus, and as the city was long famous for its decorated glazed tiles, they are tolerably certain to have been made there . . . the tiles are not dated, but the drawing of the ornate ewers, copied from inlaid Mosul vases of the XIII and XIV centuries, the archaisms of the drawing, together with the hexagonal form, all suggest the art of the XIV century." From this it is clear that although the tiles were purchased in Cairo, Wallis had reason to believe they were from Damascus, although he does not mention the Great Mosque specifically. Here it should be pointed out that Cairo was the centre for purchasing antiquities of all sorts in the Near East, a practice which continued well into the present century.

As for the larger group of tiles, bought from Habra Brothers in London in 1900, there is nothing to associate them directly with Syria, except the entry in the printed catalogue which describes them as "SYRIAN (DAMASCUS) 14th century", and another handwritten note, "said to have been in the Great Mosque at Damascus" which also draws attention to the note on the 1898 tiles regarding their date.

THE TILES

The two tiles 108, 109/1881, (fig. 1; tiles 1, 2),[12] according to the printed catalogue, were bought in Damascus for three shillings each. They measure 17 cm. between parallel sides, and are 2 cm. thick. The ware is cream-coloured and the tiles are slightly bevelled back. They are painted in dark cobalt blue, under a thick crackled glaze; tile (2) also has a wide turquoise border, with double grey outlines. The tiles were meant to be set on their points. Tile (2) is painted with an ewer (fig. *a*), with a curving spout and a tall foot, between two sprays of arabesque flowers and leaves. Tile (1) is painted with an arabesque spray of feathery leaves, including pointed leaves with curled lobes at the base.

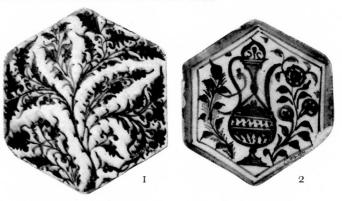

1. Two hexagonal tiles purchased in 1881. Victoria and Albert Museum.

The 1898 group (figs. 2–3; tiles 3–35), bought from Wallis in Cairo, consists of thirty-three examples. Seven of the tiles are five-sided, having been cut down from hexagonal originals; one tile was actually made five-sided, with a painted border on all sides (18). Six more fragments are half-tiles cut down from whole hexagonal tiles. The tiles vary in size from 16 to 17 cm. between parallel sides, although the majority are closer to 16 cm; they vary in thickness from 1.5 to 2 cm. The ware is a light cream colour, and the tiles are bevelled back at the side at a slight angle. Most of the tiles are painted in a dark cobalt blue, although some are painted in a brighter shade (21, 23, 29). Additional colours are turquoise, used as a wide border on some tiles; and grey-green outlines. Two tiles have brown outlines (22, 29). Most of the tiles are covered with a thick crackled glaze. Apart from slight variations in size, a glance at the series shows that there is a diversity in their general design. Seven of them have no border at all; seven more have a narrow turquoise border with a double outline on the inner side, and seventeen have wide turquoise borders with double outlines. One has a solid dark brown border (29), and another a blue outline with a thin brown line on the edge of the tile (22). This variation in the borders suggests that the tiles were not all from the same location, and certainly not by the same hand. The underglaze colours are also

(a) (b) (c) (d) (e)

variable, such as the cobalt blue. Some tiles have been painted with washes of blue of varying tonal intensity, whilst others have the blue applied directly with no tonal differentiation.

The design of the tiles shows the influence of both traditional Islamic patterns and Chinese elements. Seven of the tiles are divided to form six-pointed stars within the hexagon (3–9); five of these are painted with a central flower surrounded by a wreath of leaves and tendrils. The six triangles between the points of the stars are filled with bands of triple lines interspersed with tight scrolls, with one exception where the scrolls exist alone. One tile is painted with a six-armed fylfot contained in a hexagon within the central star (8). This fylfot is a characteristic Islamic motif, common to much metalwork of the Mamluk period.[13] The seventh tile has a flower on a spiralling stalk of leaves at the centre of the star, the points of which are themselves subdivided to form trefoils. The majority of the tiles were painted to be set on their points, like other fifteenth-century tiles from Turkey and Egypt, but unlike the majority of the tiles in the tomb of Tawrizi in Damascus, which were set with two parallel sides horizontal.[14]

Twenty-three of the tiles are decorated with flowers on a spiralling stem, or curved stalk. The flowers include marguerites (9, 11–16, 26), lotus-like flowers in profile (28, 29, 30, 35), and an odd onion-shaped flower (19–21). There are also a great variety of leaves; some are naturalistic; others are painted with tight scrolling tendrils often combined with stylized feathery stalks (13, 15–17, 19–21).[15] The single five-sided tile is decorated with an arabesque stalk of dotted leaves, with mimosa-like sprays on either side (18). The six half-tiles, all different, are painted with a variety of flowers and spiralling leaves (30–35). Another tile (28) is painted with lotus-like flowers, three of which have cross-hatched centres. This cross-hatching of flowers, either by painting or carving under the glaze, is a common feature of Yüan and early Ming porcelain.[16] The tiles with spiral stems of flowers relate to similar designs on early fifteenth-century Ming dishes.[17]

Another Chinese motif is the cloud-collar; but the elaborate form and intertwined background of the motif on one tile (27) owes as much to Islamic influence as Far Eastern. Outlining of the petals of lotus-like flowers suggests fourteenth-century Chinese prototypes, as does the tile (29) painted with three cross-hatched baskets of flowers and tendrils.[18] But none of the tiles is painted with the typical Chinese fourteenth-century spiked leaf with curling lobes at its base, and as a whole this group of tiles appears to have been inspired by contemporary Chinese porcelain rather than by earlier models.

Among the more unusual patterns, one tile (25) (fig. e) is painted with a musical instrument of the 'oud type, between a pair of birds. The birds have no close parallels on Chinese porcelain but may have been Near Eastern adaptations of the peahen motif. Another tile (26) has a crane painted on it.[19] Three tiles are painted with vessels (22–24) (figs. b, c, d). The ewer on (24) has a high pedestal foot, with a curving spout and handle, and is very similar to the ewer on (2). Not usually considered to be earlier than the seventeenth century, this shape of ewer is, however, frequently depicted on fifteenth-century hexagonal tiles. Although the writer knows of no precisely dated fifteenth-century ewers of this sort, a ewer in a private collection in the Near East (fig. 16)[20] could be of the period and the type the potters had in mind. The two other objects (22, 23) (figs. b, c) with bulky tops and double handles are a puzzle. The sprightly appearance and angularity of the drawing would indicate that metal forms were meant to be represented.

The 1900 group (figs. 4–8; tiles 36–106), bought by the Museum from London dealers, consists of seventy-one examples. Forty-nine are intact hexagonal tiles. The rest are fragments cut down from whole tiles; ten are five-sided, eight are half-tiles, and nine are smaller pieces. The whole tiles vary from 17 to 17.5 cm. between parallel sides, most of them 17.5 cm. across; they are between 1.2 and 1.5 cm. thick. The ware is light cream in colour, covered with an off-white ground.

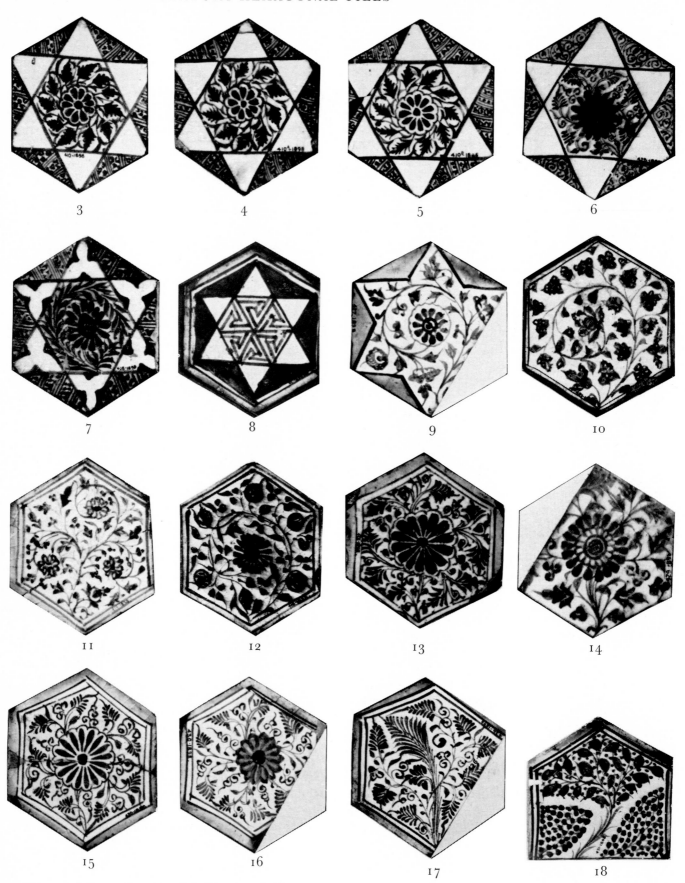

2. Hexagonal tiles purchased in 1898. Victoria and Albert Museum.

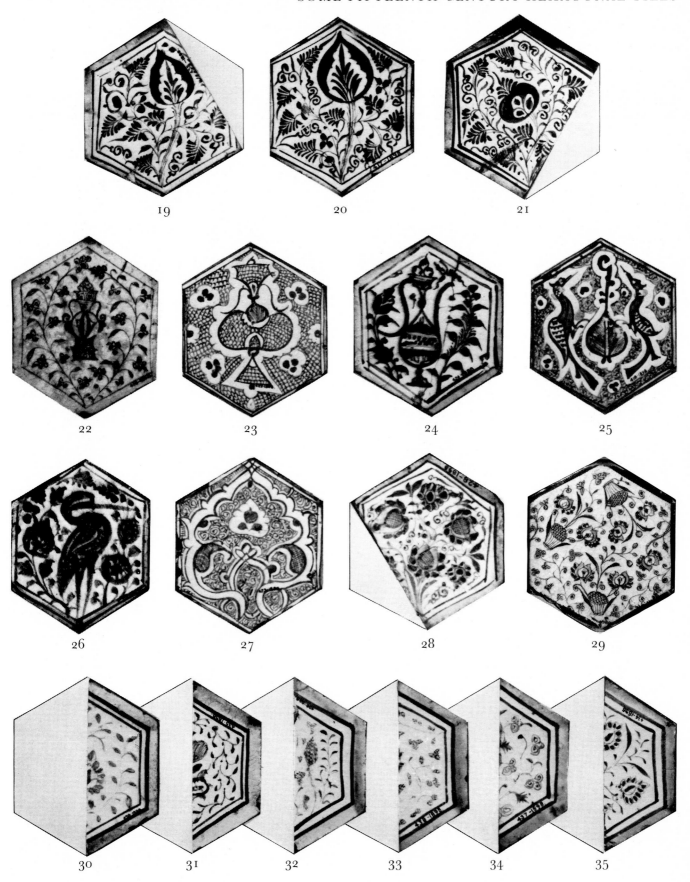

3. Hexagonal tiles purchased in 1898. Victoria and Albert Museum.

(f) (g) (h) (i) (j)

Most of the tiles are painted in dark cobalt blue, with a number in lighter shades of blue-grey (37–39, 43, 44, 51, 53, 55, 57, 58, 62, 63). Several are painted in washes of blue of varying intensity. Additional colours used for outlining the designs are grey-brown or grey-green, and turquoise is used for the borders of some tiles. Most of the tiles are covered with a thick crackled glaze. Although the tiles vary in treatment of their subjects, they form a much more homogeneous group than the 1898 tiles, and are of consistently higher quality. Seventeen of them have no borders (36–51, 57), and these are the tiles which show the strongest Islamic influence. The rest have narrow turquoise borders with double outlines. Most of the tiles are designed to be set on their points.

Again, like the 1898 tiles, the patterns show the effect of both traditional Islamic and Chinese influences. Nine tiles are divided geometrically by lines joining their points to form six-pointed stars. Five of these (36–40) have the central hexagon filled with a large flower with pointed petals, surrounded by a wreath of pointed leaves on a speckled ground. The points of the stars are decorated with spiked trefoils, and the triangles between the points with a pattern of radiating triple bars separated by dots. These tiles are more sprightly in treatment than the 1898 tiles of similar design. On one tile (41) the intervening triangles between the points are decorated with a flower and spiked leaves with curling lobes at the base, of unmistakably fourteenth-century Chinese inspiration.[21] This tile, more than any other, demonstrates clearly the conjunction of Chinese and Islamic forms. Two more tiles (42, 43) have the central hexagon and outer triangles filled with an intertwining Islamic pattern. A third tile (44) has the star outlined with heavy shaded bars, with a heavy lobed flower in the middle; the points of the star are filled with tight scrolls, and the triangles between with similar lobed leaves.

Three tiles (45, 46, 47) are painted with star-like forms. One (45) bears a six-pointed star of metallic-like character, between cloud-collars filled with tight scrolls. The other two (46, 47) have central flowers, from which radiate six blade-like petals, with subsidiary small flowers and curving, intertwined leaves on a dotted ground. Two tiles (50, 51) are also based on a division of the basic hexagon into six areas, each area filled with a voluptuous flower with curled lobes at the base, spiralling on a thick stem from a rather inadequate daisy-like flower at the centre. Another tile (49) is decorated with similar flowers on a thick stem meandering round a double vertical flower in profile of the same family. All three of these tiles are painted with patterns reversed out of a solid blue ground, a unique feature amongst the tiles discussed in this article. A fourth tile (48) is also designed with an elaborate lotus-like flower in profile on a vertical stalk, with a round medallion below, and from which spring smaller flowers of similar type on spiralling stems; the ground is covered with tight scrolls. Two more tiles (57, 58) are based on Islamic patterns of intertwine and arabesque; and these, with five tiles decorated with vessels (52–56; figs. *f–j*), complete the series in which the Islamic influence dominates. The rest of the tiles are more obviously Chinese in inspiration, though the inspiration is somewhat tailored to suit Islamic taste. Although the details of flowers and leaves vary considerably – indeed, no two tiles are alike – most of them are based on a central motif springing from the lower point of the hexagon, around which are arranged small flowers and leaves on spiralling or meandering stems (figs. 5–8). Many of them are closely linked to the type of early fifteenth-century Chinese porcelain known to have been exported to the Near East, with which the potters must have been familiar.[22] On the porcelain one finds exactly the same balance between heavy flowers and wiry, curving stems.

A large group of tiles (fig. 6) has a tapering arabesque stem, often hatched, placed vertically at the centre of the tile so that it divides it up into two equal halves. The stem is surmounted by one, two or three onion-shaped 'flowers'. These curious objects are either hatched with alternating stripes and chevron-like ticks, or filled with a pattern of scales (69, 75, 77). Subsidiary flowers are of similar kind, or of completely contrasting lotus or marguerite type. Again, impossibly thin spiral

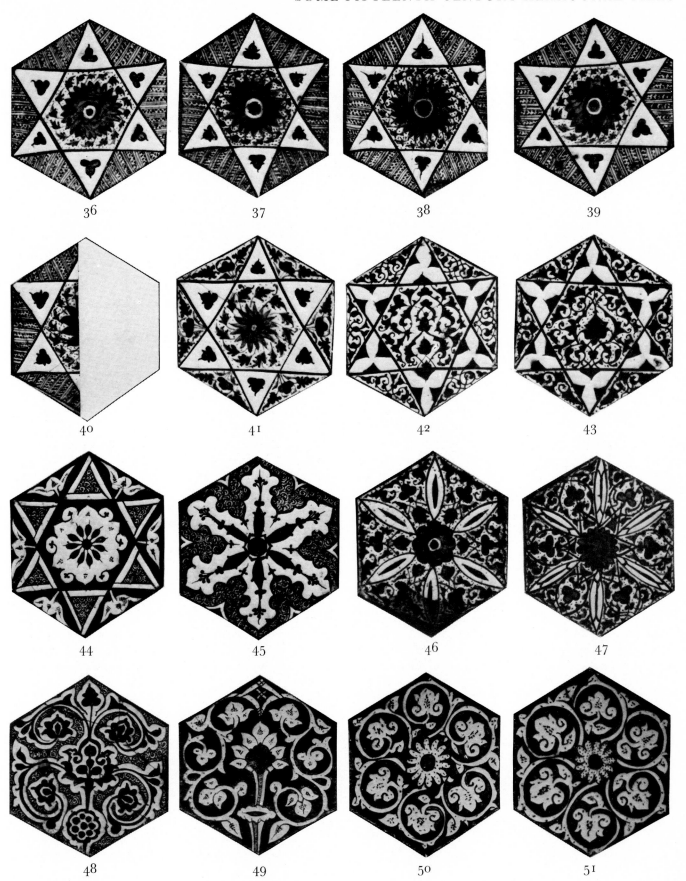

4. Hexagonal tiles purchased in 1900. Victoria and Albert Museum.

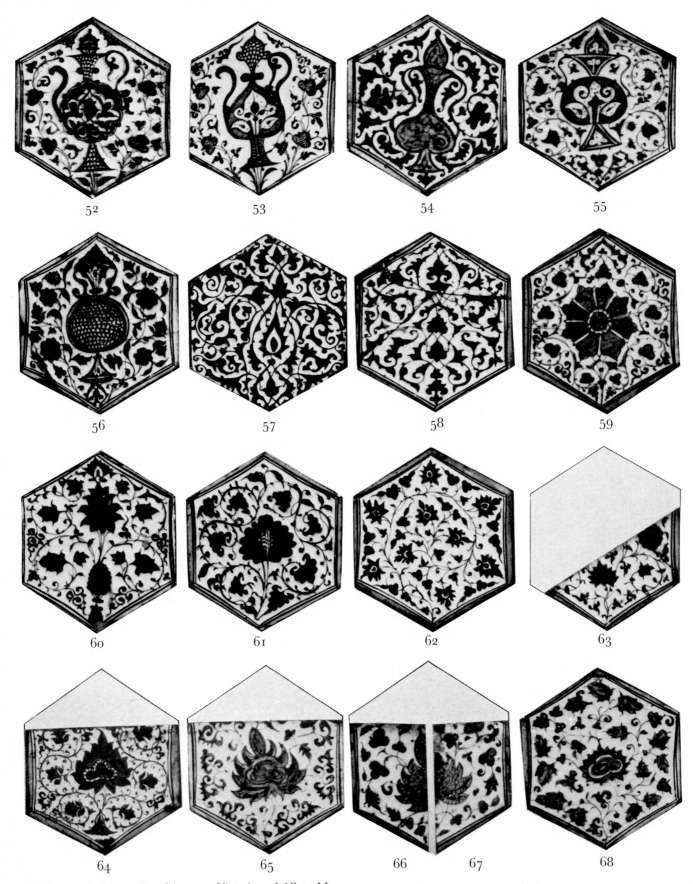

5. Hexagonal tiles purchased in 1900. Victoria and Albert Museum.

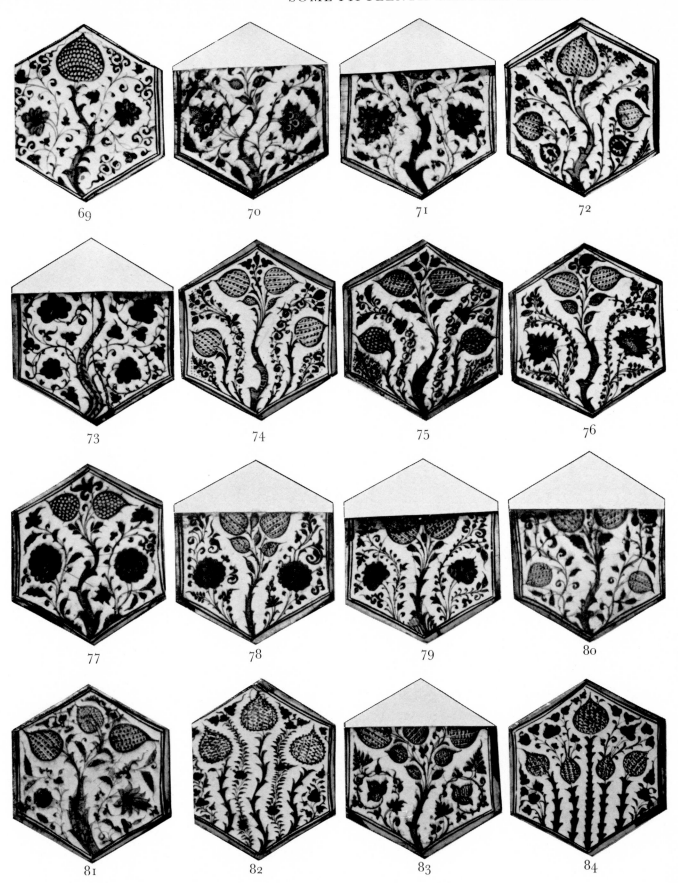

6. Hexagonal tiles purchased in 1900. Victoria and Albert Museum.

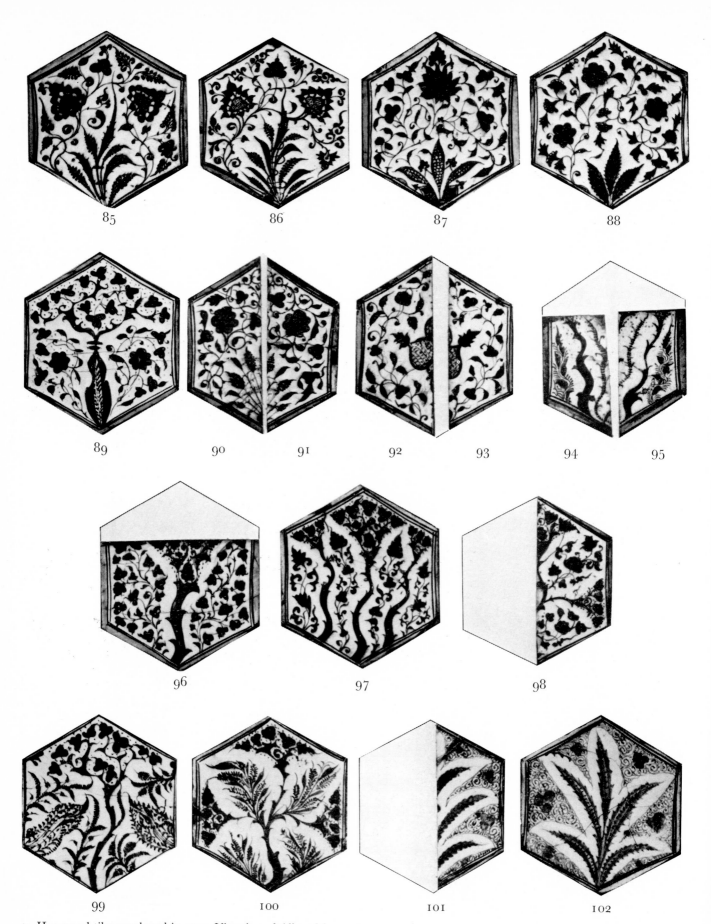

85 86 87 88

89 90 91 92 93 94 95

96 97 98

99 100 101 102

7. Hexagonal tiles purchased in 1900. Victoria and Albert Museum.

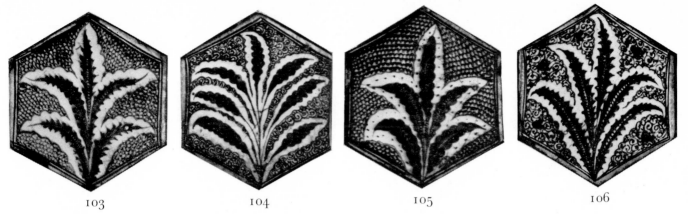

103 104 105 106

8. Hexagonal tiles purchased in 1900. Victoria and Albert Museum.

stems support the flowers. The leaves are of various kinds, even with several types on the same stalk. There are a series of Chinese dishes in the Ardebil collection with sprays of flowers, or aquatic plants[23] which suggest the sort of decoration that could have influenced the Islamic potters. But a comparison between the originals and the tiles shows that the already hybrid Chinese forms have been Islamicized; it is almost as if the potters were attempting to impose order on what must have seemed to them as inspired chaos. Although they arranged the motifs symmetrically, the Islamic potters still managed to retain the imaginative quality of the originals.

Other tiles are variations on similar themes. Six are painted with sprays of pointed leaves at the base of the tile (85–88, 90, 91); one (86) has a ribbon-like tendril weaving its way in and out of the leaves, reminding one of the ribbon that ties a bouquet on some Chinese plates. On some tiles (96–100) the centre stem becomes tree-like, branching out at the top into a thicket of foliage and dots. On one tile (99) two arabesque masses of stems and dotted leaves sweep in from the sides, like peacocks. On another tile (100) there is real virtuosity in the balance of arabesque and contrasting feathery forms, contained within the hexagonal shape.

Six remaining tiles are decorated with sprays of plantains, outlined in white on a ground of scales, or tight scrolls (101–106). The origin of the plantain can once more be traced to fourteenth-century Chinese

9. The Great Mosque, Damascus, N. end of transept, before it was destroyed by fire in 1893. *Photograph by courtesy of the Palestine Exploration Fund.*

10. The courtyard of the Great Mosque, Damascus, looking NW., with the transept restored; February, 1970.

dishes, where such a feature often forms the main subject.[24] But again the motif has been tidied up by the Islamic potters. Of the five tiles with vessels painted on them (52–56; figs. *f–j*), two have tall ewers with curving spouts, and three have vessels with twin handles. Like the vessels on the 1898 tiles, it is not easy to find contemporary Islamic parallels, although the sharply flaring foot would suggest that the prototypes were of metal. A bronze flask of East Persian origin and thirteenth-century date in the British Museum[25] has a similar flaring foot, a circular body with twin zoomorphic handles, and a panel of inlaid decoration at the neck not unlike the type of decoration on the body of one of the tile ewers (*f*).

Having described the tiles in detail, the question of their provenance arises, and in particular the alleged connection with the Great Mosque in Damascus. The Great Mosque was severely damaged by fire in 1893, and according to Murray's Guide, published in 1903, amongst the parts which suffered most were the arcades round the courtyard (except at the south-west angle) and "the immense transept running N. and S., with a dome over the crossing; this was so badly injured by fire that it had to be taken down. Many of the windows known as 'karamiyas' or 'shemsiyas' which were composed of stucco in pierced arabesque designs filled in with coloured glass, were destroyed at the same time".[26] An old photograph, now in the archives of the Palestine Exploration Fund in London, shows the exterior of the transept on the north side before the fire (fig. 9).[27] A comparison with a recent photograph (fig. 10)[28] shows how the transept was rebuilt in a different manner after the fire. The two main columns were raised on pedestals, and the tall impost blocks at the top of the columns removed. In the middle window, the six smaller columns have disappeared altogether. In the earlier photograph it is just possible to see that the lower part of the buttress piers were decorated with tiles of various kinds; it is also clear that the tiles were square tiles, and that none of them were hexagonal. It must have been these same tiles which were re-used after the fire. They are now set as panels, framed with marble inlay, on the lower part of the piers round the courtyard, on the north side of the mosque, at the beginning of the arcade at the south-east angle, and round the entrance loggia at the south-west angle (figs. 11–14).[29] These tiles, decorated in cobalt blue, turquoise, purple and apple green under a thick crackled glaze are typical seventeenth/eighteenth-century Syrian products.

In the tomb of Saladin (d. A.D. 1193) north-west of the courtyard, there are more tiles (fig. 15). But these were clearly added to the original structure at a much later date, and the central panel on the west side is dated A.H. 1027/A.D. 1618–19.[30] There are no hexagonal tiles in Saladin's tomb; nor are there any in the mosque, or round the courtyard.

When Captain Charles Wilson visited the mosque in 1895, he noted in his diary: "In some places are patches of faience work; the designs on the tiles are for the most part identical with those of the tiles in the Dome of the Rock, but not with those of the best tiles in that building".[31] This would serve very well as a description of the surviving tiles; Damascus tiles were amongst the tiles used to repair the Dome of the Rock in the

11. Nine tiles facing the pier at the E. end of the N. exterior wall of the Great Mosque, Damascus. 24 cm. square. Painted in dirty cobalt blue, pale apple/olive green, diffused turquoise, light/dark manganese purple. Syrian, seventeenth/eighteenth century.

12. Twenty-four tiles framing marble inlay at the base of a pier on the exterior wall of the Great Mosque, Damascus. 22 cm. square. Painted in dark cobalt blue, turquoise, purple, with grey-green outlines. Syrian, seventeenth/eighteenth century.

seventeenth and eighteenth centuries, originally tiled in the sixteenth century during the reign of Suleyman the Magnificent.[32]

There is, however, a very large collection of fifteenth-century hexagonal tiles in another building in Damascus, in the tomb of Ghars ad-Din al-Khalil at-Tawrizi, Vizier of Damascus, who died in A.D. 1430. The tomb, and the mosque beside it (which was part of the same foundation) are decorated with more than 1,300 hexagonal tiles.[33] The majority of these were designed to be set with two sides horizontal, and are without borders. Some tiles used in the tomb for patching, and in the mosque as part of an irregular frieze, were designed to be set on their points; these also have a wide turquoise border, and are obviously of different manufacture from the majority of the tiles in the tomb. It is, however, only with this minor group that any comparison between the Museum tiles and the Tawrizi tiles can be made, as these alone were designed to be set on their points. For parallels, there are similar ewers to that depicted on the 1881 tile (2) (fig. a) amongst tiles in the mosque frieze, and on a tile above the lintel of

13. Panel of fifteen tiles at the base of a pier at the NE. angle of the courtyard, the Great Mosque, Damascus. 22 cm. square. Painted in dark cobalt blue, turquoise, with dark grey outlines. Syrian, seventeenth/eighteenth century. Framing the panel are bands of turquoise and dark blue glazed bricks.

the door leading to the tomb. There are tiles similar in design to 1898 types (3)–(7) in the tomb, as part of the original scheme; but the development of the flower and wreath in the central hexagon is not exactly the same, and these particular tiles could in any case be set either way. None of the rest of the tiles in the 1898 group have any close parallels with the Tawrizi tiles. The 1898 tiles are also significantly smaller than the Tawrizi tiles, measuring 16 cm. between parallel sides, instead of 17.5 cm. As for the 1900 group in London, the tiles differ completely from the Tawrizi series. Although they were again designed to be set on their points, they cannot be compared with the minor Tawrizi group, as they have very narrow borders, instead of wide turquoise borders. The patterns on the Victoria and Albert Museum tiles are also painted much more skilfully than those in Damascus.

With what other hexagonal tiles can the Museum tiles be compared? There is a large group of tiles in the Murad II mosque at Edirne, in Turkey, installed after A.D. 1435. These are also set on their points, but they

are much larger than the Museum tiles, measuring 22.5 cm. between parallel sides. They are also quite dissimilar in design and execution.[34] In Egypt, there are several sets of hexagonal tiles in the Arab Museum in Cairo.[35] Although it is not certain, the Cairo tiles were probably made in Egypt; again, they have certain characteristics which set them apart from the Syrian and Turkish tiles. The majority of the Cairo tiles were designed to be set on their points; they also correspond approximately in size to the Museum tiles in London. As for the designs, there are tiles in Cairo similar to types (12), (13) and (27) amongst the 1898 London Group; and at least eighteen tiles in Cairo are paralleled

14. (a) Tiles in the entrance loggia of the Great Mosque, Damascus. Approx. 20 cm. square. Painted in dark cobalt blue, turquoise, apple green, dark purple, with dark grey outlines. Syrian, seventeenth/eighteenth century.
(b) Part of a tile inscription in the loggia of the Great Mosque, Damascus. Painted in dark cobalt blue, turquoise, apple green. Syrian, seventeenth/eighteenth century.

(a)

(b)

During this period the crafts were affected by several factors. Tamerlane himself deported large numbers of Syrian craftsmen; but it appears that the luxury crafts, like inlaid metalwork and enamelled glass, felt the impact of Mongol acquisitiveness, rather than pottery. If one is to judge from those sherds of pre- and post-conquest blue-and-white pottery that have survived, the pottery industry does not seem to have suffered any great reverse. If potters were amongst those deported, the forced emigration was apparently not on such a scale as to enfeeble the craft. On the other hand, the lavish patronage of the Mamluks and the wealthier classes in Egypt and Syria ceased, both being affected by the declining economy; this again had its greatest effect on the production of luxury goods. A third factor was the increase in imports, which did have an effect on the pottery industry; the arrival of quantities of Chinese porcelain made a resounding impact. The

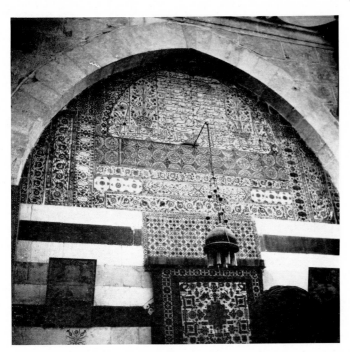

15. Tiles in the interior of the tomb of Saladin, NE. of the courtyard of the Great Mosque, Damascus. Above, to the left of the lamp-bracket, is a tile dated A.H. 1027/A.D. 1618–19. Painted in blue, turquoise, manganese purple.

16. Metal ewer in the collection of Mr. Henri Pharaon, Beirut.

in the 1900 group. Thus it is clear that the two main groups of tiles in London resemble the hexagonal tiles in Cairo rather than those from either Damascus or Edirne. Although Wallis believed that the 1898 group were from Damascus, he did in fact purchase them in Cairo. As for the 1900 group, nothing is known about their provenance before they reached the London dealers.

At this point the historical background of events in Syria and Egypt in the fifteenth century should be considered. This was the period of the Mamluk revival, following the collapse of the Mamluk Empire in the fourteenth century, culminating in Tamerlane's conquest of Syria and the sack of Damascus in A.D. 1400. Although the empire never regained its previous prosperity, it recovered well enough in the fifteenth century for it to function with reasonable efficiency. Civil strife was resolved between the various Mamluk factions in Syria and Egypt; in Syria, Sultan al-Mu'ayyad Sheikh (1412–21) and Sultan Barsbay (1422–8) successfully restored the dynasty in both political and material terms.[36]

potters' dilemma is neatly reflected in the designs they made for the hexagonal tiles; whilst on the one hand they were unwilling to renounce traditional Islamic forms entirely, on the other they attempted to incorporate some of the novelty of the Chinese designs. Although it was impossible for them to reproduce the porcelain ware, at least when it came to decoration they managed to arrive at an acceptable compromise.

In Damascus, there are no records of major repairs to the Great Mosque between A.H. 765/A.D. 1363 and A.H. 884/A.D. 1479.[37] Even at the latter date skilled workers such as lead-roofers had to be imported from Anatolia to repair the ravages of a fire, and allegedly did inferior work.[38] Like the Ottoman Empire in the seventeenth century, the time was not right for major enterprise, and as one writer says, "emphasis shifted from the endowment and construction of great monuments to the founding of small schools and convents . . . these smaller foundations represented the efforts of the *ulama* to sustain communal and religious life in the face of growing neglect by the Mamluk regime".[39] Such a situation perhaps explains why the tile-makers should

have worked on a minor building, like the tomb of Tawrizi, rather than repairs to the Great Mosque.

There was a steady interchange of trade between Syria and Egypt in the first part of the fifteenth century. Agricultural and manufactured goods were exported from Syria, and Syria received grain from Egypt in return. Sidon was still in use as a Syrian port after the fifteenth century, and it is not without relevance that the Kataeesh mosque in Sidon is also decorated with a small panel of hexagonal tiles.[40] Hexagonal tiles could have been amongst the varieties of products made in Syria and exported to Egypt; but it is more likely that it was the potters themselves who travelled. This alone would account for stylistic similarities side by side with discrepancies in size, technique and colouring. This raises an interesting question – why should tile-makers in Syria, Egypt and Turkey have all worked in the same idiom? Although it has been shown that the common style has detectable regional variations, the fundamental question of when, and where these hexagonal tiles were originally conceived, with their combination of Islamic and Chinese elements, still remains unanswered.

Notes

1. Nos. 108–9/1881. Fig. 1; tiles 1 and 2.
2. Wallis was then living at 9, Beauchamp Road, Upper Norwood. Nos. 408–440/1898. Figs. 2, 3; tiles 3–35.
3. Habra Bros., 108 Great Portland Street, London. Nos. 295/1–71, 1900. Figs. 4–8; tiles 36–106.
4. A. Lane, *Later Islamic Pottery*, 1957, p. 30; *Guide to Tiles*, 1960, pp. 15–16. G. Reitlinger, "The Interim Period in Persian Pottery", *Ars Islamica*, v, 1938, pp. 156, 158–63, 173, fig. 1. R. M. Riefstahl, "Early Turkish Tile Revetments in Edirne", *Ars Islamica*, IV, 1937, p. 274, figs. 23, 24.
5. It is a pleasure to acknowledge the help of Mr. Robert Charleston (Keeper) and Mr. Michael Archer, of the Department of Ceramics, in tracing the history of the tiles. A file is devoted to correspondence between Wallis and the Museum, and transactions involving him. It incidentally provides an insight into the administration of the Museum in the nineties; notes sent from one officer to another, although often betraying strong feelings, are of the utmost rectitude. One wonders if there was ever any verbal communication at all.
6. Henry Wallis is not to be confused with George Wallis, also a painter, and also associated with the Museum. George Wallis was born in Wolverhampton in 1811, and died at Wimbledon in 1891; he was Headmaster, School of Art, Spitalfields, Manchester and Birmingham, and Keeper at South Kensington

Museum; see S. Paviere, *Dictionary of Victorian Landscape Painters*, 1968, Leigh-on-Sea, p. 132.
7. No. 258/1891. These typical Syrian tiles are dated 11.r but the third figure is large enough to be read possibly as 0 . Thus the date could either be A.H. 1102/A.D. 1690–1, or A.H. 1152/A.D. 1739–40. The panel consists of nine tiles, depicting a ewer and two hanging lamps, with Arabic inscriptions, and is now on exhibition in the North Gallery. According to the catalogue, a similar tile panel dated A.H. 1150/A.D. 1737–8 is illustrated in *Metropolitan Museum Studies*, I, 1928–9, p. 102, fig. 4, and ascribed by M. Dimand to Syria.
8. The actual prices paid were slightly higher than those recommended; £13 10s 9d, £11 5s 6d and £33 17s 0d.
9. R.P. stands for registered paper (or file).
10. Henry Wallis, *The Oriental Influence on the Ceramic Art of the Italian Renaissance with illustrations by Henry Wallis*, London, Bernard Quaritch, 1900, pp. XVII, XIX, figs. 21–27.
11. Later to enter the Victoria and Albert Museum, no. C413–1918. See Lane, *Later Islamic Pottery*, p. 30, fig. 14.
12. For the sake of convenience, particularly in making comparisons with tiles in other collections, the hexagonal tiles in the Victoria and Albert Museum have been re-numbered as follows:
1881 Tiles: 1 (old number 108), 2 (109).
1898 Tiles: 3 (410), 4 (410A), 5 (410B), 6 (425), 7 (408), 8 (411), 9 (427), 10 (421), 11 (414), 12 (416), 13 (413), 14 (429), 15 (420), 16 (430), 17 (426),

18 (431), 19 (432), 20 (417), 21 (433), 22 (409),
23 (422), 24 (424), 25 (418), 26 (419), 27 (423,)
28 (428), 29 (412), 30 (439), 31 (435), 32 (436),
33 (438), 34 (437), 35 (434).

1900 Tiles: 36 (37), 37 (44), 38 (45), 39 (17), 40 (67), 41 (18),
42 (26), 43 (19), 44 (47), 45 (21), 46 (49), 47 (27),
48 (24), 49 (25), 50 (22), 51 (20), 52 (7), 53 (1),
54 (43), 55 (10), 56 (32), 57 (23), 58 (42), 59 (31),
60 (41), 61 (40), 62 (8), 63 (60), 64 (58), 65 (55),
66 (65), 67 (63), 68 (34), 69 (39), 70 (57), 71 (50),
72 (46), 73 (53), 74 (4), 75 (36), 76 (16), 77 (30),
78 (58), 79 (51), 80 (56), 81 (38), 82 (5), 83 (54),
84 (9), 85 (2), 86 (3), 87 (29), 88 (35), 89 (13),
90 (70), 91 (71), 92 (68), 93 (69), 94 (62), 95 (64),
96 (12), 97 (52), 98 (61), 99 (11), 100 (14), 101 (28),
102 (66), 103 (48), 104 (15), 105 (33), 106 (6).

All the tiles are in the museum, except for 14, 30–5, 40, 46, 66, 90–3, 95, 102, which were disposed of as being in fragmentary state through the London salerooms.

13. D. Barrett, *Islamic Metalwork in the British Museum*, 1949, pl. 19, 23, 25, 27.

14. For a detailed description of the tiles from the mosque of Murad II at Edirne, the mosque of Tawrizi in Damascus, the Kataeesh mosque in Sidon, and similar tiles in the Arab Museum, Cairo, see the writer's article, "Six Tiles" in the Centennial Publication of the Metropolitan Museum, New York, *Islamic Art in the Metropolitan Museum of Art*, to be published in 1972.

15. Very like the foliage of the *hummus* plant, a variety of chick-pea, common throughout the Levant.

16. J. A. Pope, *Chinese Porcelains from the Ardebil Shrine*, Washington, 1956, pl. 11.

17. *Ibid.*, pl. 35, 36.

18. *Ibid.*, pl. 8.

19. Cranes are painted on a few of Tawrizi tiles; see note 14.

20. In the collection of Mr. Henri Pharaon, Beirut. For other tiles with similar ewers painted on them, see the illustrations to the article mentioned in note 14, which also discusses this type of Islamic ewer and its relationship to the development of Chinese porcelain ewers.

21. Compare with the dish illustrated by Pope, *op. cit.*, pl. 8.

22. *Ibid.*, pl. 35, 36.

23. *Ibid.*, pl. 30, 31, 42–4.

24. *Ibid.*, pl. 13.

25. Barrett, *op. cit.*, pl. 9.

26. *Murray's Handbook for Travellers in Syria and Palestine*, London, 1903; p. 311. A. C. Dickie visited the mosque shortly after the fire and described the damage in detail – "The Great Mosque of the Omeiyades, Damascus", *Palestine Exploration Fund Quarterly Statement*, 1897, pp. 268–82. Of the decoration, he says: "The whole of the marble panelling and other interior decoration is now entirely destroyed, and scarcely a trace remains of it among the *debris*, possibly much of it has been collected and carried to a place of safety for after use in the decoration, but I could get no definite answer to any of my enquiries about this".

For further descriptions of the mosque after the fire, see Phené Spiers, "The Great Mosque of the Omeiyades", *Journal of the Royal Institute of British Architects*, Third series, IV (1896/7), pp. 25–40, 41, 57–65; V, pp. 166–71. Reprinted in Palestine Exploration Fund Quarterly Statement, 1897, pp. 281–99. For a detailed description of the architectural evolution of the mosque, see K. A. C. Creswell, *Early Muslim Architecture*, Oxford, 1932, I, pp. 100–46.

27. The plate is reproduced from the original glass negative, by kind permission of the Palestine Exploration Fund.

28. Taken by the writer in February 1970. I am indebted to Mr. Peter Parr, for various photographs of individual tiles.

29. The following tiles were noted by the writer:
Type 1 (facing the pier at the beginning of the arcade, NE. angle of the courtyard) (fig. 13) 22 cm. square, thick crackled glaze; dark cobalt blue, turquoise, with dark grey outlines.
Type 2 (facing piers on N. exterior wall of mosque) (fig. 12) 22 cm. square; dark cobalt blue, turquoise, purple, grey-green outlines.
Type 3 (facing pier, E. end of N. exterior wall of mosque) (fig. 11) 24 cm. square; thick crackled glaze; discoloured off-white/pinkish ground. The colours vary considerably on each tile; dirty cobalt blue, pale apple/olive green, diffused turquoise, light/dark manganese purple.
Type 4 (W. end of N. exterior wall of mosque) (fig. 14b) Part of an inscription; white letters on a dark blue ground, with additional turquoise and apple green.
Type 5 (round the entrance loggia at SW. angle of the courtyard) (fig. 14a). Dark cobalt blue, turquoise, apple green, dark purple, with dark grey outlines.

30. The building was long neglected, until 1898 when Wilhelm II visited Damascus and it was repaired. The inscription on the tiles pays homage to Saladin for having delivered Jerusalem from the infidels. The tiles are of Syrian workmanship, apparently made specially for the tomb as some have the edges glazed where they are exposed at the angles of the tomb. Varying in size (20 by 27 cm., 12 by 21 cm., 21 cm. square) they are painted with debased Isnik designs in blue, turquoise and manganese purple.

31. From the diary of Captain Charles Wilson, quoted by Spiers, P.E.F.Q., *loc. cit.*, p. 299.

32. E. T. Richmond, *The Dome of the Rock in Jerusalem*, Oxford, 1924.

33. See note 14. Also K. Wulzinger and C. Watzinger, *Damaskus, Die Islamische Stadt*, Berlin, 1924; pp. 12–15, 91–4. Pl. 27–9.

34. See note 14.

35. *Ibid.*

36. I. M. Lapidus, *Muslim Cities in the Later Middle Ages*, Harvard University Press, 1967, pp. 32–4.

37. *Ibid.*, pp. 199–206; J. Sauvaget, *Les Monuments Historiques de Damas*, Beirut, 1932, pp. 17–18.

38. Lapidus, *op. cit.*, p. 33.

39. *Ibid.*, p. 37.

40. See note 14.

Santina M. Levey

An Elizabethan Embroidered Cover

"Vpon the North-sea, thereby, bordereth Stow, so singly called, per eminentiam, *as a place of great and good mark & scope, and the auncient dwelling of the* Greynuiles *famous family, from whence are issued diuers male branches, and whether the females haue brought in a verie populous kindred.* Master Bernard Greinuile, *sonne and heire to Sir* Richard, *is the present owner, and in a kind magnaminitie treadeth the honourable steps of his auncestours."*[1]

★ ★ ★

STOW stood in North Cornwall just over the border from the port of Bideford, with which the family of Grenville had also been connected from at least as early as the reign of Henry II; but, although Bideford survives as a small seaside resort with a silted harbour,

1. Portrait of Sir Bernard Grenville. Inscribed "Aged 30. 1593". Exhibited at *The Special Exhibition of National Portraits*, South Kensington, 1866, Cat. No. 398. Lent by Rev. Lord John Thynne. Present whereabouts unknown.

Stow has completely vanished. Not even an adequate description of the house remains and the name itself has been transferred to Stowe House in Buckinghamshire, home of the Earls of Buckingham and Chandos, who inherited the titles and possessions of the Grenville family through the female line.[2] Of the "Greynuiles famous family", so respected by Carew and by other writers of the late sixteenth and early seventeenth centuries, very little remains; the old Medieval and early Tudor mansion of Stow was pulled down in 1679, and even the great Baroque palace which replaced it lasted only a further forty years until 1720, when the family finally left the County. Of the family papers also – inventories, household accounts, letters and diaries – which had miraculously survived in the attics of the farmhouse built from the stables of the old Stow, only a handful of letters survive,[3] the remainder having been burnt in the early nineteenth century by Lord Carteret, then head of the family. The records of the Borough of Bideford, the town of which the Grenvilles were overlords, suffered a similar fate later in the same century at the hands of a misguided town clerk, thus destroying the other major source of information concerning the family; and the few portraits and personal papers which did survive until the dispersal of the contents of Stowe House in the sales of 1848 and 1921 appear also to have vanished without record.[4]

Although, therefore, the name of Grenville still evokes images of past grandeur and of chivalry, due largely to the literary skills of Sir Walter Raleigh and of Tennyson,[5] very little is known, or ever can be known, about the human and personal aspects of the family. It is partly for this reason that a small embroidered cover[6] which was bequeathed to the Museum in 1968, is of such interest.

The cover (frontispiece), which is of linen embroidered with silk and metal threads, has in its centre a heraldic shield emblazoned with the arms of Grenville impaling Bevill.[7]

The marriage thus recorded is that of Bernard Grenville and Elizabeth Bevill, which took place at Withiel

2. Long Pillow Cover. English: second half sixteenth century. Linen embroidered with black silk in back, chain, cord, braid and buttonhole stitches. From the Collection of Lord Falkland. T.81–1924.

Parish Church on 10 July, 1592. Though the cover may have been embroidered at the time of the marriage, the arms would have been used throughout the lifetimes of both husband and wife. Bernard Grenville (fig. 1) had the misfortune, as far as posterity is concerned, to have been the son of one famous man and the father of another. His father was the Sir Richard Grenville who, after a very active life which had involved him in both national and international affairs, died heroically at the hands of the Spanish on board his ship the *Revenge* in 1591.[8] Sir Bernard's son was Sir Bevill Grenville, "the Mirror of Chivalry and Hero of his Country",[9] who died in defence of his king at the Battle of Lansdowne Hill in 1643. Of Sir Bernard Grenville, who died quietly in his bed at the age of 69, virtually nothing is known and of his wife, Elizabeth, even less. She was the heiress to her father, Phillip Bevill of Brinn and Withiel, and also to her uncle, John Bevill of Killigarth, and the marriage appears to have been arranged by Sir Richard Grenville before he left on his last voyage to the Azores.[10] Although Sir Richard died intestate, he had left an indenture, upheld after his death,[11] by which Bernard Grenville inherited considerable lands in Cornwall and Devon; the Grenvilles' Irish property also, which had been left to the second son, John, came to Bernard after the latter's death at sea in 1595, as did the property left in trust for her lifetime to Richard's wife, Mary. Of the worldly goods in which this landed wealth was probably reflected, our embroidered cover would appear to be a lone survival. As such it is in no way unexpected; although Carew described the Cornish gentry as keeping "liberall, but not costly builded or furnished houses . . ." he continued "yet the women would be verie loth to come behind the fashion, in newfanglednes of the maner, if not in costlynes of the matter."[12] In contemporary inventories, beside the references to furnishings of silks, of cloth of gold and of velvet, may be found descriptions of:

Item. vij longe cushions of needleworke of sundry colours whereof iiij some with gold.[13]

Itm. one paire (of pillow beeres) wrought in coulours silke and golde.[14]

Itm. another paire imbrodered with a runninge worke of pomgranats, grapes and roses silke and golde.[15]

Itm. Another paire with a traile worke of sundre flowers, strawberys and pinkes.[16]

and the collections of this and other Museums contain comparable pieces (fig. 2). The presence of the coat of

arms is also typical in reflecting the period's self-conscious delight in all matters relating to family pedigrees and to grants of arms, which resulted in the use of heraldic devices in portraits, in plaster work, in wall painting, woodwork and embroidery (fig. 3). But perhaps it is not too fanciful to claim that the arms on the cover reflect a particular interest of Sir Bernard's. He attended University College, Oxford, and appears later to have made some mark as an antiquarian.[17] By 1620 his knowledge of his own family's pedigree seems to have been considerable;[18] in 1620 the Royal Heralds held a Visitation of Devon and Cornwall and, from amongst the hundreds of entries, that of the Grenville family stands out.[19] Although not so elaborately drawn nor as beautifully illuminated as the coats of arms of the cities or of the city companies, the Grenville arms are alone in having a whole folio devoted to them (fig. 4). The pedigree, which is signed by Sir Bernard and which may also have been drawn out by him, covers eighteen generations as opposed to the average six or seven, whilst the arms of most families are but sketchily drawn out or are missing altogether.

Although the Grenville connection adds a note of personal interest to the cover, it is not the only aspect which merits attention. The design of the embroidery contains one uncommon element and may also throw light on the early career of a little-known embroidery designer of the late sixteenth and early seventeenth century. At first sight the design looks little different from many others of the period but, within the interlaced ribbons which enclose the floral sprigs of the border are a series of inscriptions (fig. 5), unparalleled, as far as is known, in any other embroidery of the period. Although the pink silk in which they were worked has faded to a pale beige, almost indistinguishable from the linen ground, a series of twenty-two paired phrases can be made out; each pair surrounding one of the oval compartments and the pairs being alternately in English and in a mixture of French and Latin. Inscriptions as such do appear in other embroideries, the most striking example in the collections of this Museum is that of *The Shepherd Buss*[20] (fig. 6). Others may be found in the embroideries at Hardwick Hall and at Oxburgh Hall, but in these cases the phrases are

3. Long Cushion Cover. English: second half sixteenth century. Linen canvas embroidered with silk in tent stitch. In the centre the arms of Warnford impaling Yates, probably referring to the marriage of John Warnford and Susannah Yates in the mid-sixteenth century. T.120–1932.

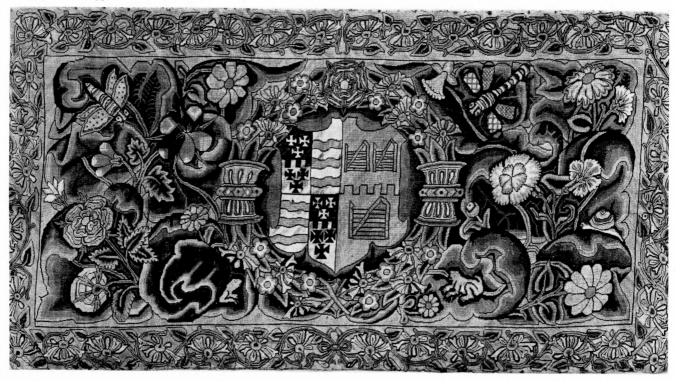

5

4

4. The Grenville Arms from The Visitation of Cornwall, 1620. Harleian Mss. 1164, f. 79. By kind permission of the Trustees of the British Museum.

5. The Grenville Cover. Detail showing two inscriptions: "WISDOOME IS NOT PROFITABLE TO A FOOLE" "SORROWFUL SIGHES IS THE GREIFE OF THE HART". T.262–1968.

6. "The Shepherd Buss". English: late sixteenth century. Linen embroidered with black silk in stem, back and satin stitches with speckling and couched work. The emblems and some of the rebuses are copied from Claude Paradin, *Devises Heroiques*, Lyon, 1557. T.219–1953.

6

heraldic or emblematic in nature and form an integral part of the design; the inscriptions on the Grenville cover are less easy to identify.

Taking first only the English inscriptions, these fall into three groups. Some, such as "REVERENTLY OBAY THY PARENTS" and "THE WICKED & DISOBEDIENT SEKE GONFVSION",[21] clearly have Biblical origins.[22] A second group, for example, "HE WISE AND DESCREET THAT CAN RETYAIN HIS TONG" and "FREINSHIP IS BETTER THAN RICHES"[23] are drawn from the store of common proverbs so widely used in the sixteenth century. From the time of Chaucer such phrases had played an important part in literature and from the fifteenth century they were used increasingly in education.[24] One example of a fifteenth-century English-Latin Grammar, with prose passages

7. A Manuscript Copy-Sheet. English: c.1600. Signed "by me Thomas Carwytham" and showing both the master's and the pupil's work. $12\frac{1}{4}$ in. × $8\frac{1}{2}$ in. L.1482–1943.

based on precepts and proverbs, has survived at Magdalen College, Oxford,[25] and many proverbial collections were published during the sixteenth century.[26] Similar moral maxims and proverbs were also used as "texts" for speeches and for formal letters, and books such as William Fulwood's *The Enimie of Indlenesse teaching the manner and stile howe to endite, compose, and write all sortes of Epistles and letters* (1568) were specially written to assist in such formal compositions.[27] Sir Bernard's own letters can provide examples of the resulting stilted style:

My Hon[ble]

Ladey the Idolitry in the 32 of Exodus in setting up a gooldne Calfe for ye Israelites to worship cannot dehort my minde from y[r] La[d] owr Bryd did singe your affection to us so sweetly at hys returne from yow as it hath armed me to slight all opposition & to signifie unto yow y[t] my desire is so aremouable to make y[r] daughter myne & my sonn yowrs . . . etc.

Yowr faythefull neuey

Bar Grenville.

31 December 1618.[28]

Proverbial collections, grammars or other text books may, therefore, have provided a source for the inscriptions on the cover, but not only can the biblical and proverbial phrases not be exactly paralleled in any surviving book, the non-biblical and non-proverbial phrases, which out-number the former, suggest an alternative source which may perhaps be substantiated by other aspects of the cover's design. Most of the phrases used are single or double-line maxims such as "HE THAT HATH LEST WITT IS MOST POORE – IT IS BETTER WANT RICHES THAN WITT" and "IT IS NOT STRANG TO SEE GREAT MEN TO FALL". These are comparable to the phrases found in writing-masters' copy-books of the sixteenth century onward.[29] The sixteenth century saw the spread of the art of writing, nicely illustrated in the Grenville family by the difference between Mary, wife of Sir Richard Grenville, who could only make her mark at the end of her will of 1623,[30] and Grace Grenville, wife of Sir Bevill, who not only wrote long letters to her husband but dealt with the household accounts and supervised the education of her own children and of those of the neighbouring gentry.[31] Writing masters were considered to be men of some education and the texts, in English, Latin and French, with which they headed their copy-sheets (fig. 7) were intended to develop the moral fibre as well as the manual dexterity of their pupils. The rather pious note of the Grenville cover phrases is echoed in many of the published copy books;

8. The Grenville Cover.
Detail showing the border
sprigs: Pansy, Borage,
Marigold and Pink.
T.262–1968.

9. Details of patterns in
Thomas Trevelyon's *Miscellany*
of 1608. Pansy, Borage,
Marigold, Pink, Grapes.
Now in the Folger Shakespeare
Library, Washington.

10. Page from Thomas Trevelyon's *Miscellany* of 1608 showing stylized sprigs within interlace compartments. Now in the Folger Shakespeare Library, Washington.

for example, in John de Beau Chesne's *A Booke Containing Divers Sortes of Hands* (1571) appears the phrase "It is the part of a yonge man to reuerence his elders." which compares with the Grenville cover phrase "REUERENCE THY ELDERS WITH OBEDIENCE".

Similarly the surplus letters and the mis-spellings which occur on the cover – "WISDOME IS THE TREASURE OF WITI-

EG" also occur in the copy books, where the writing-master was more interested in the perfection of his calligraphy than of his English: "Pride's a fantastic Frenzie, which exiles Good qualities, and temptingly beguiles. gh."[32] Indeed it is not clear whether the many mistakes on the cover ought to be blamed on an illiterate embroideress or on the original writing-master, but the completely garbled French and Latin texts suggest at least the total lack on her part of any acquaintance with foreign languages. The faintly pencilled outlines of the letters have been misread with the result that "Belles paroles n'écorchent pas la langue"[33] has become "BEUES PAROLLES NES CORCHENT PAS LA LANGUE" and "Pres de l'église: Loin de Dieu" has, in the words of Peter Quince, been "translated" into "PRES DE LE GLISE LOIN DE DLEU". Several other phrases have been mangled beyond interpretation.

Surviving printed copy books, however, provide no exact source for the embroidered phrases and, given the conditions under which the cover was probably worked, a manuscript source is more likely. At the end of the sixteenth century manuscript copy books were as common as printed ones[34] and the Grenville household, with its large numbers of children,[35] isolated in Cornwall and headed by a man of known scholarly interests,[36] would in all probability have employed a writing-master, together with other tutors. The writing-master with whom it would be pleasant to link the Grenvilles is one Thomas Trevelyon who, in 1608 and 1616, produced two large *Miscellanies* containing sections not only on alphabets, copy-texts, history and mythology but also on designs for a variety of purposes, including embroidery.[37] Unhappily it has so far proved impossible to find any evidence linking Trevelyon with the Grenvilles, excepting his Cornish name and the evidence contained in the cover and in his manuscripts themselves.[38] That a writing-master should also design embroideries is not unlikely,[39] and the Elizabethan embroiderers were accustomed to taking their designs from a variety of sources – wall-papers, book-bindings, engravings etc. – and the illuminated letters and elaborate borders with which copy books were often decorated contained many elements suitable for embroidery patterns. One elaborately-drawn letter "C" on a manuscript in the British Museum[40] has in fact been pricked, possibly for this very purpose.

Although at first sight the distinctive sprigs of pink, marigold, borage and pansy (fig. 8), which make up the border of the cover, appear to be based on the wood-

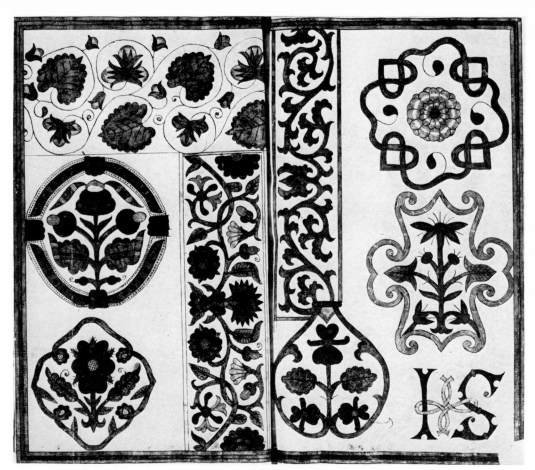

11. Pages from Thomas
Trevelyon's *Miscellany* of
1616 showing further
examples of sprigs and
interlace. By kind
permission of Mr. Boies
Penrose.

12. Pages from Thomas
Trevelyon's *Miscellany* of
1616 showing part of one
of the ten decorative
alphabets, with copy texts.
By kind permission of
Mr. Boies Penrose.

13. Page from Thomas Trevelyon's *Miscellany* of 1616 showing a pattern of grapes and leaves comparable to that in the centre of the Grenville cover. By kind permission of Mr. Boies Penrose.

cut illustrations of an early herbal (one of the major sources of embroidery patterns[11]), closer examination does not bear this out. The strange trefoil roots, the stiff stems, the heavy outlines and the almost cross-section view of the pink cannot be matched in any herbal but the same characteristics do appear in the Trevelyon designs (fig. 9, 10). Two other features of the embroidery also figure in Trevelyon; these are the heavy interlace of the border ribbons (plate 1 and figs. 10 and 11) and the spidery riot of flowers, grapes and leaves in the centre (figs. 1, 13), a combination of disorder and formality which had initially suggested two different sources for the design.

None of the embroidery's phrases appear in the Trevelyon manuscripts, although his biblical texts and moral precepts are similar in tone (fig. 12), and it must also be admitted that a few designs, identical to some of Trevelyon's, do appear in the manuscript of a contemporary writing master.[42] In 1608 Joseph Lawson wrote *The Pens Excellency*, a folio volume devoted largely to the arts of calligraphy and of heraldry but also containing a small section of designs, some of which reappear in Trevelyon's *Miscellany* of 1616. The designs concerned do not include any of those relating to the Grenville cover and Joseph Lawson, a loyal man of Norfolk,[43] is unlikely to have had any contact with the Grenville family, but whether Trevelyon took more of his material from other unknown designers[44] or whether the apparent link with the Grenville embroidery is mere coincidence cannot as yet be established.

Notes

1. Richard Carew, *The Svrvey of the Covnty of Cornwall*, 1602, p. 119.

2. Roger Granville, *History of the Granville Family*, Exeter, 1895.

3. St. D. Kemeys-Tynte, *Some Original Letters of Sir Bevill Grenville*, Exeter, 1893. A further nine letters are in the John Forster Collection (Catalogue Number 234), now in the Victoria and Albert Museum.

4. Duke of Buckingham and Chandos, *Sale of the Contents of Stowe House*, Buckingham, 1848. (Priced and annotated by H. R. Forster). Lot 181. "Portrait of Sir Bernard Grenville – (Zucchero)."
The Grenville cover was probably sold at this sale, although it cannot be identified from the catalogue. The donor's father, Mr. Henry Lucas, is known to have acquired the cover at a country sale later in the nineteenth century.
The Rt. Hon. The Baroness Kinloss, *Sale of the Ducal Mansion of Stowe; the contents of the Mansion, etc.*, Buckingham, 1921. Lot 2402. "100 letters, 1582–1597." Lot 2431A, "Indentures, etc. 1583 etc." Lot 2458, Household Book of Stowe, 1576".

5. Sir Walter Raleigh, *Report of the Truth of the Fight about the Iles of the Açores, this last summer betwixt the "Revenge" and an Armada of the King of Spaine*, 1591. Alfred, Lord Tennyson, *The Revenge*, 1830.

6. The purpose of the cover is not clear. It measurements, 25 in. × 35 in., do not conform to the surprisingly uniform measurements of Elizabethan cushion covers and pillow beres. The Grenville cover is wider than the normal cushion cover width (22 in.) and from the edges, which are decorated with blanket stitch, it is clear that the cover was never backed or joined in any way. It can only be assumed that it was a purely decorative cover for a small table, cupboard top or wide window ledge.

7. *Party per pale* (for a marriage).
Dexter (for the husband): *Per pale tierce.*
 1st. *Gu: 3 rests or et sable*
 (for GRENVILLE of Stow, Cornwall).
 2nd. *Gu: a chevron engrailed ermine, between three sabres argents* (the latter a mistake for *three paws ermine*, for WORTHAM of Lifton, Devon).
 3rd. *Argent: or a bend azure three bezants or* (for WHITLEIGH, Bideford, Devon).
Sinister (for the wife): *quarterly.*
 1st and 4th. *Argent: a bull passant gules*
 (for BEVILL of Brinn and Withiel, Cornwall).
 2nd. *Or, three bars gules with a martlet for difference* (for BOHUN, Devon, a 4th son).
 3rd. *Argent: a bear rampant sable* (a mistake for *a bear saliant sable* for BEARE of Killigarth and Bryn, Cornwall).

8. For a full description of Sir Richard Grenville and of the position held by the family in the County see A. L. Rowse, *Sir Richard Grenville*, 1937.

9. From a collection of verses by various authors, published in his honour by Oxford University, 1643. Another elegy, from the same collection, by Martin Llewellin ends with the couplet –
"Where shall ye next fam'd Granville's ashes stand?
Thy Grandsyre fills the seas and thou ye land."
Quoted in *The Parochial History of Cornwall*, II, Truro and London, 1868, p. 367.

10. A. L. Rowse, *op. cit.*, p. 337.

11. *Ibid.* and *Chancery Series*, II, vol. 233, no.119 and vol. 237, no. 138.

12. Richard Carew, *op. cit.*, p. 64.

13. C. L. Kingsford, "Essex House, formerly Leicester House and Exeter Inn. Appendix: Inventory for Probate of the Goods of Robert, Earl of Leicester, 1588". *Archaeologia* LXXIII, 1923, p. 28–54.

14. E. P. Shirley, "An Inventory of the Effects of Henry Howard, K.G.; Earl of Northampton taken in 1614". *Archaeologia*, XLII, 1869, pp. 347–78.

15. *Ibid.*

16. *Ibid.*

17. Roger Granville, *op. cit.*, p. 127.

18. It was possibly at the instigation of Sir Bernard that the Parish Records of Kilkhampton, in which the baptisms, marriages and burials of many of the Grenville family were recorded, were "newelle engrossed and written out of the olde Register Book accordingle as there it is registered from the yere of our Lord God 1539 unto this present yere, 1598." Rev. R. Dew, *A History of the Parish and Church of Kilkhampton*, 1926, p. 19.

19. British Museum, *Harleian Mss.* 1164, ff. 79, 80.

20. For a detailed description of the inscriptions on this coverlet see J. L. Nevinson, "English Domestic Embroidery Patterns of the sixteenth and seventeenth centuries." *The Walpole Society*, XXVIII, 1940, pp. 6–8.
G. Wingfield Digby, *Elizabethan Embroidery*, 1963, p. 105.

21. The spelling, in all cases, is as on the original.

22. *The Bible*, "Book of Proverbs." Chapters 4 and 6.

23. Morris Palmer Tilley, *A Dictionary of the Proverbs in England in the sixteenth and seventeenth centuries*, University of Michigan, 1950. Tilley cites the general version as "He is wise that can hold his tong" and quotes "Where friendes be, there be goodes, By thys is meant that friendes be better than money". from Richard Tavener, *Proverbes or Adagies Gathered out . . . of Erasmus*, 1596.

24. For a full discussion of the use of proverbs in sixteenth- and seventeenth-century England see Rudolph E. Habenicht, *John Heywood's "A Dialogue of Proverbs, 1561"*, University of California Press, Berkeley and Los Angeles, 1963.

25. William Nelson, *A fifteenth Century School Book*, Oxford, 1956. (French and Italian Grammars also relied on proverbs for their texts).

26. The first book printed on Caxton's press was Anthony Wydewille, Earl River's translation of Guilleaume de Trignonville's *Les ditz moraulx des philosophes* (1400), and Erasmus's famous collection of proverbs, *Adagiorum Chiliades*, was reprinted several times both in the original Latin and in English, after the first translation by Richard Tavener in 1539.

27. Jean Robertson, *The Art of Letter Writing. An essay on the handbooks published in England during the sixteenth and seventeenth centuries.* University Press of Liverpool, 1942.

28. From a letter to Lady Grace Smith, Bernard Grenville's aunt and the future mother-in-law of his son, Bevill. Roger Granville, *op. cit.*, p. 145. This letter almost merits the rebuke of Sir Thomas Wilson that "The misticall wise menne and Poeticall clerkes, will speake nothyng but quaint prouerbes, and blynd allegories, delityng muche in their awne darkness, especially, when none can tell what thei dooe saie." (1553). Quoted in Rudolph E. Habenicht, *op. cit.*, p. 24, note 47.

29. I am indebted to my colleague, Miss J. I. Whalley, for her advice on copy books.

30. A. L. Rowse, *op. cit.*, p. 338.

31. St. D. Kemeys-Tynte, *op. cit.*, Letter VII, 8 March, 1641, from Sir Bevill to his wife, Grace, ". . . I will bring Hatts for the boyes, and am glad you say they learne well . . ."

32. Edward Cocker, *Multum in Parvo or The Pen's Gallantrie. A Copy-Book. . .* , 1660. His final page reads:
 "Jealously aiming at God's Glory, and the
 Advancement and Perfection of this incomparable Science I have finished this
 Monument of my Industrie with wch I
 present ye World. Aabcdefghijklmnopqr."

33. One of the many French proverbs quoted in John Ray. *A Collection of English Proverb; . . . with short annotations whereto are added local proverbs, . . . old proverbial rythmes, etc . . ."* 1670.

34. The first copy-book printed in England was the 1570 edition of John de Beau Chesne's, *A Book containing Divers sortes of Hands.*

35. Sir Bernard and Elizabeth Grenville had seven children and there were at least the same number of cousins living in the immediate vicinity of Stow.

36. The books and pamphlets of William Easte, Rector of Bideford, are dedicated "To the Right Worshipfull S. Bernard Graynuile, Knight, my singular Patron". Roger Granville, *op. cit.*, p. 132.

37. For a full discussion of Thomas Trevelyon: the few known details of his life and his probable career as a copy- or writing-master – see J. L. Nevinson, "The Embroidery Patterns of Thomas Trevelyon", *The Walpole Society*, XLI, 1966–8, pp. 1–38, plus 36 plates.

38. Both manuscripts are now in America; the 1608 copy is in The Folger Shakespeare Library, Washington, and the 1616 copy is in the Collection of Mr. Boies Penrose.
 I am extremely grateful to Mr. J. L. Nevinson for making available to me his microfilm copies of these manuscripts and also for allowing me access to his notes on Thomas Trevelyon.

39. It is said that Bess of Hardwick had the designs for her embroideries sketched out for her by craftsmen working on her new house, and an eighteenth-century schoolmaster, continuing perhaps a traditional side-line of the writing-master, drew embroidery patterns for the daughters of a local gentleman: *Sussex Archaeological Collections*, IX, 1857, pp. 182ff.

40. British Museum, *Additional Mss*, 4384, f.1.

41. For a detailed discussion of sixteenth- and seventeenth-century embroidery designs see J. L. Nevinson, "English Domestic Embroidery Patterns of the sixteenth and seventeenth Centuries". *op. cit.*
 G. Wingfield Digby, *op. cit.*, pp. 51–2.

42. British Museum, *Additional Mss*. 36991.

43. The first page of his manuscript is inscribed: "Pennarum Nitor or The Pens Excellency. Norfolk & C. Arms by Joseph Lawson, 1608". Not only are the great majority of the arms shown those of Norfolk gentry but Lawson uses Norfolk armorial mottoes for several of his copy phrases.

44. An account of another late sixteenth- to early seventeenth-century scrivener who also produced "A Booke of divers devices and sortes of pictures with the alphabete of letters devised and drawn with the pen . . . Devised and made by T. F." (Thomas Fella) is given by J. L. Nevinson in "Lively drawings of a Suffolk Scrivener", *Country Life Annual*, 1964, pp. 156–8.

Simon Jervis

Antler and Horn Furniture

THE acquisition by the Museum in 1969 of a suite of furniture (W.1–4–1970) formed of antlers and horns provides an opportunity for a brief account of the use of this bizarre material in interior decoration and furniture (figs. 1–2).

The earliest instance of its use which I have been able to trace is a gothic *Kronleuchter* or circular candelabrum now in the Städtisches Museum at Erfurt, though formerly in the Rathaus.[1] Dated to about 1400,[2] it has a circular iron candle support which joins up the branches of a pair of antlers; the bases of the two branches are joined by a female head of carved and polychrome wood. This, and a similarly arranged example in the Cathedral at Erfurt,[3] which incorporates a carving of the Coronation of the Virgin, appear to represent an early stage in the development of the so-called *Leuchterweibchen*, a candelabrum which usually took the form of a female torso, often with a

mermaid-like tail, to whose base or shoulders were affixed a pair of antlers, the latter arrangement giving the impression of wings. Sometimes, as in an example shown in the masterpiece of the Master MZ, "The Embrace"[4], dated 1503, and in another dated 1502 incorporating a Virgin and Child, in the Bayerisches Nationalmuseum,[5] the ends of the antlers were joined by an iron candle support which thus formed a circle similar to the *Kronleuchter*; more normally, however, the *Leuchterweibchen* was suspended directly from the antlers, which were not joined up.

A woman of secular aspect in the fashionable clothes of the day was the most common Renaissance *Weibchen*;[6] gothic examples were usually of a sacred character such as the Coronation of the Virgin and the Virgin and Child already mentioned. In 1513 Dürer designed one incorporating a mermaid for his friend Pirckheimer and in about 1520 another, in the form of a dragon, which

1. Armchair from a suite of furniture composed of antlers, recently acquired by the Museum. Probably made in about 1862 and attributed to the firm of Rampendahl of Hamburg.

2. Mirror from the same suite as the armchair in Fig. 1. The suite also includes another armchair, and a sofa not illustrated.

was executed by Veit Stoss for Anton Tucher (1458–1524), who, in 1522, gave it to the "Regimentstube", the *Schatzkammer* of the Rathaus in Nuremberg (see fig. 14).[7] Other variations included Cupid with a bow,[8] a wild man,[9] a double portrait of the Emperors Maximilian I and Charles V, carved by Jörg Lederer in about 1516 to 1519,[10] and a superb figure of Lucretia stabbing herself, in the Rathaus at Sterzing, which uses ibex horns rather than antlers.[11] Antlers were also used in a very fine late gothic *Kronleuchter*, one of a series in the Rathaus at Lüneburg, where they form part of a mandorla surrounding a figure of Saint Ursula.[12] They are similarly arranged in a wall-light with a figure of Christ in the Museum für Kunst und Gewerbe in Cologne.[13] Other variations on the *Kronleuchter* decorated with antlers or horns include one which is composed of a number of angelic *Leuchterweibchen* placed back-to-back,[14] one with a stag's head and antlers,[15] and

3. Illustration by Hans Burgkmair to Emperor Maximilian I's *Weisskunig*, showing the education of the young King, and including, top left, a *Leuchterweibchen*.

another formed as a bull's head with its horns.[16] A splendid illustration of a typical early sixteenth-century *Leuchterweibchen* in a contemporary interior is provided by one of Hans Burgkmair's illustrations (fig. 3) to the Emperor Maximilian I's "Weisskunig", a fictionalized autobiography first published in 1755.[17] Antlers, if some examples sketched by Professor Heideloff in about 1852[18] are authentic, were also used to decorate chairs and cupboards in the late gothic period. Their earliest use in wall decoration, however, appears to be in a room decorated in about 1520 to 1530 with a fresco of the Hapsburg family tree in Schloss Tratzberg in the Tyrol, which incorporates naturalistically modelled stags' heads supporting antlers at dado level, beneath which their bodies are frescoed two-dimensionally on the wall.[19] A striking use of antlers in a chimney-piece occurs in the Château de Filain in Haute-Savoie, where they surmount a life-size deer, which appears to leap out of a bas-relief landscape, pursued by the pack; it dates from the mid-sixteenth century.[20] A drawing by J. C. Buckler, dated 1823, shows the Hall of Evercreech Park, Somerset, with life-size plaster deer with apparently real antlers above the panelling; it appears to date from about 1600.[21] Life-size deer were again a feature of three Hohenlohe castles, Schloss Neuenstein, Schloss Weikersheim and Schloss Hermersberg, where superb stucco schemes incorporating antlers and horns were executed in 1599, 1601 and after 1603 respectively, by Gerhardt Schmidt of Rotenburg in Brunswick and Christoph Limmerich of Neuenstein.[22] In the case of Weikersheim, the plaster decoration in the magnificent Rittersaal also includes an elephant with genuine ivory tusks; a lion, on the other hand, is endowed with a distinctly man-made crown! Antlers mounted on a naturalistic deer's head cannot usually be considered anything more than a hunting trophy; however, a pair of late sixteenth-century examples in the Bergische Museum, in Schloss Burg an der Wupper, are decorative creations in their own right; one has a figure of Bacchus astride the neck of the deer, which holds a bottle in its mouth.[23] The description of "une teste de cerf, avec ramure, estant au milieu du manteau de la chemynee, a ung crucifix en chief", found in Marguerite d'Autriche's library in 1524, suggests that this was a tribute to St. Hubert rather than a purely decorative feature.[24]

The Cavendish stags in the Great Hall and Withdrawing Chamber overmantels at Hardwick are a late sixteenth-century English instance of the use of antlers

Aspectus triplex scenographicus Cervi picti in Vdo à Ioanne Holzer, ad Angulum Diversorii, dicti Bauerntanz.

Sistе gradum et Pictoris Opus mirarе Viator,
Quo tua se vertunt lumina, Cervus adest:
Ac unus tantum; Caput unum: falsa sed, artem
Natura, hic Palmam praeripuisse sibi.

Du siehest einen Hirsch, wo es dein Aug begehrt:
Drey sinds und aber doch nur einer mit Geweihen.
Hier triumphiert die Kunst; ists dan nicht unerhört,
Daß sich drey Hirsche hier den Kopf einander leihen?

I. E. Nilson sculps. et excud. Aug V.

4. An engraving by Johann Esaias Nilson (1721–88) showing a fresco by Johann Evangelist Holzer (1709–40), incorporating antlers, on the exterior of the Gasthof "Zum Bauerntanz", Stadt Augsburg, Kunstsammlungen.

in an interior; they were the work of Abraham Smith.[25] However, they probably reflect the needs of heraldry rather than a new taste for antlers in interior decoration; it is noticeable that the plasterwork in the Great Chamber, although it contains deer, does not incorporate real antlers. Another sixteenth-century, though later, example of the use of antlers in architecture occurs in the fantastic plates of Wendel Dietterlin's *Architectura*; they occur not only in the naturalistically sculpted stags at bay, of which he seems to have been so fond,[26] but also in a pilaster, in a pediment, and in a frame for an escutcheon.[27] A pair of antlers were at one point affixed to the cornice of the late sixteenth-century Great Bed of Ware and a ceremony known as "Swearing on the Horns" observed; one suspects, however, that this relates to the iconography of cuckoldry, rather than to decorative usage.[28] In 1623 antlers were used in the "Hornstube" in the Veste in Coburg, issuing from carved decoration above its doors; this room had a hunting theme throughout its decoration.[29] Somewhat

later in the seventeenth century, in 1665, an Italian stuccator, Giovanni Domenico Rossi, incorporated antlers in an elaborate plaster ceiling in Schloss Crottorf, in the Westerwald.[30] Although not strictly interior decoration, antlers crop up as a feature of a fountain at Rozendael, illustrated in a late seventeenth-century Dutch work by Peter Schenck dedicated to the Duke of Albemarle.[31]

Throughout the eighteenth century the use of horns or antlers in furniture or interior decoration seems to have been, surprisingly, in abeyance. An amusing case of antlers in an exterior is recorded in one of a suite of prints by the Augsburg decorative artist, Johann Esaias Nilson (1721–88), after frescoes by Johann Evangelist Holzer (1709–40); it shows a naturalistically modelled stag's head with antlers, having three bodies, one a frontal view, and the others depicting each side in contrasting positions (fig. 4); Holzer's fresco was on the corner of the Gasthof "Zum Bauerntanz", and he is said to have been advised in this conceit by the animal painter, J. E. Ridinger.[32] Depicted in a mid-eighteenth-century painting in Schloss Kranichstein is a living conceit even more fantastic – a team of heavily antlered deer drawing a carriage containing the Crown Prince

5. Section of a plate of 1787 from Le Rouge's *Jardins Anglo-Chinois* showing the deer park at Steinfort; it includes a chair of Chinese character incorporating antlers.

of Hesse-Darmstadt.[33] The only eighteenth-century example of furniture that I have been able to find is a curious chair of Chinese character with antlers affixed to its back rail, illustrated in 1787 in a plate of the deer park at Steinfort in Le Rouge's *Jardins Anglo-Chinois* (fig. 5).[34] Around 1800, however, they were used to decorate a temple of Diana and the roof of a feeding-trough for park animals, among other similar examples, illustrated in Grohmann and Baumgärtner's *Ideen-magazin für Liebhaber von Gärten, Englischen Anlagen und für Besitzer von Landgütern*, which was published in Leipzig.[35] Like Le Rouge's great work, this journal opens up an enchanted world where Turkish interiors adjoin Tahitian pavilions, and Chinese dovecotes are illustrated alongside Egyptian monuments, doubling as benches and open-air bookcases, Russian cottages, and gothic ninepin alleys, all set within the English gardens of villas in the English style.[36]

In addition it illustrates examples of a taste for rural furniture made of roots and untrimmed branches, which also seems to have originated in England.[37] Particularly grotesque designs for tables and chairs of this type were published by Edwards and Darly, in their *A New Book of Chinese Designs . . .*, of 1754 (fig. 6).[38] Although not, as the preface claims, "Entirely new, and . . . the only ones that ever were published", a number of designs for "Rural Chairs for Summer Houses", and "Rural Garden Seats", given by Robert Manwaring in his *Cabinet and Chair-maker's Real Friend and Companion* of 1765, represent a considerable advance in neatness and practicability on their prototypes in Edwards' and Darly's work.[39] However, the culmination of this genre in England is an anonymous and undated late eighteenth-century pattern book entitled *Ideas for Rustic Furniture proper for Garden Seats, Summer Houses, Hermitages,*

6. A chair from Edwards and Darly's *New Book of Chinese Designs* of 1754 which uses roots to create a shambling appearance.

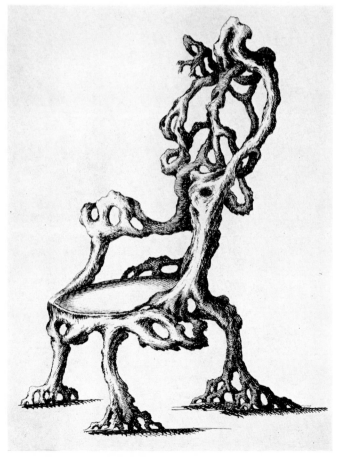

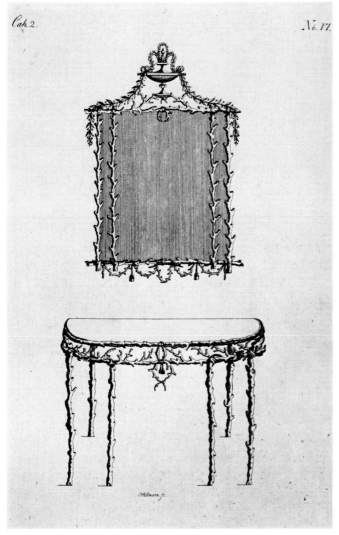

Cah. 2. No. 11.

7. A table and mirror from the late eighteenth-century pattern book, *Ideas for Rustic Furniture*, which was reprinted in Grohmann and Baumgärtner's *Ideenmagazin*.

Cottages, &c., published in London for J. Taylor's Architectural Library (fig. 7).[40] This consists of twenty-five plates and a frontispiece, all showing furniture formed of a regular and tamed network of twigs, which seems a far cry from Edwards' and Darly's uncouth and shambling creations (fig. 6): a set of chairs in the Museum (W.61–66–1952) are probably based on its designs (fig. 8). It perhaps owes something to William Wright's *Grotesque Architecture, or, Rural Amusement* of 1767, which has a plate of a "Hermetic Retreat" of similarly regular twigginess.[41] However, an earlier and closer source is Charles Over's *Ornamental Architecture* of 1758,

which, as well as a lurching "Chinese Arch" in the Darly manner, illustrates "An Hermitage", and "A Banqueting Room", both of which combine neatness with twigginess.[42] Rustic furniture of branches and twigs was later executed in cast-iron; A French iron-founder's catalogue of about 1850, for example, contains a number of garden benches formed of untrimmed naturalistic branches.[43] The Coalbrookdale Company's well-known "Fern" and "Lily of the Valley" cast-iron seat furniture, on the other hand, would seem to be the products of a specifically Victorian taste for plant ornament, although a mid-eighteenth century walnut chair with back, etc., formed as bulrushes, in the Museum (W.46–1952), is somewhat similar in feeling.

8. One of a set of chairs in the Museum whose design is probably derived from the late eighteenth-century pattern book, *Ideas for Rustic Furniture*. See fig. 7.

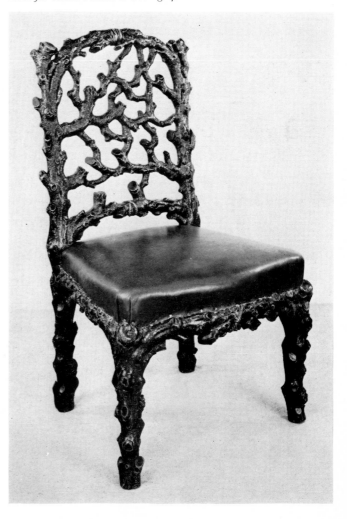

After the publication of *Ideas for Rustic Furniture* a number of its plates were borrowed by the German *Ideenmagazin* mentioned above (for example fig. 7).[44] It seems likely that antler furniture was the hybrid offspring of this taste for rustic furniture imported from England, the revived gothic tradition of using antlers in candelabra, and their sixteenth- and seventeenth-century use in plasterwork. As a result of the nineteenth-century cult of the stag, whose most celebrated exponent was Sir Edwin Landseer, the numerous progeny of this triple parentage were widely popular. In the 1851 Exhibition the stag and/or its antlers crop up, to mention a few examples, on a bracket shown by the Gutta Percha Company, a cast-iron vase made by the Coalbrookdale Company, on a panel carved in wood and "carton-pierre" by M. Cruchet of Paris, and, in profusion, on the Balmoral table-cloth, by Messrs. Hunt & Sons of Dunfermline.[45] The base of a tea-poy by Messrs. A. J. Jones, of Dublin, "exhibits the chase of the giant deer by wolf-dogs";[46] it was part of a large

9. A statuette of Queen Victoria, under a canopy of giant deer antlers, from the top of an "Omnium", or *étagère*, shown by Messrs. A. J. Jones of Dublin at the 1851 Exhibition.

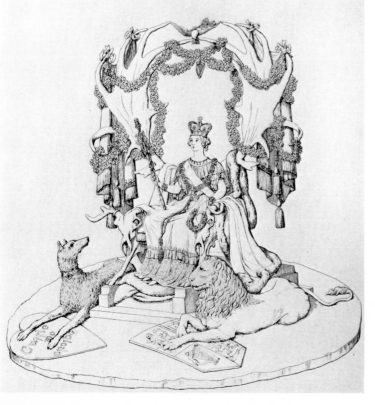

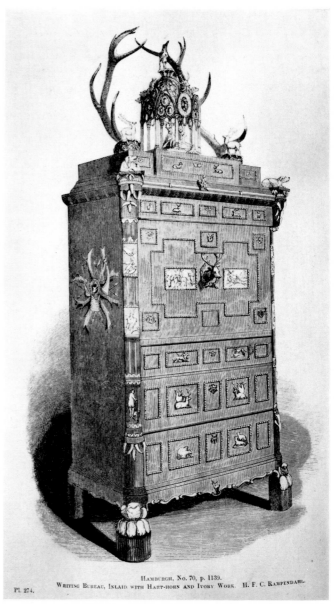

HAMBURGH, No. 70, p. 1139.
Pl. 274. WRITING BUREAU, INLAID WITH HART-HORN AND IVORY WORK. H. F. C. RAMPENDAHL.

10. A writing-bureau using antlers and horns as decoration shown by the firm of Rampendahl of Hamburg at the 1851 Exhibition.

suite executed from Irish bog-yew, which also included "a lady's work-table supported by the crest and antlers of the Irish giant deer",[47] and, as an ornament on top of an "Omnium" or *étagère*, a statuette of the youthful Queen Victoria, enthroned on a seat with deer legs, and arms decorated with skulls of the giant deer (fig. 9); she sits under a canopy of giant deer antlers, which are curiously reminiscent of those surrounding St. Ursula in the medieval candelabrum mentioned above.[48]

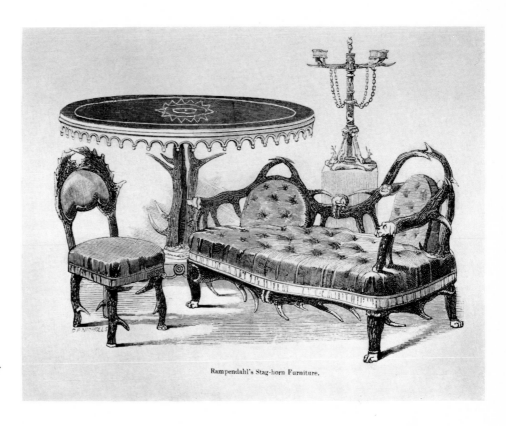

Rampendahl's Stag-horn Furniture.

11. Furniture shown by the firm of
Rampendahl of Hamburg at the
1851 Exhibition.

As well as stags and antlers executed in a variety of other materials, the 1851 Exhibition also contained the real thing, in the form of a "Looking-glass with stag-horn frame", and "Various specimens of stag-horn furniture" shown by H. F. C. Rampendahl of Hamburg, and illustrated in the Official Catalogue;[49] the "Various specimens" comprised a writing-bureau, candelabra, chairs, a sofa, and a table (figs. 10–11). They represent an uneasy compromise between the jagged outlines of the natural material, and the plump rotundity favoured by commercial mid-nineteenth-century furniture manufacturers. A large suite in the Horn Room at Osborne House is so close to the Rampendahl examples in the exhibition that it must be attributed to this firm and dated to about 1851 (fig. 12).[50] The presence in the gardens of Osborne of a garden-seat made of coal is a reminder that the Victorian fascination with unlikely and intractable materials should be added to the cult of the stag as a reason for the nineteenth-century popularity of antler furniture.[51]
At the London 1862 Exhibition, Rampendahl showed more antler furniture, on this occasion, it would appear, handling the material with greater ease and producing

less awkward results than in 1851;[52] the sofa and chairs were upholstered in green plush, while the table had a marble top (fig. 13). Frankfurt-am-Main was said to be the centre of the trade in this type of furniture and the most famous instance of its use the Platte, the hunting lodge of the Dukes of Nassau near Wiesbaden, which was built from 1822 to 1824, but unfortunately destroyed during the Second World War.[53] Another example of its use is a hunting-box in Czechoslovakia, Ohrada near Hluboka, which contains chairs, a table covered with deer-skin, and a large deer-skin carpet; and there are further examples in the Palace of Mafra in Portugal.[54] The examples at Ohrada are said to have been made by Martin Klenovic, a forester in the service of Prince Schwarzenberg, who was wounded by a poacher and employed his retirement from 1849 to 1885 in their manufacture.[55] Rampendahl's furniture was said to have met with "the unanimous approval of the British, Scottish, and Irish nobility and gentry".[56] Evidence that the venatorial character of such furniture indeed won approval in Ireland is provided by the Museum's purchase from a private collection in that country of a suite consisting of a mirror, two armchairs

and a sofa, covered, like Rampendahl's 1862 furniture, in green plush (see figs. 1–2). Their credibility as trophies of the chase, however, is somewhat reduced by the knowledge that the antlers of which they are formed come from such widely separated areas as America and South-East Asia.[57] But they are at least functional (and in fact surprisingly comfortable), which is more than

12. The Horn Room at Osborne, showing furniture similar to that exhibited by the firm of Rampendahl of Hamburg at the 1851 Exhibition. See figs. 10 and 11. By courtesy of the Department of the Environment.

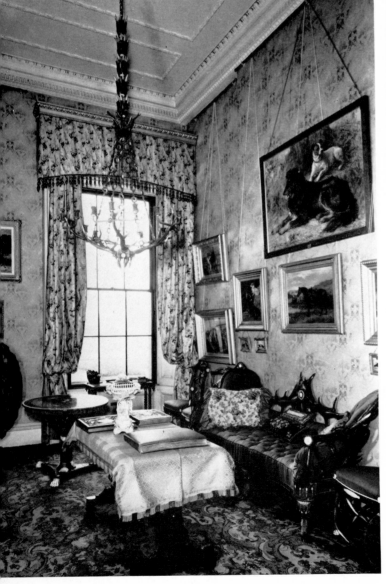

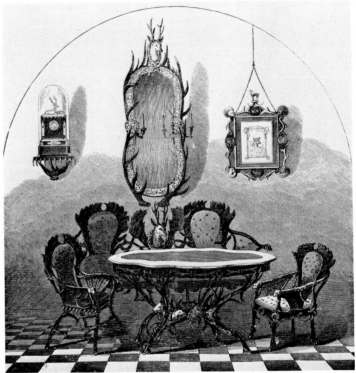

13. Furniture shown by the firm of Rampendahl of Hamburg at the 1862 London Exhibition.

can be said for a chandelier shaped like a gigantic thistle, which it took M. Edouard Grawert of Berlin, "artiste et peintre de la cour", twelve years to complete; it was made of antlers, horns, teeth, and hooves, and was exhibited at the 1867 Paris Exhibition by W. Jaehnert of Berlin.[58] Even more bizarre was a stuffed bear "arranged as a Dumb Waiter", shown by Ward & Co., the Naturalists, at the 1876 Philadelphia Exhibition.[59]

In 1877, Messrs. Jetley of North Audley Street, London, showed furniture made principally of the horns of the sambre deer and the Indian antelope, including a suite made for an Indian nabob, which was wrongly described at the time as a "Novelty in Furniture".[60] Three years later the *Art Journal*, remembering that "Many visitors to the Vienna and Paris Exhibitions were struck with the application made by the Austrians of Stag and Buck Horn to ornamental and other uses", announced that "This application of Nature to Art has been with success introduced by Messrs. Silber and Fleming, of London". A "Swing Lamp fitted with Miratus Duplex lamp" and a "Gun Rack" were illustrated.[61]

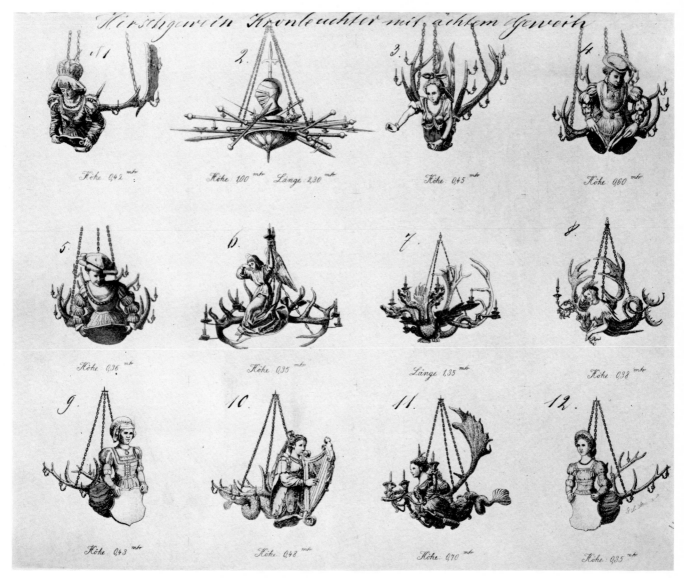

14. A catalogue of about 1884 of reproduction *Leuchterweibchen* made by C. W. Fleischmann of Nuremberg; numbers 7 and 8 are copies of the dragon and mermaid examples designed by Dürer.

While horn or antler furniture remained a comparatively specialized genre, the revival of the *Leuchterweibchen* was a more general success and most German magazines and works on interior decoration published at the end of the nineteenth century illustrate examples; even now they are a common feature in German bars and restaurants with pretensions to historical associations and/or decoration. Nineteenth-century examples fall into three fairly distinct classes; firstly there were direct copies of fifteenth- and sixteenth-century originals; in

about 1884, for example, C. W. Fleischmann, a manufacturer who specialized mainly in reproductions of German tiled stoves, published an engraving of his papier-mâché reproductions of *Leuchterweibchen*, including the mermaid and dragon examples originally designed by Dürer (fig. 14).[62] An archaeological copy of this type crops up as late as 1898 in a design for a gothic room designed by an architect named S. A. Bürkel.[63] A dependent but distinct group is formed by *Leuchterweibchen* inspired by fifteenth- and sixteenth-

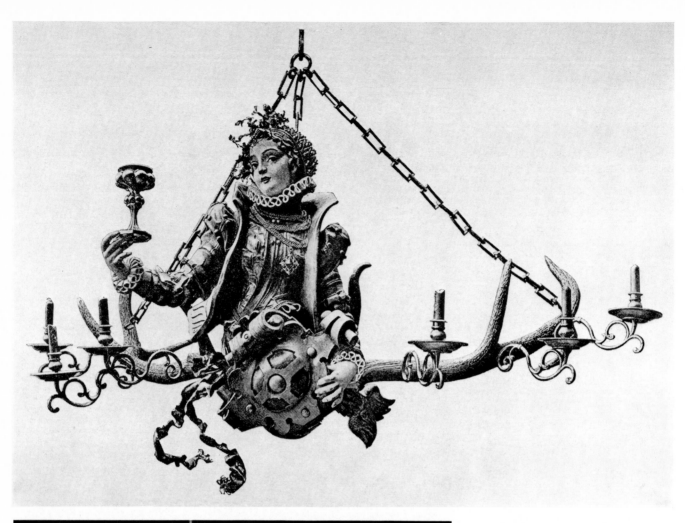

15. A *Leuchterweibchen* of 1886 by the sculptor Herterich of Munich.

16. A *Leuchterweibchen* of 1882 designed by Professor A. Halbreiter, and executed by the sculptor Herterich of Munich.

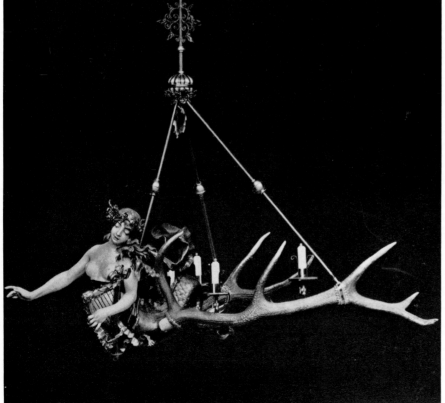

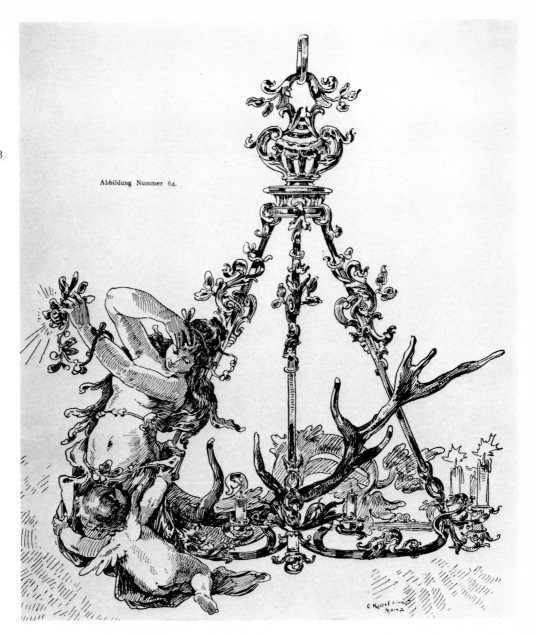

17. A *Leuchterweibchen* of 1898 executed by F. Paul Krüger of Berlin.

Abbildung Nummer 64.

century examples but with a distinctly late nineteenth-century cast; examples are a *Leuchterweibchen* in sixteenth-century costume holding a cup, by the sculptor Herterich of Munich (fig. 15),[64] and a similar specimen, without the cup, which was in 1885 among the studio paraphernalia of the Philadelphia-born New York decorative painter, W. H. Lippincott (1849–1920), who had purchased it in Nuremberg.[65] The third class, which borders on this latter group, is formed by *Leuchterweibchen* predominantly nineteenth-century in design and feeling; typical of these is the baroque lady who breasts the scented atmosphere of the painter Hans Makart's studio in Vienna in Rudolf von Alt's view of this room in 1885.[66] An even more attractive piece was designed by Professor A. Halbreiter and executed by Herterich, the Munich sculptor already mentioned, in 1882 (fig. 16),[67] and a culmination of

this type is an example of 1898, executed by F. Paul Krüger of Berlin, in which the "Weibchen" is held up by a vigorously flying putto (fig. 17).[68] These late nineteenth-century *Leuchterweibchen* were usually fitted for gas or electricity; this is also true of a number of circular *Kronleuchter* also produced at this period and illustrated in the magazines.[69]

As a postscript to this account it seems worth mentioning that recently a small vogue for horned and antlered furniture seems to have set in, possibly influenced by the display of the Museum's pieces in the Recent Acquisitions Court;[70] while some of the pieces sold to cater for this vogue are clearly nineteenth-century, others would appear to be of recent manufacture. If this is so, it would seem that, whatever its aesthetic merits, this curiosity on the fringe of decorative art history is endowed with surprising vitality.

Notes

1. Illus. *Katalog des Städtischen Museums zu Erfurt, Mittelalterliche Sammlung*, Gemäldegalerie, Erfurt 1924, pl. 2 (see also p. 13), and Dr. Alfred Overmann, *Die Älteren Kunstdenkmäler . . . der Stadt Erfurt*, Erfurt 1911, pp. 395–6.

2. Overmann, *loc. cit.* The *Katalog, loc. cit.*, dates it to about 1370 on the basis of its resemblance to a tomb in the Barfüsserkirche (illus. Overmann, p. 35).

3. Described by Overmann, *op. cit.*, p. 396.

4. Illus. Max Lehrs, "The Master MZ", *The Print Collector's Quarterly*, XVI, 1929, p. 235.
 An earlier illustration of a *Leuchterweibchen* occurs in an illuminated MS by Willem Vrelant of about 1460. See Eberhard Lutze, *Die Bilderhandschriften der Universitätsbibliothek Erlangen*, Erlangen, 1936, p. 239.

5. Illus. Theodor Müller, *Die Bildwerke in Holz, Ton und Stein*, Bayerisches Nationalmuseum, Munich, 1959, p. 122, pl. 109.

6. See Müller, *op. cit.*, p. 107, pl. 93, for an example of about 1480–90, and p. 122, pl. 110, for an example of about 1510. See also Hermann Lüer, *Kronleuchter und Laternen*, Kgl. Kunstgewerbemuseum, Berlin, 1903, pl. 6–8, for three sixteenth-century examples, and Professor Heideloff, Gothic Furniture, *The Art Journal*, IV, 1852, p. 52, for another.

7. Both designs and the extant "dragon" example, now in the Germanisches Nationalmuseum, Nuremberg, are illustrated in Detlef Heikamp, "Dürers Entwürfe für Geweihleuchter", *Zeitschrift für Kunstgeschichte*, XXIII, 1960, pp. 42–55; the "dragon" was first published in Heinrich Kohlhausen, "Ein Drachenleuchter von Veit Stoss nach dem Entwurf Albrecht Dürers", *Germanisches Nationalmuseum, Nuremberg, Anzeiger*, 1936–9, pp. 135–41, illus. Not previously noted is the fact that Heideloff, *op. cit.*, p. 50, illustrated the "dragon" in 1852, when it was still at Schloss Gleisshammer.

8. The design is illustrated in Heikamp, *op. cit.*, where he tentatively attributes the original to Dürer.

9. On an example in the Schloss und Heimatmuseum in Jever, illus. Gerhard Wietek, *Altes Gerät für Feuer und Licht*, Oldenburg, 1964, p. 27.

10. Illus. Heinrich Kreisel, *Die Kunst des deutschen Möbels*, I, Munich, 1968, pl. 349; see also p. 152.

11. See Philipp Maria Halm, *Studien zur Süddeutschen Plastik*, Augsburg, 1927, II, pp. 67–95, where its execution is attributed to Jörg Kölderer, a view which is disputed by Dr. Wilhelm Pinder (*Die Deutsche Plastik*, Potsdam, 1929, II, p. 495). Many other subjects are mentioned in sixteenth-century documents printed in Heikamp, *op. cit.*

12. Illus. Kreisel, *op. cit.*, pl. 347; the whole room is illustrated by C. H. Baer, *Deutsche Wohn & Feserräume aus sechs Jahrhunderten*, Stuttgart, 1912, p. 40. Another Kronleuchter, with a figure of St. Michael, is illustrated in *Zeitschrift des Kunstgewerbevereins*, Munich, 1897, p. 53. A similar example with St. Michael from the Church of Schlagsdorf is illustrated in Sigrid Wechssler-Kümmel, *Schöne Lampen Leuchter und Laternen*, Heidelberg, 1962, p. 214.

13. Illus. Wechssler-Kümmel, *loc. cit.*

14. Illus. Heideloff, *op. cit.*, p. 49.

15. Illus. *ibid.*, p. 50.

16. Illus. Lüer, *op. cit.*, pl. 13.

17. Illus. *Jahrbuch der Kunsthistorischen Sammlungen des allerhöchsten Kaiserhauses*, VI, 1888, p. 57. Another edition, P. Musper, Stuttgart, 1968.

18. *Op. cit.*, p. 52.

19. Illus., Baer, *op. cit.*, p. 38; see also Dehio, *Tirol*, 4th ed., Vienna, 1960, p. 217, where the frescoes are attributed to Hans Maler von Schwaz.

20. Illus., *Collection Plaisir de France, Styles Regionaux*, Paris, 1967, III, p. 93.

21. Illus., Margaret Jourdain, *English Decoration and Furniture of the Early Renaissance*. London, 1924, Fig. 7.

22. See Walther-Gerd Fleck, *Schloss Weikersheim und die hohenlohischen Schlösser der Renaissance*, Tübingen, 1954, pp. 10, 14 and 16; and Figs. 13, 24 and 40. See also Baer, *op. cit.*, pp. 72 and 73.

23. Illus. J. Christoph Roselt, *Das Bergische Museum, Schloss Burg an der Wupper*, Hamburg, 1969, pl. 22.

24. Havard, *Dictionnaire de l'Ameublement*, I, p. 636.

25. Christopher Hussey, Hardwick Hall, *Country Life*, LXIV, 1928, p. 876.

26. Wendel Dietterlin, *Architectura . . .*, Nuremberg, 1958, pl. 24, 81 and 121.

27. *Ibid.*, pl. 142, 74 and 126.

28. Fred. Roe, "The Great Bed of Ware", *Connoisseur*, LXXXVIII, 1931 p. 115.

29. Illus., Kreisel, *op. cit.*, pl. 456. It is possible, however, that they may be part of the frieze added in the nineteenth century.

30. Fritz Arens, "Ein neuentdecktes Werk von Giovanni Domenico Rossi, Stuckator der Trierer Domapsis", in *Festschrift für Alois Thomas*, Trier, 1967, p. 5 and pl. 2.

31. Petrus Schenck, *Paradisus Oculorum, sive Conspectus elegantissimi centum, . . .*, Amsterdam, n.d., pl. 73 and 74. Some plates of this work are dedicated to William III of England.

32. See Marianne Schuster, *Johann Esaias Nilson*, Munich, 1936, p. 39, fig. no. 6. I am grateful to Dr. Rolf Biedermann for this reference.

33. Illus., *L'Homme et L'Animal*, Paris, 1962, pl. 380.

34. Le Rouge, *Jardins Anglais*, Paris, 1787, Cah. XVIII, pl. 8.

35. Johann Gottfried Grohmann and Dr. Friedrich Gotthelf Baumgärtner, *Ideenmagazin für Liebhaber von Gärten, Englischen Anlagen und für Besitzer von Landgütern*, Leipzig, n.d., II, Cah. 15, No. IV, III, Cah. 30, No. IV.

36. *Ibid.*, III, Cah. 27, No. IX, I, Cah. 12, No. VII, "Un pavillon ouvert dans le goût de ceux d'Otahiti" (cf. II, Cah. 17, No. II, "Otaheitisches Sommer Haus"), II, Cah. 19, No. VIII, Cah. 18, No. IX, Cah. 24, No. V, Cah. 20, No. III. Another remarkable instance of the use of the Tahitian style was a cabinet on the Pfaueninsel whose ceiling was painted by Lüttke, in 1796, as a Tahitian hut, and its walls with Tahitian views. Illus. Walter Stengell, *Alte Wohnkultur in Berlin und in der Mark*, Berlin, 1958, pl. 43 and p. 34.

37. *Ibid.*, I, Cah. 1, Nos. III and IV, Cah. 2, No. VI.

38. Edwards and Darly, *A New Book of Chinese Designs . . .*, London, 1754, pl. 87, 66, 86 and 117.

39. Robert Manwaring, *The Cabinet and Chair-maker's Real Friend and Companion, or, the Whole System of Chair-making Made plain and easy*, London, 1765, pl. 26, 27, 28 and 29.

40. I am grateful to my colleague, Desmond Fitz-Gerald, for drawing my attention to this work.

41. William Wrighte, *Grotesque Architecture, or, Rural Amusement*, London, 1767, pl. 2 (cf. pl. 8, "Rural Hermitage", pl. 19, "Rustic Seat to Terminate a View", and pl. 20, "Grotesque or rural Bath").

42. Charles Over, *Ornamental Architecture in the Gothic, Chinese and Modern Taste*, London, n.d. (1758), pl. 18, 16 and 27.

43. C. Guesnu, *Ornements en Fonte de Fer*, L. Denouvilliers, Rue de Lancry, Paris, n.d. (c. 1850?), pl. 36 bis.

44. See Footnote 37.

45. *Art Journal Illustrated Catalogue of the 1851 Exhibition*, pp. 223, 12, 60 and 102. See also another panel, by M. Lienard of Paris, containing deer (p. 74), a sculpture by San Giovanni showing the kill, with hounds (p. 106), a similar Scottish scene with a deer-hunter, executed in silver by H. McCarthy of London (p. 146), and Fourdinois's celebrated sideboard in "The Renaissance style" (p. 285).

46. Ibid., p. 263.

47. Arthur J. Jones, Son & Co., *Description of a Suite of Sculptured Decorative Furniture, illustrative of Irish History and Antiquities, manufactured of Irish Bog Yew*, Dublin, 1853, p. 8, No. 11.

48. *Ibid.*, Frontispiece, and cf. note 12.

49. *Official Catalogue of the 1851 Exhibition*, III, p. 1138.

50. The suite consists of six side-chairs, one couch, one footstool, one table, one chandelier, two wall sconces, two candlesticks, one book and one clock (by F. Böhler of Frankfurt).

51. The seat, designed by Mr. L. Gruner, and made out of a block of parrot or cannel coal from the collieries of The Earl of Wemyss, near Kirkcaldy, Fife, was exhibited by The Prince Consort at the 1851 Exhibition. I am grateful to Mr. E. A. Sibbick for this information.

52. Illus., *Illustrierter Katalog der Londoner Industrie-Ausstellung von 1862*, Leipzig, 1864, II, p. 150.

53. *Ibid.*

54. I am grateful to Mr. Claude Blair and Mr. Ronald Lightbown for this information. Mr. Anthony North informs me that there is more furniture of this type at Schloss Erbach; Graf Franz I zu Erbach (1754–1823), who greatly encouraged the wood, horn and ivory turners' guild in Erbach, himself executed an antler candlestick (illus., Hans Werner Hegermann, *Elfenbein*, Hanau am Main, 1966, pl. 31), and Christian and Eduard Kehrer, after the Graf's death, produced boxes formed of sections of antler decorated with carved figures of game (illus., *ibid.*, pl. 36).

55. I am grateful to Mr. Josef Dolejši for this information.

56. "den ungetheilten Beifall der britischen, schottischen und irischen Nobility und Gentry", see Footnote 46.

57. I am grateful for this information to Messrs. J. E. Hill and M. C. Sheldrick of the British Museum (Natural History).

58. *Catalogue of the Paris 1867 Exhibition*, Prussia and North Germany, Paris, 1867, p. 57. A sneering reference to this extraordinary confection is to be found in Exposition Universelle de Paris en 1867, *Documents et Rapports*, Brussels, 1868, II, p. 10.

59. *Official Catalogue of the British Section*, London, 1876, p. 158.

60. *Art Journal*, 1877, p. 318. I am grateful to Miss Elizabeth Aslin for supplying me with this and the following reference.

61. *Art Journal*, 1880, p. 268.

62. C. W. Fleischmann, *Summary Catalogue and XX Engravings*, Nuremberg, 1884(?), pl. 14 (Victoria and Albert Museum Library; the Dürer examples are numbered 7 and 8 in ink on this copy).

63. Illus., *Zeitschrift des Kunst-Gewerbe Vereins in München*, 1895, pl 33.

64. Illus., *ibid.*, 1883, pl. 17.

65. Illus., *Art & Decoration*, I, 1885, p. 114, cf. *ibid.*, p. 112.

66. Illus., Mario Praz, *An Illustrated History of Interior Decoration*, London, 1964, pl. 378.

67. Illus., *Zeitschrift sed Kunst-Gewerbe Vereins in München*, 1882, pl. 24, cf. p. 64.

68. Illus., Alexander Koch, *Moderne Innen-Architektur und Innerer Ausbau*, Darmstadt, 1897, p. 50.

69. Examples are illustrated in *Zeitschrift des Kunst-Gewerbe Vereins in München*, 1881, pl. 37, *ibid.*, 1884, pl. 21, Alexander Koch, *op. cit.*, p. 55, and Ferdinand Luthmer, *Werkbuch des Dekorateurs*, Berlin, 1897, p. 89 (an example derived from Koch's work).

70. Bevis Hillier, "Fantasies from the curious and rare", *The Times Saturday Review*, 2 January, 1971, states that the designer, Norman Redmile, is "currently working on a French château with Erté. The furniture is to be all of antlers; 'Most of it is still walking about in Scotland' ".

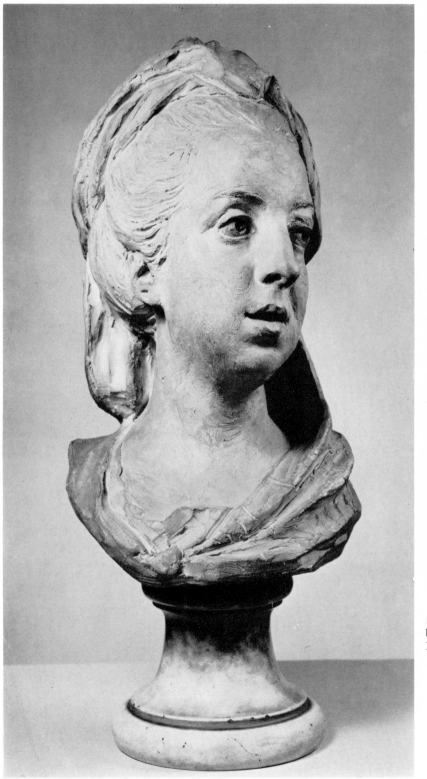

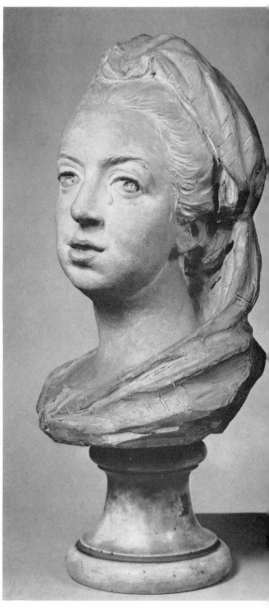

1–2. COMTESSE DE FEUQUIERES. Terracotta sketch mode
by Jean-Baptiste Lemoyne. Victoria and Albert
Museum, Room 6 (A.25–1959).

Terence Hodgkinson

French Eighteenth-century Portrait Sculptures in the Victoria and Albert Museum

THE rigorous training to which sculptors were submitted in eighteenth-century France, at the Academy in Paris and at the *Ecole royale des Elèves protégés* and afterwards at the French Academy in Rome, was intended to produce accomplished servants for the *Direction générale des Bâtiments du Roi*. Nevertheless, during much of the century, official projects were modest; sculptors competed, sometimes bitterly, for the exiguous spoils, and the correspondence of the *Direction générale* is full of complaints from artists about delays in payment. For a number of sculptors it was therefore providential that the increasing prosperity and self-confidence of the middle-class created an expanding market for portrait busts. The first sculptor to execute busts of fellow-artists, relatives and friends had been Coysevox; the most prolific portraitist in the reign of Louis XV was Jean-Baptiste II Lemoyne; and towards the end of the century there were Jean-Jacques Caffiéri and the incomparable Houdon. All these became portrait specialists—Houdon is described by a modern biographer as "bustier malgré lui"—but throughout the period great sculptors, who were not primarily portraitists, such as Jean-Louis Lemoyne, Nicolas and Guillaume Coustou, Bouchardon, Michelange Slodtz, Pigalle and Pajou, executed memorable likenesses. In no other time or place has there been such a galaxy of sculpted portraits, the supreme technical skill of the artists serving the century's consuming interest in personality.

Yet English collectors have paid little attention to this great achievement. John Jones, for instance, whose bequest to the Victoria and Albert Museum included superlative French pictures, porcelain and furniture, did not collect any portrait busts. Nor did Baron Ferdinand de Rothschild, the creator of Waddesdon Manor, where the only example is Lemoyne's *Madame de Pompadour*, which came from the Paris collection of Baron Edmond at a later date. Even the Wallace Collection possesses only two French busts of the eighteenth century, albeit great masterpieces, the Houdon portraits of *Madame Victoire* and *Madame de Sérilly*. Until recently, the only one in the Victoria and Albert Museum was the *Head of a Girl*, sometimes called the *Boudeuse*, by Saly, which surprisingly was bought as long ago as 1863. So, in the last twenty years, the Museum has made a modest attempt to redress the balance; and the purpose of this article is to record the French portrait sculptures that have been acquired.[1] The earliest in date is an unsigned terracotta head of a

woman, which has the snapshot quality of portraits by Jean-Baptiste II Lemoyne (b.1704; d.1778)[2] (figs. 1–2). The head is slightly turned, the lips are parted, the eyelids seem to flicker and a tear courses down the left cheek. Louis Réau recognized it as a preparatory study for the statue of the *Comtesse de Feuquières* (b.1653; d.1743), which formed part of the monument to herself and her father, the painter Mignard. It was in 1735 that the countess, by then over eighty years old, ordered a monument from Lemoyne, which was to incorporate a copy of the Desjardins bust of her late father[3] and a statue of herself as a mourner. In the Salon of 1738 the sculptor exhibited a terracotta head of madame de Feuquières, which was presumably connected with this commission and which might be the Museum's terracotta.[4] The monument, completed in 1744, was placed in the church of the Jacobins in rue Saint-Honoré and was later dismembered during the Revolution; but the bust of Mignard and the Lemoyne figure survived and can be seen today in the neighbouring church of Saint-Roch. The catalogue of the collection of La Live de Jully describes in 1764 a bust which may well be the one now in the Museum: "Un buste en terre cuite de LE MOINE, portrait de Madame La Comtesse de Feuquières, fait d'après nature, & qui a servi d'étude à cet Artiste pour le tombeau qu'elle a fait ériger à Paris dans l'Eglise des Jacobins de la rue S. Honoré, à la mémoire de Mignard son pere, où elle est représentée à genoux & pleurante Elle avait été une des plus belles femmes de son temps & dans l'âge de 82 ans (car c'est a cet âge que M. LE MOINE fit son portrait) elle conservoit encore la beauté & la fraîcheur d'une belle femme de quarante ans. . . .'[5]

René-Michel Slodtz (b.1705; d.1764), known from childhood as Michelange, was a year younger than Lemoyne and they would have been together at the French Academy in Rome, if Lemoyne had not been prevented by a family bereavement from taking up his place. In the event Slodtz travelled to Rome as a *pensionnaire* with Trémolière, Subleyras and three other painters in 1728; he stayed there for no less than eighteen years. The contemporaries of Michelange regarded him as a sculptor of the first importance. Yet, before the publication of François Souchal's recent book on the Slodtz family, it was difficult for posterity to comprehend his artistic personality. This book has re-established his position and has told us, in particular, a great deal about the years in Rome, when he acquired his technical skill in handling marble and developed his

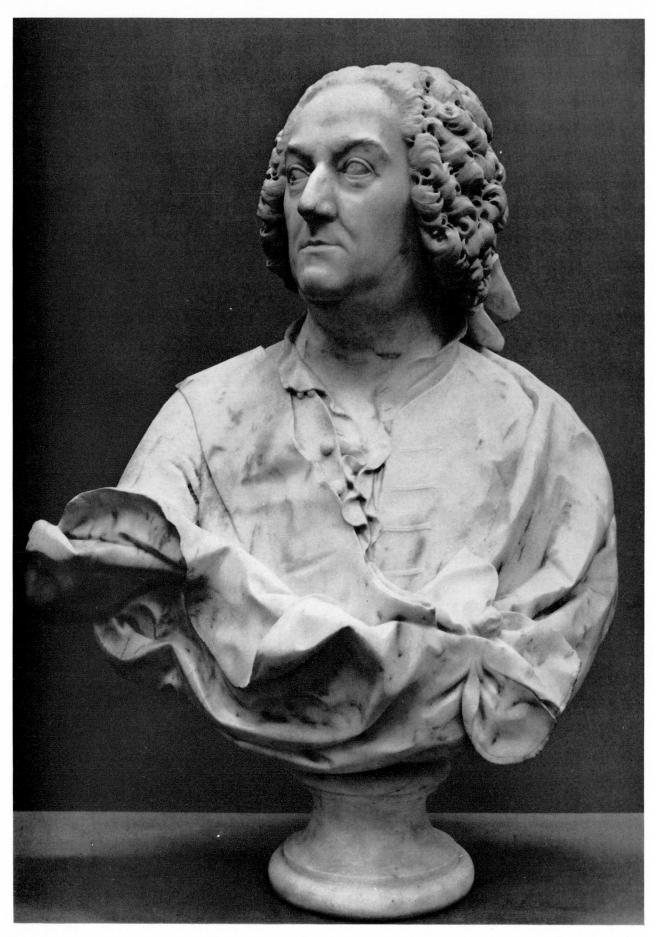

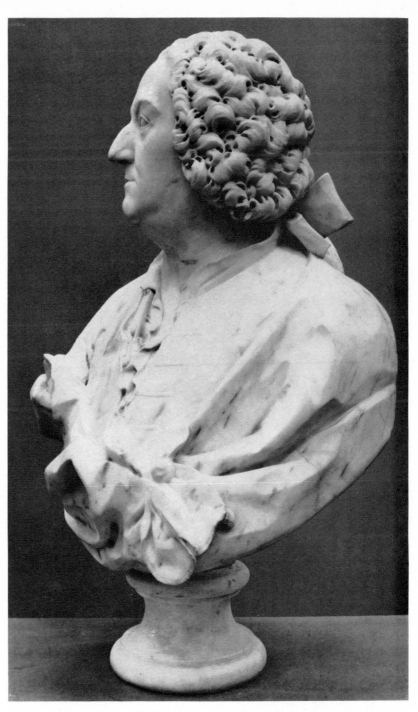

3–4. JEAN FRANÇOIS DE TROY. Marble bust by René-Michel (Michelange) Slodtz. Victoria and Albert Museum, Room 5 (A.70–1952).

elegant berninesque manner. Among the works of this period, ascribed to him by Souchal, is a plaster bust in the French Academy in Rome of about 1740, representing the painter *Jean-François de Troy* (b.1679; d.1752), who was Director at the time.[6] The ascription is based on analogies with the bust of Wleughels, the previous Director, and with other sculptures, known to be by Slodtz. The close personal association between Slodtz and the sitter at this date lends extra weight. A marble version of this bust, which was acquired by the Museum in 1952 and has hitherto been unrecognized, can accordingly now be attributed to Slodtz[7] (figs. 3–4). In the Museum's version the badge of the

Order of Saint-Michel, which was awarded to de Troy in 1738 and which is represented in the plaster version, has been broken away, the fracture being disguised. The mutilation may perhaps have occurred in the Revolution. The identification of the sitter as de Troy has a special poignancy, if we accept Michael Levey's very cogent suggestion that the marble *Head of a Girl*, by François-Jacques-Joseph Saly (b.1717; d.1776), acquired by the Museum in 1863 (fig. 5), represents the daughter of de Troy, his last surviving child, who nevertheless died before him.[8] The old identification of the sitter as Alexandrine d'Etiolles, daughter of Madame de Pompadour, had been shown by Michèle

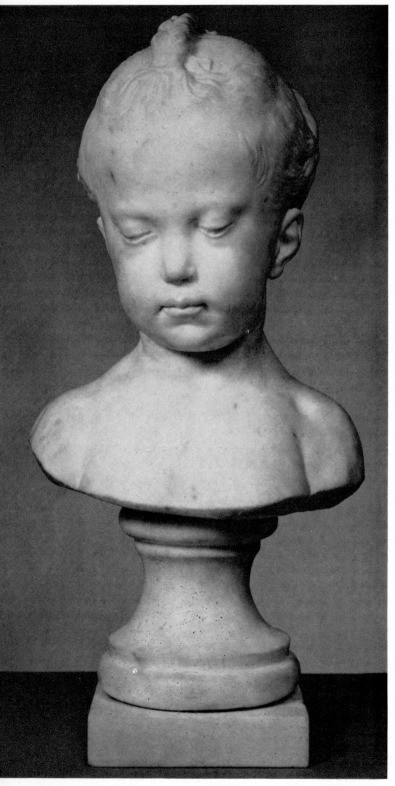

Beaulieu to be unacceptable.[9] The Museum's version of this popular portrait, although possibly less good than the version in the David-Weill collection at Neuilly-sur-Seine, certainly dates from the eighteenth century.[10] There are no French busts in the Museum's collections dating from the 1750's and '60's; and by 1775, when the terracotta bust of the poet and dramatist Michel-Jean Sedaine (b.1719; d.1797) was executed by Augustin Pajou (b.1730; d.1809)[11] (figs. 6–7) the essentially rococo style of Jean-Baptiste II Lemoyne and of Michelange Slodtz had been very largely replaced by mid-century classicism. Houdon had returned from Rome and was at the beginning of his great career, and Pajou, formerly a pupil of Lemoyne, was the most successful sculptor in Paris. The bust of Sedaine, who was a personal friend, is a good example of his sensitive and unemphatic portrait style.

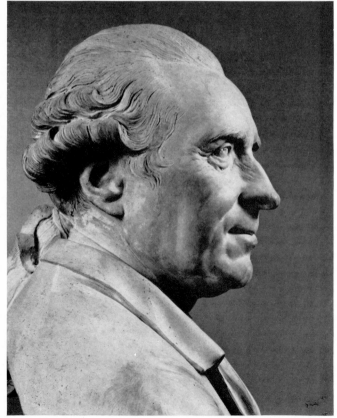

5. HEAD OF A GIRL, PROBABLY THE DAUGHTER OF JEAN-FRANÇOIS DE TROY. Marble bust by Jacques Saly. Victoria and Albert Museum, Room 7 (8510–1863).

6–7. (*opposite*) MICHEL-JEAN SEDAINE. Terracotta bust by Augustin Pajou. Victoria and Albert Museum, Room 7 (A.27–1959).

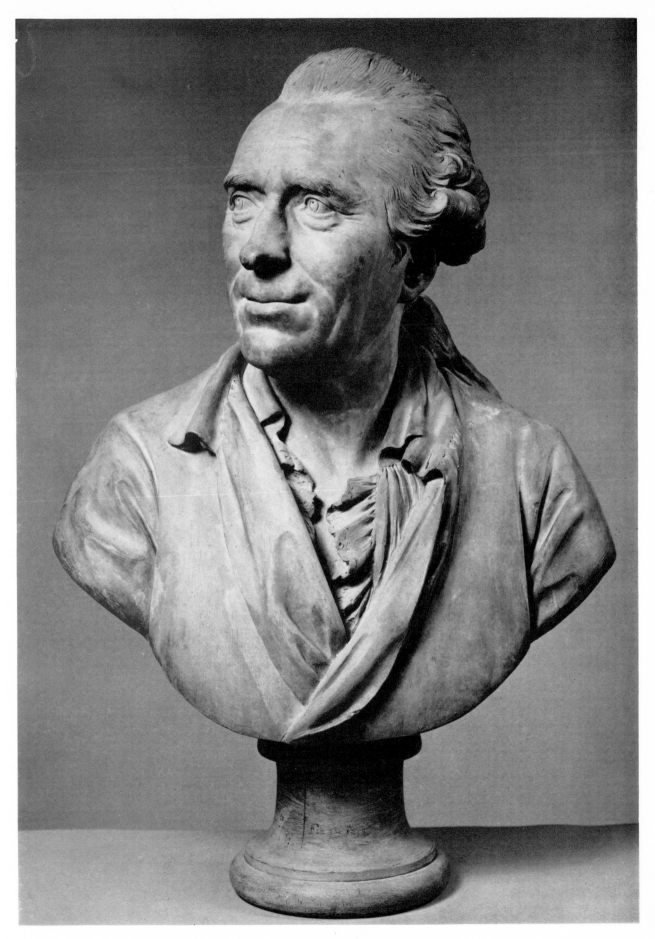

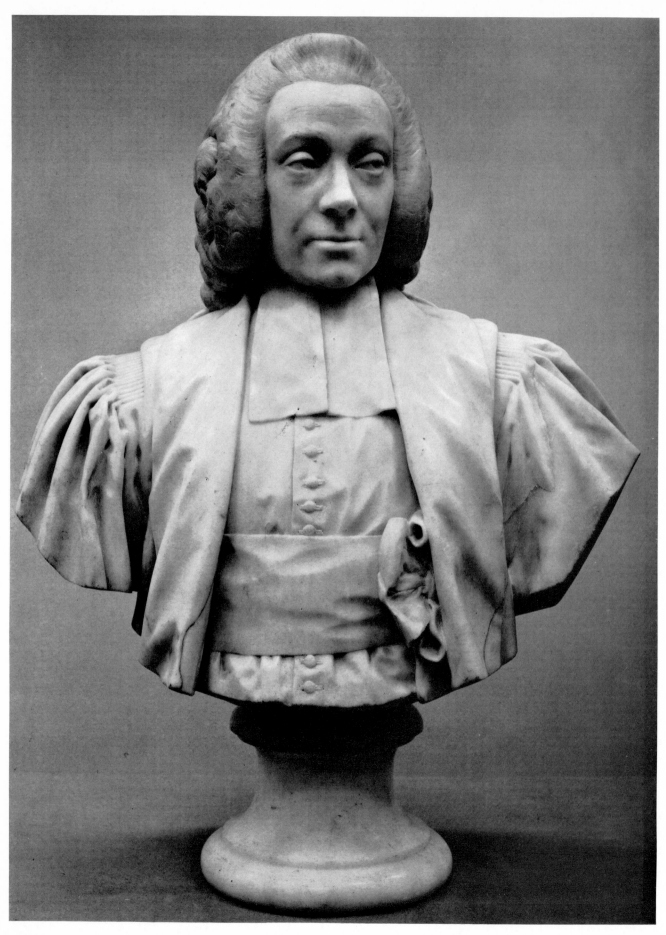

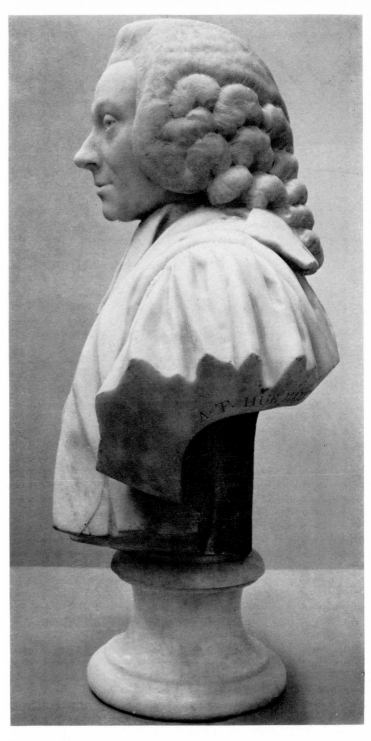

8–9. MARQUIS DE MIROMESNIL. Marble bust by Jean-Antoine Houdon. Victoria and Albert Museum, Room 7 (A.19–1963).

Also from 1775 dates the earlier of the Museum's two marble busts by Jean-Antoine Houdon (b.1741; d.1823): that of the *Marquis de Miromesnil* (b.1723; d.1796)[12] (figs. 8–9). It was in this year that the sitter was appointed *garde des sceaux* and the portrait must commemorate the occasion. But, although Miromesnil is shown in the robes of a magistrate and wearing a particularly stiff and voluminous wig, the likeness is highly individualized. A contemporary critic discerned in it "le recueillement profond, l'exactitude minutieuse et vigilante du dépositaire des Loix, dont les fonctions ne sont que de conserver, de maintenir ou de remettre en vigueur".[13] There is a second marble version of this bust, dated 1777, now in the Frick Collection, New York, in which the expression of the eyes is slightly different. Houdon employed a variety of devices for giving life to the eyes of his portraits. In both the London and the New York versions of the Miromesnil bust the treatment of the eyes is essentially the same: a deep boring in the centre of a circular excavation overlapped by the eyelid; but in the London version the inscrutability of the sitter is emphasized by making

the excavation irregular and the rim round the boring indistinct. In the New York version the clarity of the cutting gives a more penetrating glance. There is a slightly later unsigned marble at Montpellier and a bronzed plaster at Orléans. The London version, which is fully signed and dated, was shown in the Salon of 1775.[14]

It was during the final visit to Paris from Ferney in 1778 that Voltaire (b.1694; d.1778) was persuaded to sit for Houdon, a few weeks before he died. Subsequently a quantity of Voltaire busts were executed, showing him either bald or wearing a wig, with contemporary clothes or "à l'antique", as required by the buyer. Houdon also executed two marble statues of Voltaire, seated and wearing the robes of a philosopher, one now in the Hermitage, Leningrad, and one in the Comédie Française. For this representation the subject was supplied with imaginary hair bound with a ribbon. It was Houdon's standard practice to issue busts copied from his statues, and the Museum's well-known bust of *Voltaire*, which is mounted on a base bearing masks of Comedy and Tragedy, a fool's head and musical instruments, is derived from the seated figure[15] (figs. 10–11). An almost identical version is in the M. H. de Young Memorial Museum, San Francisco.[16] Each has a badly cut inscription on the back connecting it with the Marquis de Villette, who was Voltaire's host in Paris on the final visit; but the significance of the inscriptions is unclear and they seem to have been added during the nineteenth century.

10. Inscription on the back of the bust of Voltaire by Jean-Antoine Houdon (A.24–1948).

11. VOLTAIRE. Marble bust by Jean-Antoine Houdon. Victoria and Albert Museum, Room 7 (A.24–1948).

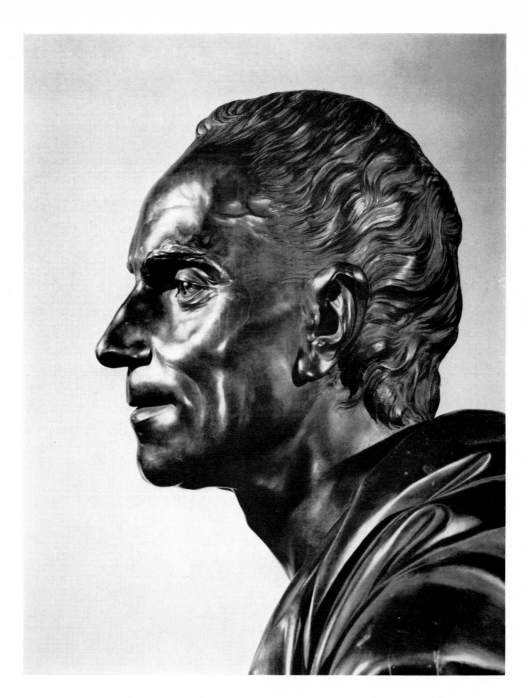

12–13. CLAUDE-JOSEPH VERNET.
Bronze bust by Louis-Simon
Boizot. Victoria and Albert
Museum, Room 7
(A.26–1959).

The head of the bronze portrait of *Claude-Joseph Vernet* (b.1714; d.1785), the great painter of seascapes, by Louis-Simon Boizot (b.1743; d.1809) is modelled with such authority that the bust was at one time ascribed to Houdon, although the slightly awkward relationship of head to draped shoulders is not characteristic[17] (figs. 12–13). The bronze, which was exhibited in the Salon of 1783,[18] may have originated in a family commission, since the sculptor's wife was the niece of the sitter. Boizot used the likeness again, ten years later, when he was called upon to execute a bust of Vernet for the *Galerie du musée central*. In this later version, which belongs to the Louvre but is now in the Musée Calvet, Avignon, the head is set differently on the shoulders and the drapery is replaced by a

frilled shirt and a cloak.[19] Boizot, who is in need of a biographer,[20] was the most successful pupil of Michelange Slodtz. Most of his output consists of decorative sculpture and for eleven years he was in charge of the modellers at the Sèvres porcelain factory. He executed only a small number of portraits.

Jean-Baptiste Pigalle (b.1714; d.1785), favourite sculptor of Madame de Pompadour and financially the most successful sculptor of the period, also executed comparatively few portraits; of these a high proportion represented intellectuals within his own circle. His last work was a portrait of an old friend, the famous engineer *Jean-Rodolphe Perronet* (b.1708; d.1793), who constructed the Pont de la Concorde and the Pont de Neuilly and was founder of the *Ecole des Ponts et*

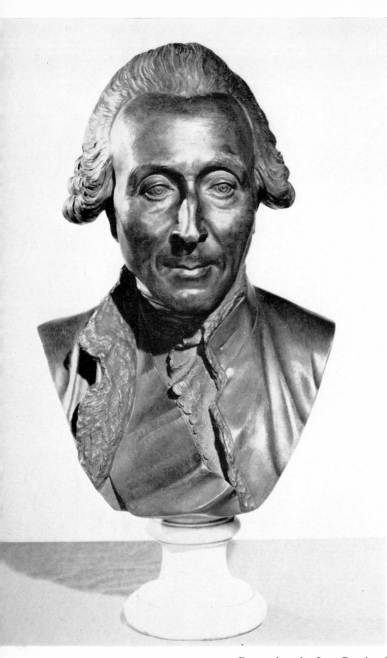
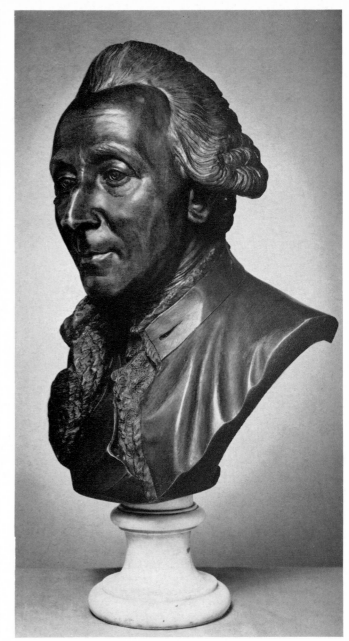

14–15. JEAN-RODOLPHE PERRONET. Bronze bust by Jean-Baptiste Pigalle. Victoria and Albert Museum, Room 7 (A.24–1959).

Chaussées[21] (figs. 14–15). An unsigned terracotta version exists and also the Museum's magnificent bronze, which conforms closely to the terracotta and is inscribed "Jean Rodolphe Perronet per Ingenieur Des Ponts Et Chaussees Age de 76 Ans. Fait par J. B. Pigalle Son Ami Age de 71 Ans 1785". The surface of the bronze is chased with great refinement and the features, beautiful in themselves, are recorded with insight and with absolute technical mastery.

One year later than the Pigalle portrait is the terracotta of an unknown man, signed by Pierre Mérard (d.1800), an able but little known pupil of Bouchardon, who became professor in the *Académie de Saint-Luc*[22] (fig. 16).

Somewhat apart from these personal documents are two formal royal portraits by Edmé Bouchardon (b.1698; d.1762). For his life and works a posthumous *Eloge historique*, delivered to the Academy of Painting on 4 September, 1762, by his admirer and friend comte de Caylus, is the principal contemporary source.[23] Among the sculptures mentioned by Caylus are two bronze medallions of Louis XV and of his son, which were then in the château of Pontchartrain: "Le Roi voulut bien donner quelques séances à Bouchardon pour faire son portrait, et cette étude, après avoir servi pour les médailles et les monnaies, a été employées pour exécuter un médaillon que M. de Maurepas fit jeter en bronze. Ce médaillon a pour pendant le portrait de

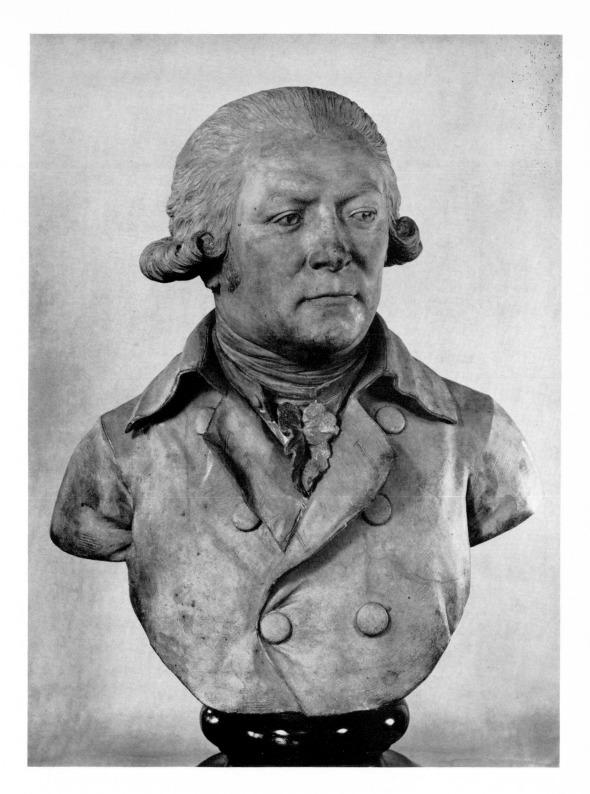

16. UNKNOWN MAN.
Terracotta bust by
Pierre Mérard.
Victoria and Albert
Museum, Room 7
(A.4-1949).

M. le Dauphin que Bouchardon fit encore. Ces deux ouvrages font l'ornement d'un cabinet à Pontchartrain et méritent d'être vus''.

As the medallions were subsequently unrecorded, and no other versions are known, it was an event of some interest when the Museum was offered in 1969 two oval reliefs in bronze of *Louis XV* (b.1710; d.1774) and *Louis, Dauphin de France* (b.1729; d.1765), inscribed respectively in a manner characteristic of this sculptor:

ED. BOUCHARDON EFFINGEBAT AN° 1738 and ED. BOUCHARDON EFFINGEBAT AN° 1745[24] (figs. 17–18).
The contents of Pontchartrain have been dispersed at various times and the Museum's bronze medallions were acquired by the vendor without history; so the possibility of establishing with absolute certainty that they are identical with the versions commissioned by Maurepas[25] is remote. The portrait of Louis XV, which is notably superior in quality to that of the Dauphin,

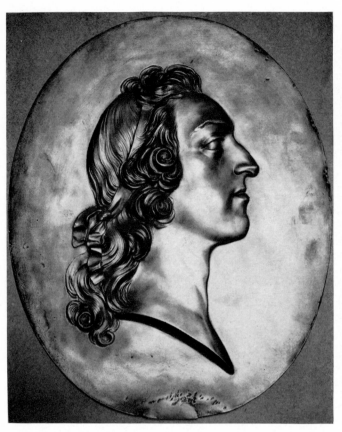

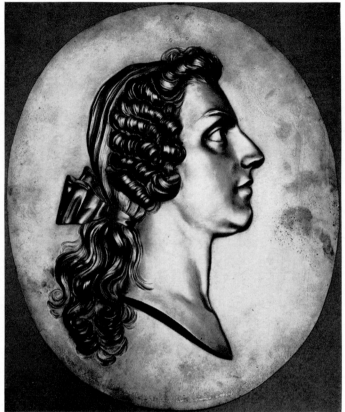

17. LOUIS XV. Bronze relief by Edmé Bouchardon. Victoria and Albert Museum, Room 5 (A.189–1969).

18. LOUIS, DAUPHIN DE FRANCE. Bronze relief by Edmé Bouchardon. Victoria and Albert Museum, Room 5 (A.190–1969).

is the same likeness which appears on the *Louis d'or* of the years between 1740 and 1765, known as the *Louis au bandeau*, and also on medals of this period. It would seem then that Bouchardon made a drawing of Louis XV from life, which was used by the *Monnaie* for coins and medals, and that subsequently he executed a relief based on the drawing, which Maurepas arranged to be cast in bronze for Pontchartrain. The date on the

bronze medallion (1738) probably refers to the year in which the original drawing was made. The medallion of the Dauphin seems to have had a different history and was perhaps simply ordered from Bouchardon by Maurepas to make a companion to the portrait of the king. The key position occupied by Bouchardon in the history of French classicism and the rarity of his sculptures lend importance to the acquisition of these reliefs.

Notes

1. A terracotta version (A. 17–1947) of the bust of Louis XV as Apollo by Lambert-Sigisbert Adam (See *Burlington Magazine*, XCIV, 587, February 1952, p. 37) is not included in this survey, as I now believe it to be a nineteenth-century pastiche.

2. A.25–1959. H. 14¾ in (37·46 cm), without base. No inscription. The back of the veil is modelled and fired as a separate piece. Bought Sotheby, July 2, 1959, Lot 63, property of a gentleman. Formerly David-Weill collection. See L. Réau, *Une dynastie de sculpteurs au XVIIIe siècle: Les Lemoyne*, Paris 1927, p. 63, 108, 152 (Cat. 132), plate LXIV, fig. 99. Exhibited Wildenstein, New

York, *French XVIIIth century sculpture formerly of the David-Weill Collection*, 1940.

3. P. Huisman, 'Les bustes de Pierre Mignard' in *Gazette des Beaux-Arts*, LI, April 1958, pp. 267–72.

4. J-J. Guiffrey, *Collection des livrets des anciennes expositions depuis 1673 jusqu'en 1800*, Paris 1869. Exposition de 1738, no. 162.

5. A. L. de la Live de Jully, *Catalogue historique du cabinet de peinture et sculpture française de M. de la Live*, Paris 1764, p. 15.

6. F. Souchal, *Les Slodtz*, Paris 1967, p. 206, 211, 676 (no. 165), pl. 19C.

7. A.70–1952. H. 24¾ in (62·86 cm), without base. No inscription. Bought from Gerald Kerin Ltd. in 1952. First published as by

Slodtz in *Burlington Magazine*, cxi, 792, March 1969, p. 159, fig. 66.

8. M. Levey, "A new identity for Saly's bust of a young girl" in *Burlington Magazine*, cvii, 743, February 1965, p. 91.

9. M. Beaulieu, "La Fillette aux nattes" in *Bulletin de la Société de l'histoire de l'art français*, 1955, p. 62.

10. 8510–1863. H. 13½ in (34·29 cm), without base. Bought without history in 1863. No inscription.

11. A.27–1959. H. 19⅛ in (48·58 cm), without base. Inscribed: Pajou fe 1775. On the circular wooden base is written: Sedaine Fait par Pajou, now hardly legible. Bought Sotheby, July 3, 1959, Lot 71, property of a gentleman. Formerly David-Weill collection. According to H. Stein, *Augustin Pajou*, Paris 1912, p. 59, the bust was for a long time in the possession of the sitter's family. Exhibited Wildenstein, New York. *French XVIIIth century Sculpture formerly of the David-Weill Collection*, 1940. Wildenstein and Co. possess a terracotta bust of Madame Sedaine, for which see H. Stein, *op. cit.*, p. 61.

12. A.19–1963. H.29⁹⁄₁₆ in (75·09 cm), without base. Inscribed: A. T. HUE MARQUIS DE MIROMENIL GARDE DES SCEAUX. HOUDON F. 1775. The nose has been fractured and replaced, apparently long ago and there is a fissure in the left shoulder produced by a flaw in the marble. Bought from the Estate of René Fribourg, Sotheby, October 17–18, 1963, Lot 733. The bust appeared in the Paris antique trade in 1898 and was then said to have come from the Goulaine family in Normandy. Subsequently it was in a private collection in Connecticut and in the Baron Cassel van Doorn collection. Additional details of the Miromesnil busts are given in *The Frick Collection, an illustrated catalogue*, iv, 1970, p. 120. See also T. Hodgkinson, "Houdon and Clodion, Masters of Elegance" in *Apollo Magazine*, May 1971, p. 397. The catalogue entry in L. Réau, *Houdon*, 1964, Part iii, p. 37 (no. 163) mistakenly implies the existence of a fourth marble version.

13. L. Petit de Bachaumont, *Mémoires secrets . . .* xiii, London 1780, p. 214 (letter of 29 September, 1775).

14. J-J. Guiffrey, *op. cit.*, Exposition de 1775, no. 253.

15. A.24–1948. H.19⅞ in (50·48 cm), including base, which is carved in one with the bust. Inscribed: HOUDON F. 1781 au Marquis de Villette. Bought with the assistance of the National Art-Collections Fund from Sir Francis Oppenheimer, who had inherited it from his father. Sold Christie, 23 February, 1899, Lot 140 from the collection of Alfred Morrison deceased, of Carlton House Terrace. Exhibited Burlington Fine Arts Club, *Winter Exhibition, 1923–4*, No. 1 (typescript catalogue) and Royal Academy, *France in the eighteenth century*, 1968, no. 804, fig. 345. First published by L. Réau "A bust of Voltaire by Houdon" in *Burlington Magazine*, xci, 552, March 1949, p. 63.

16. The San Francisco version was given to the de Young Museum in 1961 by Mrs. E. John Magnin. It had been bought by Seligmann and Co. from the Schmoll Collection in Paris in the 1920s and then sold to Mrs. Henry Walters, from whose collection it was again sold, Parke Bernet, April 23-26, 1941, Lot 663. It is inscribed: HOUDON F. 1781. AROUET VOLTAIRE a été DONNE PAR Mr DE VILLETTE A LA comNE DE FERNEY. Miss Jennifer Montagu has noted a third version, bearing a similar cartouche on the base, but without drapery on the shoulders, sold Hôtel Drouot, Paris, 10 April, 1919 from the collection of Viscount F. B. (Marius Paulme, *expert*) and on 18-19 June, 1964, from the collection of Etienne Ader.

17. A.26–1959. H.21¹⁄₁₆ in (53·5 cm), without base. Bought Sotheby, July 23, 1959, Lot 70, property of a gentleman. Formerly David-Weill collection. Previously on loan to the Musée des Arts Decoratifs from the Doistau collection. G. Giacometti, *Houdon*, ii, 1929, p. 158 and plate facing p. 160 published the bust incorrectly as by Houdon, the mistake being repeated by L. Réau in *Gazette des Beaux-Arts*, xvii, 1927, p. 348, but corrected in his *Houdon*, 1964, Part ii, p. 372 and Part iii, p. 80. Exhibited: Wildenstein, New York, *French XVIIIth century Sculpture formerly of the David-Weill Collection*, 1940.

18. J-J. Guiffrey, *op. cit.* Exposition de 1783. no. 254.

19. P. Vitry, "Liste des bustes d'artistes commandés pour la grande galerie et salles de peinture du Louvre" in *Bulletin de la Société de l'histoire de l'art français*, 1930, Part i, p. 138–9.

20. An unpublished thesis exists, for the Ecole du Louvre, by Madame Thérèse Picquenard.

21. A.24–1959. H. 17 in (44·3 cm), without base. Bought Sotheby, July 3, 1959, Lot 72, property of a gentleman. Formerly David-Weill collection. A terracotta version, without inscription, was sold from the Marius Paulme collection, Galerie Georges Petit, 15 May, 1929, Lot 343, plate 225. Both versions were first published by L. Réau in *Revue de l'art ancien et moderne*, xlii, 1922, pp. 392. See also his *J-B. Pigalle*, 1950, pp. 119–21 and plate 46. Exhibited: Wildenstein, New York, *French XVIIIth century Sculpture formerly of the David-Weill Collection*, 1940.

22. A.4–1949. H. 20 in (50·8 cm), without base. Inscribed: PAR MERARD EN JUIN 1786. Bought without history from Alexander Sandor in 1949.

23. Reprinted in Comte de Caylus, *Vies d'Artistes du XVIIIe siècle*, Paris 1910, p. 76.

24. A.189–1969 (Louis XV) H. 21¹¹⁄₁₆ in (55·1 cm). A.190–1969 (The Dauphin) H. 22¼ in (56·5 cm).

25. Jean-Frédéric Phélippeaux comte de Maurepas (b.1701; d.1781).

John Lowry

A Burmese Buddhist Shrine

THE Burmese collections of the Museum have been enriched by the acquisition of a shrine (B. *Thihā-thanapalin*)¹ with its main Buddha figure and additional items shown in figs. 1 and 2. It was originally acquired by an army officer, Lt.-Col. F. D. Raikes, C.I.E. (1848–1915); he took part in the final stages of the third Burmese war, which culminated in the capture of Mandalay in 1885. Raikes collected the group after the fall of the capital; about the turn of the century he brought it to this country, where it has remained ever since.² According to documentation left by Raikes, the shrine came from the royal palace at Mandalay. This was originally a complex of several buildings, of which the remaining structures were destroyed during the last war. A contemporary site-plan of the palace shows, lying within the protecting stockade, the royal apartments in the centre surrounded by many other buildings such as tombs, stables, servants' and troops' quarters, etc. The most likely buildings to have housed the shrine were either the royal pagoda located to the north-east of the royal apartments outside the inner enclosure near the stockade to the east of the water-gate entrance, or a building described as "Thibaw's Monastery", which lay to the south of the east gate and the Tooth Relic tower (fig. 4). It was probably not the main icon but was situated in a position corresponding to a side chapel, where it would have allowed a more intimate form of worship and may also have been regarded as being particularly receptive to prayers. It probably took its place in an interior of carved and gilt wood, as fine and profuse as the shrine itself, and must have looked rather like the shrine which belonged to a chapel in the Thamidaw Kyaung, Amarapura, built during the reign of Pagān Min (fig. 3).

Arranged in front of the shrine, and also on the lower platform, are various receptacles, etc., used during worship. The box (B. *Kamawa Thitta*), fig. 5, contains manuscripts (*Kamawas*), written in Pāli on lacquer pages, comprising extracts from the *Vinaya*. They are used during the initiation of laymen into the monkhood, and are also read at intervals apart from initiation; this probably accounts for their presence in the *Kamawa Thitta* where they would be easily accessible. The bowls (fig. 6) are receptacles for offerings such as fruit, sweets or other food, while the two vases (fig. 7) are for flower offerings. The two *stūpa*-shaped receptacles, each supported by three figures (fig. 8) are probably for betel-nut offerings. The appearance of these figures, dressed in a curious mixture of Indian and Burmese costume, on objects connected with Buddhist ritual, is surprising since their clothes identify them as alchemists (B. *Zawgyis*) whose activities relate them with Ari monks. In spite of alchemy's association with the Aris and, therefore, Tantrism, it maintained

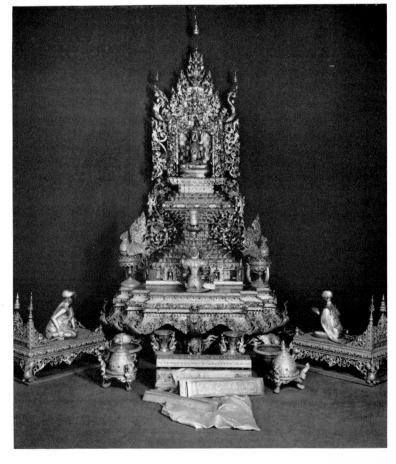

1. Detail of fig. 2, showing the shrine and platform on which it is supported. It is probable that the figure of Brahmā or Sakka was placed so that it looked towards the Buddha when the shrine was in worship as in fig. 2. It is shown in the reverse position here so that it may be seen more clearly.

2. Shrine (B. *Thihāthanapalin*) with a figure of the Buddha attended by Sāriputta and Moggallāna, and with various receptacles, etc. Carved wood covered with gilt lacquer in relief and inlaid with coloured glass, pieces of mirror and semi-precious stones. Burmese; 19th century. Height 112½ in. (285·5 cm). Victoria and Albert Museum (I.S. 11 (1–31) – 1969).

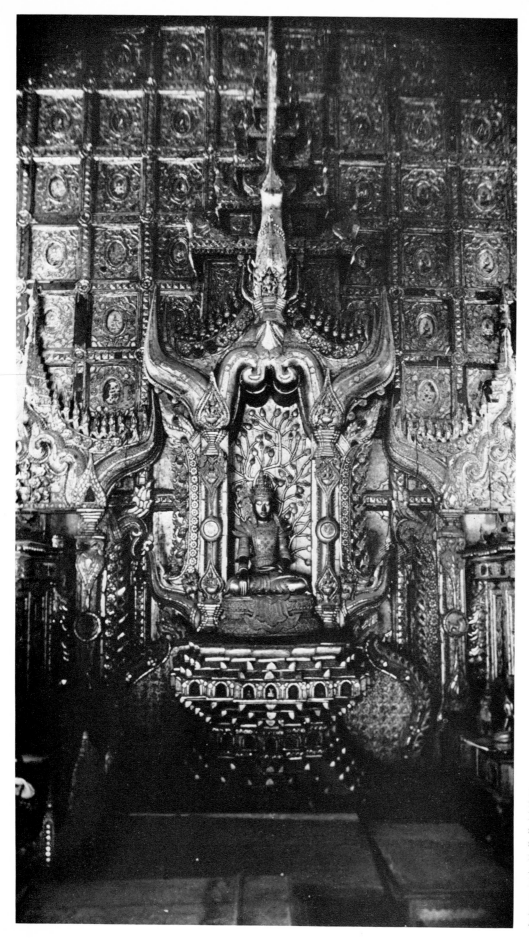

3. Chapel in the Thamidaw monastery (destroyed in the last war), Amarapura, showing a Buddha figure in a shrine almost identical with a royal throne. (See, Archaeological Survey of India Annual Report, 1914–15, pl. XLV, and pp. 56–65). Photo, *Archaeological Survey of Burma*.

its status as a science in Burma until the late 19th century.[3] One of its main activities was, inevitably, the search for the philosophers' stone which, as well as being able to transmute base metals, in Burmese alchemy had the additional property of giving longevity to the person who carried it in his mouth. It was sought after by Burmese Buddhists not because they hoped to escape the effects of *Kamma* but in order to be present when the next Buddha Metteya (Maitreya) appeared on earth.[4] This, however, is not sufficient to account for the somewhat unconventional presence of alchemists on these receptacles. A possible explanation may be found in the fact that King Pagān Min was said to be deeply interested in alchemy. It is conceivable, therefore, that these receptacles were made for him, and that the alchemists were included to correspond to his own ideas regarding their relationship with Buddhism. Assuming that the receptacles belong to the shrine, the implications of this are that the

shrine was made for Pagān Min while he was at his capital at Amarapura from 1846 to 1853. It may have belonged to the Eindawya pagoda, which was Pagān Min's chief religious foundation,[5] and then been moved from Amarapura to Mandalay, where Pagān lived until 1881, when the capital was transferred between 1857 and 1859; alternatively it may have remained at the Eindawya, and Raikes might have been misled in the confusion at the end of the campaign into believing that it belonged to the Mandalay palace. The presence of lions in niches round the base of the shrine, corresponding to similar lions in niches round the base of royal thrones (more fully discussed below), leaves little doubt that if it did not belong to Pagān Min, it was made for some other royal patron who cannot now be identified.

The two containers in the form of sacred geese (B. *Hinta Kun Ok*; Sanskrit, *Hamsa*; fig. 9), are for betel-nut offerings. These birds have a long history in Burmese

4. Plan for the building of Mandalay palace, drawn about 1857, showing the approximate locations of the royal pagoda and Thibaw's monastery. It is clear, from plans made after 1886, that considerable changes were made in the original scheme while building was taking place. India Office Library, *Add. Or., 1911*.

5. Box for manuscripts (B. *Kamawa Thitta*); wood covered with gilt lacquer in relief and inlaid with coloured glass. Height 7½ in. (19 cm). Width 25½ in. (65 cm). Victoria and Albert Museum (I.S. 11 (25) – 1969).

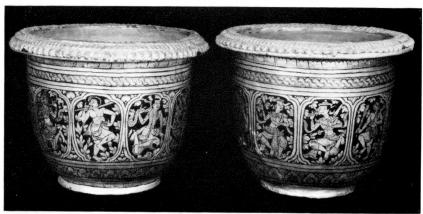

6. Bowls for offerings. Wood covered with black lacquer and gilt decoration, and with raised gilt decoration round the rim. Height 7½ in. (19 cm). Victoria and Albert Museum (I.S. 11 (30–31) – 1969).

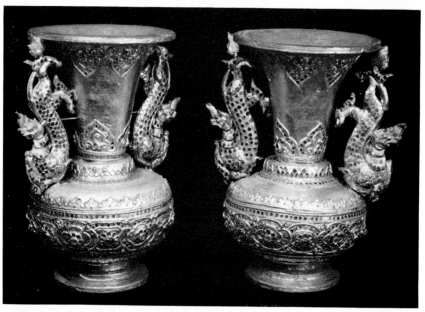

7. Vases for flower offerings. Wood covered with gilt lacquer in relief and inlaid with coloured glass. Height 9½ in. (24 cm). Victoria and Albert Museum (I.S. 11 (28 and 29) – 1969).

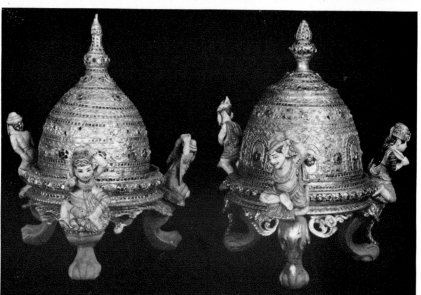

8. *Stūpa*-shaped receptacles supported by figures of alchemists (B. *Zawgyis*). Wood, carved and covered with gilt lacquer in relief and inlaid with coloured glass, the figures painted. Height 8½ in. (21 cm). Victoria and Albert Museum (I.S. 11 (16 and 17) – 1969).

culture. They are sacred to the Mons, who regarded them as emblems of their sovereignty and symbols of purity and gentleness; Pegu, the capital of their kingdom, was originally called Hamsavati. One of the thrones in the Mandalay palace, placed in the Hall of Victories, had carved figures of sacred geese round the base. It is possible that betel-containers in this shape were reserved for royal use, as they appear in contemporary illustrations of royalty.[6] (A very fine example of gold and semi-precious stones, formerly belonging to the Burmese royal regalia, was presented to the Museum by the Burmese Government in 1964, fig. 10.) On each side of the shrine are seated figures of the Buddha's two chief disciples; to the right (proper) Sāriputta,[7] who was renowned for his wisdom (fig. 11), to the left (proper) Moggallāna, celebrated for his magical accomplishments (fig. 12). They both have shaven heads and wear monks' robes, and sit in a position which is accepted as being respectful if kneeling cannot be sustained. Moggallāna holds his hands with the palms together in *Namaskāra mudrā* showing deferential esteem towards the Buddha, while Sāriputta listens intently to his words. Placed before the shrine in this way facing towards the Buddha, they enable the worshipper to identify himself with them and, by association, to acquire some of their sanctity.

9. Receptacles in the form of sacred geese. Wood and sheet metal covered with gilt lacquer in relief and inlaid with coloured glass and semi-precious stones. Height 24 in. (61 cm). Victoria and Albert Museum (I.S. 11 (14 & A and 15 & A) – 1969).

10. Betel container in the form of a sacred goose, of gold and semi-precious stones. Formerly part of the Burmese royal regalia. Presented by the Burmese Government. Height 16¼ in. (41·5 cm). Victoria and Albert Museum (I.S. 246 & A – 1964).

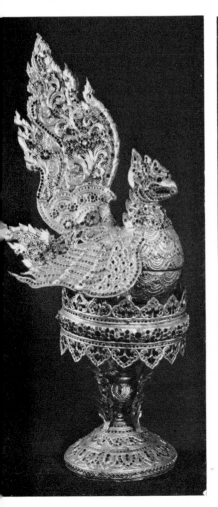
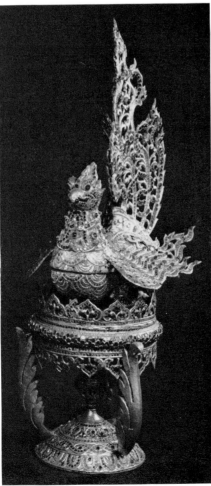
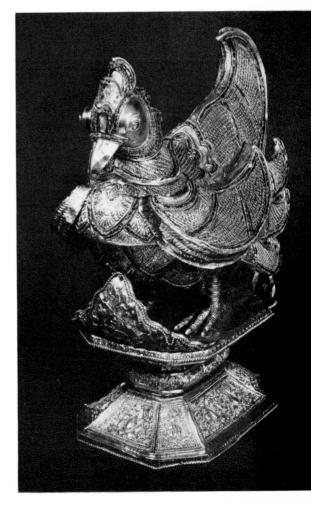

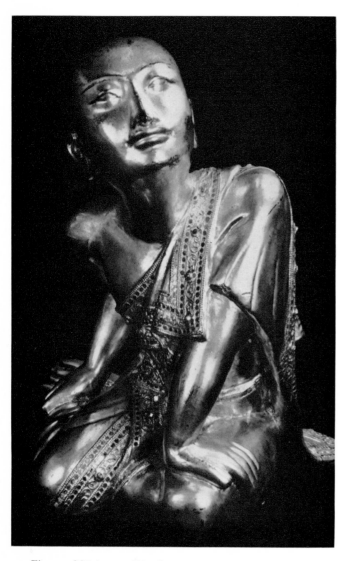

11. Figure of Sāriputta. Wood, carved and gilt and inlaid with coloured glass. Height 14¼ in. (36 cm). Victoria and Albert Museum (I.S. 11 (22) – 1969).

This grouping of the Buddha with his two chief disciples, which is probably the Theravāda equivalent to the similar Mahāyāna group of the Buddha with two Bodhisattvas, is typically Burmese. It is found in wall-painting as early as the Pagān period (fig. 13), and is a comparatively common arrangement in small sculpture such as bronzes (fig. 14). The treatment of these two monks, as supporters in a shrine group, so that Sāriputta is differentiated from Moggallāna, is conventional. A similar figure of Sāriputta, for example, is in the British Museum (fig. 15); it shows that the

correct position of the left hand is on the ground instead of on the knee, thus avoiding the unfortunate distortion of the arm belonging to the figure of Sāriputta in the shrine group.

It is difficult to identify precisely the figure kneeling at the front of the shrine holding a lamp (fig. 16), but it is probably either Brahmā or Sakka (Indra). There would be good reasons for either of these two Hindu gods to be represented in this position on this shrine. Sakka, although ruler of the lowest layer of minor gods and therefore inferior to Brahmā, whose kingdom was above him,[8] appears to have been the more popular of the two.[9] He is mentioned in several Buddhist texts, and seems to have been the representative of the gods at each of the most important episodes in the life of the Buddha from his birth to his entry into Nibbāna. At Kusinārā the Lord Buddha granted the request of Sakka to be allowed to stand guard over Buddhism and to punish the wicked and reward the faithful.[10] Since there is little consistency in the iconographical rules governing the appearance of these deities, neither his white colour nor the fact that he does not carry a thunderbolt provide evidence which might positively settle the matter either way. On balance, however, there seems to be a greater likelihood that it is Sakka. It is probable that, in any case, he was simply regarded as an attendant Nat whose duty it was to hold a light representing the Buddha's teaching and reminding the faithful of his injunction to "be a lamp unto yourselves". One can only speculate on the impression which the dim light given out by this lamp, reflecting on gilt and fragments of mirror, might have created in the dark interior of a chapel.

Both Sakka and Brahmā appear on thrones belonging to Burmese kings; the former twice, at the top of the pediment[11] and on the right hand door, the latter only once but in the position of honour in the middle of the left hand door. The absence of doors on the shrine prevents them from being shown in similar positions, but there is, nevertheless, a remarkable similarity between the design of the royal throne[12] (fig. 17) and Burmese shrines dedicated to the Buddha. Perhaps one of the closest in conception is the shrine formerly in the Sanuzaung of the Thamidaw Kyaung which formed part of the Sangyaung Sanghārāma of Amarapura shown in fig. 4. This appears to be almost a facsimile of a royal throne on a reduced scale. Others, such as those formerly in the Atumashi Kyaung,

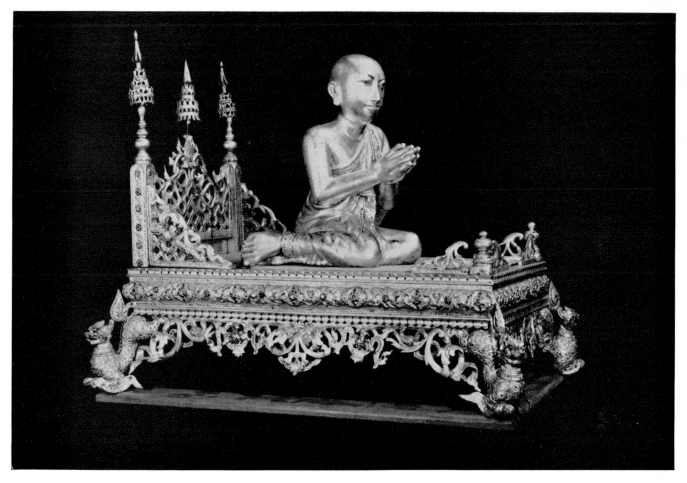

12. Figure of Moggallāna seated on a couch. Wood, carved and gilt, with gilt lacquer relief decoration inlaid with coloured glass (the umbrellas are of sheet metal). Height 20 in. (50·5 cm). Victoria and Albert Museum (I.S. 11 (21 and 23) – 1969).

Mandalay[13] and the Uzina Pagoda, Moulmein[14] show a greater degree of variation; the elaborately carved and gilt foliage on the upper part of the latter being particularly similar to that on the shrine recently acquired by this Museum. The design of shrines supporting Buddha figures and royal thrones falls into two main parts, the upper section in the form of a doorway and the lower which is the throne itself (B. *Palin*; P. *Pallanka*); the Buddha and the king when seated on the throne occupy identical positions. The doorway is based on conventional architectural patterns, with a heavy, curved pediment (B. *Ukintaw*) having a finial at the centre and two horn-shaped sections, which curve upwards each side. These are repeated, on a slightly smaller scale, on the door-posts, which also have capitals and socles shaped like an hour-glass similar to the throne itself. This archi-

tectural basis has almost entirely disappeared in the shrine and, apart from the columns on each side of the doorway, it only remains to control the areas of elaborately carved and gilded foliage and scroll-work. The stepped and waisted shape of the throne is a highly stylized representation of the double-lotus throne conventional in Buddhist art, but elsewhere usually shown more naturalistically treated; at the top, the steps recede again to form what is, on the shrine, virtually another throne. Also, on royal thrones, there are two rows of niches in which models of various animals or birds, etc., were placed according to the function of the throne.[15] The two most important of these were in the Great Audience Hall (B. *Mrenam*) (fig. 17), now destroyed, and that in the Council Chamber (B. *Hluttaw*), in the Mandalay Palace, both of which had lions in the throne niches and were

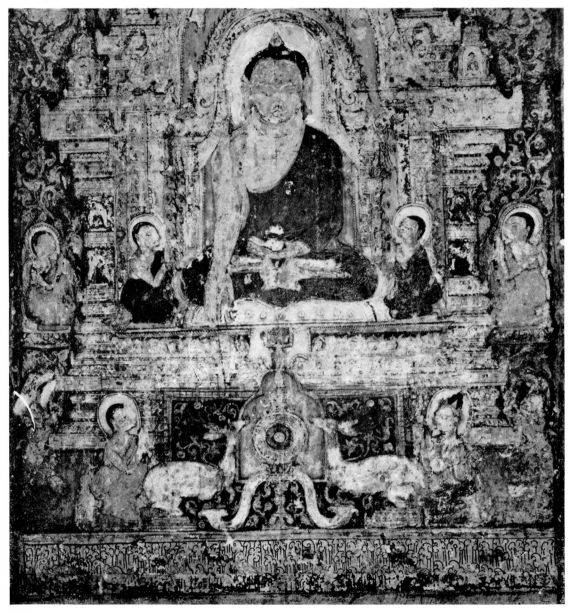

13. Wall painting showing figure of the Buddha flanked by figures of Sāriputta and Moggallāna. From a temple, Pagān; 11th or 12th century. Photo, *J. C. Irwin*.

therefore referred to as the Lion Thrones (P. *Sīhāsana*).[16] In the same way, lions are placed in niches round the base of the Museum's shrine (fig. 18). The long history of lions as supports for the Buddha's throne in Buddhist art and the many references to the lion in Buddhist literature as a symbol of ideal qualities are too well known to be repeated here. Other similarities between royal thrones and the shrine are the praying figures placed in the foliage on each side of the latter (fig. 19), which correspond to the seven *Sammādevas* which are placed on each side of the royal throne,

and the two *Kinnaras*[17] at the bottom of the foliage. The four umbrellas placed at the top of each side of the pediment and at each corner of the platform on which Buddha sits probably represent the four *Lokanats* placed at the top and bottom of the door-posts on the royal throne.[18] The umbrella on the pediment immediately over the head of the Buddha perhaps represents Sakka again while the one on top of the finial possibly symbolizes the universal spread of the authority of Buddha's teaching. The pattern at the back of the doorway, behind the Buddha (fig. 19) is the Makara-

scale pattern (B. *Makan Kwet*). This was carved on the wings placed on each side of the lower "throne" portion of the royal Lion Throne, which is rendered as foliage on the shrine. The most obvious difference between royal thrones and the shrine is the cloud design above *garudas* (fig. 20) on which the whole shrine is supported. It is difficult to find any close parallel to this in Burmese art or to suggest any symbolism for *garudas* in this context; it can only be assumed that the idea of lifting up the shrine in this

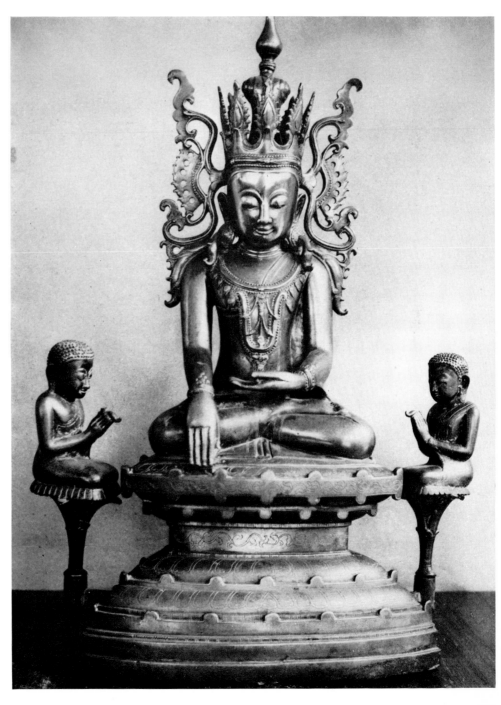

14. Figure of the Buddha, dressed in royal robes as the subduer of Jambhupati, flanked by figures of Sāriputta and Moggallāna. Bronze; 16th or 17th century. Rangoon, Archaeological Department. Photo, *J. C. Irwin*.

way came from the person who commissioned the shrine (or his spiritual preceptor) or from the master craftsman responsible for its construction. Whichever was the case, it has been superbly realized, in such a way that the whole shrine gives the impression of floating just above the ground resting on clouds supported by *garudas*. The design of shrines and royal thrones is evidently the result of a long tradition, but it is difficult to say when they achieved their present similarity. No royal thrones have survived earlier than the one formerly in the *Hluttaw*.[19] The two separate parts of both shrine and royal throne, the doorway and the throne, both have their own distinct development in Buddhist architecture and sculpture dating from at least the Pagān period and, possibly, earlier.

The waisted throne on which Buddhas are seated can be traced to a silver reliquary excavated from Khin Ba's mound, Hmawza (Old Prome), which may date from as early as the eighth century A.D.[20] Doorways with curved pediments from which the later type developed can be seen on the Ananda Temple, Pagān (late 11th century)[21]; but when the date of the earliest caves on the Powun-daung Hills near Mon-ywa is established, it is possible that the horned type of pediment may be earlier than the Pagān period.[22]

The combination of doorway and waisted, stylized lotus-throne can also be traced to the Pagān period, where it is found in wall paintings belonging to the 11th or 12th century (fig. 21). It may also have pre-Pagān origins as there is in existence a stone sculpture excavated at Hmawza[23] showing an aediculated Buddha figure seated on a primitive waisted throne (fig. 22). Although its precise date cannot be judged, the site is generally regarded as belonging, in part at least, to the pre-Pagān period. Certainly this seems to be borne out by the style of some of the sculptures which have been excavated. There can be little doubt that this example is one of the earliest representations of the combined doorway and throne from which later shrines and royal thrones developed.

The similarity between shrines and royal thrones in Burmese art raises interesting questions regarding the status of the monarch. Traditionally, as with royalty in most areas affected by Indian culture, the kings of Burma aspired to the rank of Universal Monarch (*Chakravartin*). This is illustrated by the great importance which was placed on the possession of a white elephant. This animal not only imparted prestige by giving visual evidence that its owner was a *Chakravartin* but also reassured the people that its ownership gave the king power to regulate the seasons. Clearly it would not be difficult to interpret the status of Universal Monarch as being equivalent to that of a god-king. But while this was explicit in the monarchy of some other countries in South East Asia, such as Cambodia, it was never accorded formal sanction in Burma. The

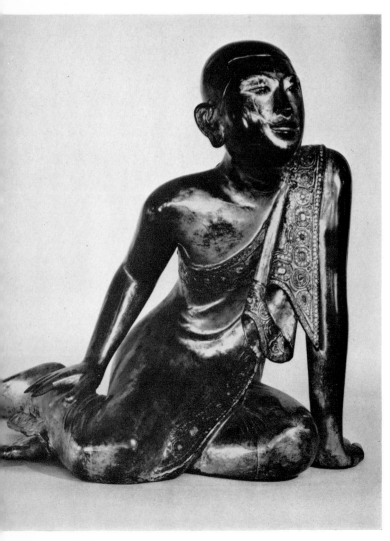

15. Figure of Sāriputta. Wood, carved, lacquered and gilt, and inlaid with coloured glass. Burmese; 19th century. British Museum (1961, 10/16, 4).

16. The Royal Lion Throne which was formerly in the Great Audience Hall, Mandalay Palace. The empty niches originally held figures of seated lions.

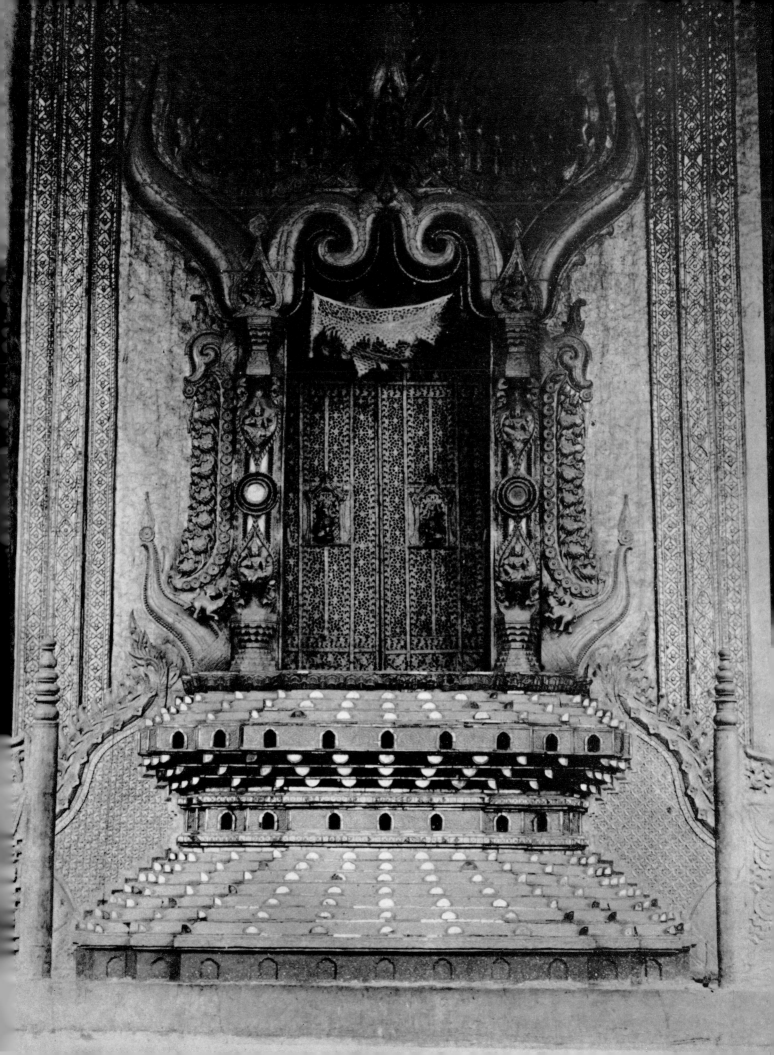

similarity between the shape of Buddha shrines and royal thrones implies that the functions of head of state and chief patron of the church were combined in the person of the monarch. Mindon had no doubt that his duties as protector of the *sangha* were more important

17. Figure of Brahmā or Sakka. Carved and painted wood, and sheet metal, covered with gilt lacquer in relief inlaid with coloured glass. Height 25½ in. (64 cm). Victoria and Albert Museum (I.S. 11 (18 & A) – 1969).

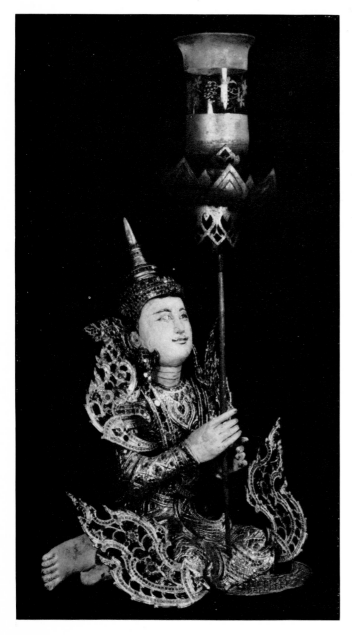

18. Part of the left-hand side of the doorway of the shrine showing *Sammādeva* figure and Makan Kwet (*Makara*-scale) ornament at the back.

than those as king. The close connection between the religious and secular power of the monarch is emphasized by the row of lotus petals which normally form a seat for the Buddha and which can be seen at the top of the lower part of the Lion Throne shown in fig. 16. Moreover this throne was built on a low platform of earth which, according to tradition, was taken from twelve different places all of which have close associations with the life of the Buddha such as

Kapilavastu, Vārānasī, Rājagriha, Magadha and Devadaha (his mother's birth-place)[24]. But while it was possible for a king (Alaungpaya) to recite the words which Buddha spoke at his birth as part of his own coronation ceremony,[25] he stopped well short of regarding himself as already a god, and merely took the name which means "He who aspires to become a Bodhisattva"[26].

The converse of the god-king is the attribution of royalty to the Lord Buddha. While this contradicts the whole of Buddha's teaching, it has become part of Buddhist thinking since at least the early Pāla period in India. The reasons for this are obscure. It is possible that it is a feedback from the idea of the *Chakravartin* being a god-king, or it may have originated from a ceremony at Nālandā in which a figure of the Buddha was temporarily dressed as a *Chakravartin*. Alternatively, it may represent the Buddha symbolizing the state of Sambhogakāya ("Body of Bliss"). It would, however, be out of place to discuss these arguments here. In Burma, as in other areas of South East Asia, figures of Buddha such as that belonging to the shrine (fig. 23) became popular, and the name given to them, Jambhu-pati, positively establishes the reason for showing the Buddha in this way. This relates to a story found in

one of the Buddhist texts which describes how the Buddha donned the regalia of Universal Monarch in order to subdue a renegade prince with the name of Jambhupati, who had invaded the territory of a peaceful Buddhist king. He overcame the prince, who atoned for his aggression by adopting the teaching of the Buddha.[27] The Buddha figure as the subduer of Jambhupati which is placed in the aedicule of the shrine wears a crown, necklace and other jewellery, and the elaborate costume of a king instead of the simple robes of a monk. It forms the focal point to which the rest of the shrine is orientated.

The group as a whole, in addition to illustrating the skill of several craftsmen, carpenters, sculptors, wood-carvers, gilders and glass-inlay workers, brings together their work and sets the image of the Buddha in its context as an object of worship. It is possible, therefore, to look at the group from two points of view: as a sumptuous example of the creativity of Burmese craftsmen and, secondly, as an instrument through which the Buddhist worshipper communicated with his deity. Both aspects are complementary to each other, the individual pieces thus ceasing to be isolated entities but taking their place with the others to make their own contribution to the ritual of worship.

19. (*left*) The lower, right-hand side of the throne showing figures of lions (*chinthe's*) placed in niches round the base.
20. (*right*) Part of the lower, right-hand side of the supporting platform of the shrine showing clouds and *garudas*.

21. Wall painting showing figure of the Buddha seated on a waisted and stepped throne and placed in an aedicule formed by a doorway and pediment. From a temple, Pagān; 11th or 12th century. Photo, *J. C. Irwin*.

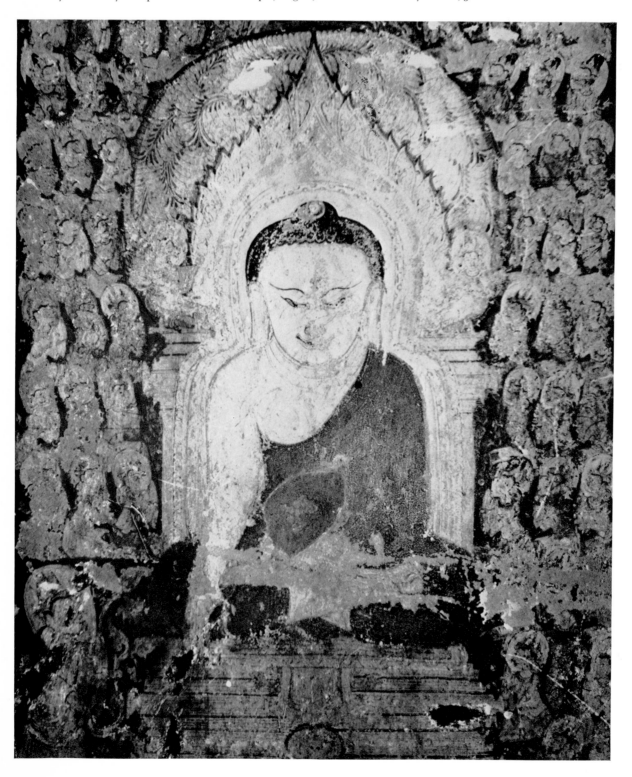

22. Figure of the Buddha seated in a doorway on a waisted double-lotus throne. Excavated at Hmawza (Old Prome).
Photo, *Archaeological Survey of Burma*.

23. Figure of the Buddha dressed in royal robes as the subduer of Jambhupati. Carved wood covered with gesso, gilt and inlaid with coloured glass. Height 21½ in. (52 cm). Victoria and Albert Museum (I.S. 11 (13) – 1969).

Notes

1. Pāli, *Sīhāsanapallanka*. I am grateful to U Tet Htoot for help with the Pāli and Burmese words and in other ways in the preparation of this article.

2. This probably ensured its preservation. Writing in 1931, less than fifty years after the fall of Mandalay, C. Duroiselle, *Guide to the Mandalay Palace* (2nd ed.), p. 1, says, " . . . much of the painting, gilding, and ornaments which, when it [the palace] was inhabited, must have made of it a glorious sight and a joy to the eye, have disappeared or faded . . . "

3. The religion of the Ari monks was a fusion between Tantric Buddhism imported from India and indigenous folk-cults. Alchemy was part of the lore inherited from Tantrism which claimed to bestow supernatural powers. Its influence remained up to, and probably after, the introduction of Western scientific disciplines.

The practice of alchemy by Buddhist monks was officially discouraged. It was lumped with sorcery, astrology, medicine, tattooing and the distribution of love-charms and talismans against wounds, and made punishable by the civil authority instead of the ecclesiastical courts. J. George Scott, *Gazetteer of Burma and the Upper Shan States*, Rangoon, 1900, vol. II, pt. I, pp. 4–5.

4. Maung Htin Aung, *Folk Elements in Burmese Buddhism*, 1962, p. 45.

5. It was built in 1847, while Pagān was at Amarapura, on a site that lay about midway between Amarapura and Mandalay (Taw Sein Ko, *Archaeological Notes on Mandalay*, p. 16). V. C. Scott O'Connor, *Mandalay*, p. 80 describes the Eindawya as being in a "western suburb" of Mandalay.

6. Henry Yule, *A Narrative of the Mission sent by the Governor-General of India to the Court of Ava in 1855*, London 1858, frontispiece.

7. A Pāli verse arranged in the form of a Burmese magic square reflects the disposition of these three figures,

> *On my head, Buddha the Greatest,*
> *On my right, Sāriputta,*
> *On my left, Moggallāna . . .*

In a ritual described by Maung Htin Aung (*ibid.*, p. 8), however, the position of the two disciples is reversed so that Sāriputta is on the Buddha's left and Moggallāna is on his right.

8. Brahmā's mount, however, is the sacred goose (see figs. 9 and 10), and there is evidence of the worship of Brahmā, as well as other Hindu deities, during the Pagān period. (Than Tun, "Religion in Burma", *Journal of the Burma Research Society*, XLII (ii), December 1959, p. 49).

9. "Sakka, the Lord of the Tāvatimsa [heaven], takes a great interest in human affairs, and as he is in heaven what the earthly king was in Burma, that is, supreme, his presence as a tutelary, a protecting and advising deity in the transaction of state business and religious ceremonies was much to be desired; hence his presence over the Throne." Duroiselle, *ibid.*, p. 37.

10. Jeya Sankhayā (Burmese, *Zeya Thinkhayā*), *Shwe Bon Nidan (Account of the Golden Palace)*, 1783 A.D. (Rangoon 1960), p. 5.

11. Yi Yi, *The Thrones of the Burmese Kings*, Journal of the Burma Research Society, vol. XLIII, pt. II, December 1960, p. 106.

12. Yi Yi, *ibid.*, pp. 97–123.

13. F. O. Oertel, *Note on a Tour of Burma in March and April, 1892*, Rangoon, 1893, pl. 15.

14. Oertel, *ibid.*, pl. 35.

15. Yi Yi, *ibid.*, p. 98.

16. The presence of lions on Burmese thrones had a special significance. They were thought of as *kethara* lions which, traditionally, are more powerful than other lions and therefore symbolize the power of the monarchy to overcome the enemies of the state. Jeya Sankhayā, *ibid.*, p. 7.

17. Burmese, *Kunnayas*. They had gentle manners, ate only the pollen of flowers and were endowed with the five kinds of beauty (beauty of flesh, bone, complexion, hair and voice); at the Buddha's enlightenment they were said to have danced with joy. Jeya Sankhayā, *ibid.*, p. 9.

18. Duroiselle, *ibid.*, p. 37 (Yi Yi, *ibid.*, gives only two).

19. If the convention of building complete new palaces when the capital was moved was observed, this would have probably been made some time between 1857–59. The manuscript upon which Yi Yi's article is based (*op. cit.*) describes the making of thrones (including one similar to that illustrated in fig. 17) at the beginning of Bodawpaya's reign in 1782 A.D. The author of the manuscript says that the designs of the thrones were traditional but does not give his sources (*ibid.*, p. 97).

20. Archaeological Survey of India Annual Report, 1926–27, pl. XL f.

21. Director of Archaeological Survey, Burma, *Pictorial Guide to Pagān* (2nd ed.), Rangoon, 1963, p. 15.

22. Archaeological Survey of India Annual Report, 1914–15, C. Duroiselle, *The Rock-cut Temples of Powun-daung*, pls. XXXI and XXXIII. Its origins may lie in the culture of the Mons. An architectural fragment from the Mon area of Thailand, showing upturned ends of pediments is illustrated in *The Arts of Thailand* (a catalogue of an exhibition held in the United States in 1960–61–62), Bloomington, Indiana, p. 52. no. 5. In Indian art it occurs in representations of architecture in the sculpture of Gandhāra.

23. Archaeological Survey of India Annual Report, 1909–10, pl. XLVII 2.

24. Yi Yi, *ibid.*, pp. 113–114.

25. G. E. Harvey, *History of Burma*, 1925, p. 325.

26. In principle, the king's authority and respect rested on *kamma*; it was clearly the merit accumulated in his previous existences which resulted in his rebirth as a king (Dr Thaung, "Burmese Kingship in Theory and Practice", *Journal of the Burma Research Society*, XLII (ii), December 1959, p. 173). But Alaungpaya's choice of name was based firmly on tradition going back to the Pagān period. Burmese kings were conventionally regarded as Bodhisattvas, paradoxically even as Metteya (Thaung, *ibid.*, pp. 175 and 179, and Than Tun, *ibid.*, p. 51). Since Metteya is the next Buddha, the equation of the monarch with a Buddha is implicit; moreover, the word *purha* needed to be carefully qualified to indicate whether it meant the king or the Buddha (Than Tun, *ibid.*, p. 51).

27. *The Arts of Thailand* (*ibid.*, n. 22), pp. 73 and 193.

Michael I. Wilson

The Case of the Victorian Piano

EVER since the development of the metal-frame pianoforte in the early part of the nineteenth century, its necessarily bulky and cumbersome shape has constituted a challenge to artists and designers. Nevertheless a number of these proved themselves, during the Victorian era, to be effectively interested in the production and ornamentation of pianos of a higher artistic standard than most of the commercial models of the period. It is the purpose of this article to examine the work of some of the more important figures in this movement.

The first efforts at improvement were made in case decoration rather than in case design. From the later medieval period onwards it was generally accepted that a keyboard musical instrument ought to be visually as well as aurally beautiful; thus the tradition of decorating the cases of such instruments is an ancient one and common to Western Europe as a whole, although

Upright Gothic Piano Forte.

Front View

Side View

Plan at a.

Plan at b.

1. Design for an upright in Gothic style. From P. and M. A. Nicholson, *The Practical Cabinet Maker, Upholsterer and Complete Decorator*, 1826.

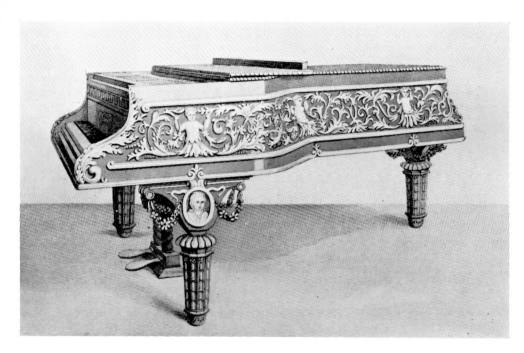

2. Broadwood grand designed by E. M. Barry and shown at the Great Exhibition, 1851. From J. Tallis and Co., *Tallis's History and Description of the Crystal Palace* [etc.], III [1852].

originally it concerned mainly painted decoration. Different countries tended to adopt different styles; speaking very generally, we find Italian harpsichords and clavichords painted with allegorical and religious scenes and with Renaissance-style grotesques, Flemish ones with exterior imitation marbling and with floral designs painted on the soundboards under the strings, German and French examples bearing floral patterns and chinoiseries. It was expected of every keyboard instrument-maker that he should be able to decorate his own cases fittingly – the noted Ruckers family of Antwerp were members of the painters' guild of St. Luke – and occasionally even famous artists undertook this work for patrons. The focal point of all such ornamentation was the inside of the lid, which was normally raised when the instrument was played and would then be seen to advantage.

In England, however, the convention of the painted case virtually died out during the eighteenth century, although a few examples in both rococo and neo-classical taste are extant. The harpsichords and early pianos of the Shudi/Broadwood era, while beautifully veneered, are for the most part unadorned save for their elegant marquetry name-boards and stringing of different woods. Gilt brass mounts in the French taste were applied to Regency square and grand pianos, as was boulle-work; a typically opulent Regency instru-

ment is the "Patent Sostenente Grand" by Mott, of about 1818, to be seen in the Royal Pavilion at Brighton. The use of Wedgwood-inspired medallions was also fairly popular, and the taste for this may well have been stimulated by a remarkable grand piano designed in 1796 by Thomas Sheraton for the Spanish Prince and First Minister Don Manuel de Godoy, which the Prince presented to his Queen. The satinwood case of this instrument is profusely set with Wedgwood and Tassie medallions, in addition to much applied gilt ornament and a miniature (now unfortunately missing) of Godoy himself.[1] Sheraton's design was doubtless widely known from the engraving, a hand-coloured copy of which is in the possession of John Broadwood and Sons, who made the original instrument (and may well have commissioned the design). In the Victoria and Albert Museum is a square piano built about 1800 and signed by Florez of Madrid, the decoration of which bears witness to the influence of the Sheraton design; its mahogany and rosewood case incorporates a number of Wedgwood-style medallions made of cut horn and paper in imitation of jasperware.[2]

Sheraton is the first known English furniture designer of stature to have produced an idea for a grand piano, although various eighteenth-century artists including William Kent, Thomas Chippendale and Robert Adam had designed chamber organs, and Adam had engraved

a wildly impracticable harpsichord case in *The Works in Architecture*.[3] But the basic shape of Sheraton's piano is still that of the normal eighteenth-century harpsichord, and it is noteworthy that in the design Sheraton omits the pedals, which presumably he thought unsightly, although they were in fact added in construction. On the other hand his piano may have been the first in which the principle of separate legs fixed to the frame was introduced, as distinct from the six-legged trestle stand associated with the harpsichord.

Although as the nineteenth century progressed the piano became more unwieldy (by reason of the technical efforts made to increase its range and power), there was no immediate general effort on the part of architects and designers to improve its shape; instead they concentrated for the most part on the decoration of the case. Gothic and Classical designs were published in P. and M. A. Nicholson's *The Practical Cabinet-Maker* (1826) and in Ackermann's *Repository* of the same year, whilst undated designs for three Gothic uprights by A. W. N. Pugin are preserved in the Prints and Drawings Department of the Victoria and Albert Museum[4] (fig. 1). At the Great Exhibition of 1851 most of the pianos shown appear to have been commercial models of little decorative interest, with the exception of an impressive

upright in the Elizabethan style designed and shown by P. O. Erard, two Broadwood horizontal grands designed respectively by E. M. Barry and G. S. Morant, and another made by J. and J. Hopkinson. The Barry Broadwood had an ebony case carved by J. Thomas and gilded by Morant, a top inlaid with satinwood by G. Watson, and medallions of Handel, Mozart and Beethoven on the legs (fig. 2). The Hopkinson is still extant and is at Wightwick Manor, Staffordshire; in 1851 it was awarded six first-class prizes, and at the Paris Exhibition of 1878 it was one of a group of pianos shown by Hopkinson that won for their maker a gold medal. Such instruments typify the opulent decoration applied to the average piano of the mid-nineteenth century. The famous Dimoline upright with papier-mâché case by Jennens and Bettridge, exhibited at the Crystal Palace in 1851, must be mentioned here, if only to be dismissed as an eccentricity.[5]

Attempts to treat piano cases in the reformed Gothic style were made during the 1860s, notably by Charles Bevan in a remarkable satinwood grand designed for Titus Salt junior and made by Erard, as part of a suite of Gothic furniture. The decorations, mainly of rich and varied inlay, were executed by the Leeds firm of Marsh and Jones, who thereafter produced a very similar

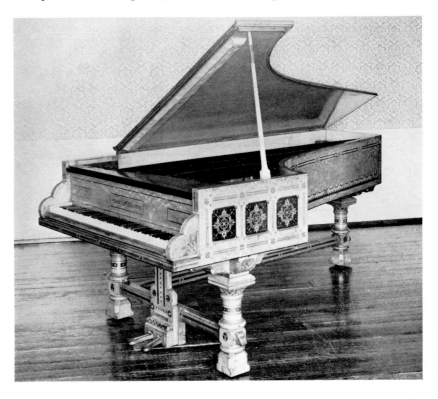

3. Erard grand with case in reformed Gothic style by Marsh and Jones after Charles Bevan. Lotherton Hall (City of Leeds Museums).

instrument to their own design which was clearly influenced by that of Bevan; it now belongs to Leeds City Art Gallery and is at Lotherton Hall[6] (fig. 3). A tracing of a third grand piano in the same style exists in the Department of Prints and Drawings at the Victoria and Albert Museum. The Museum has recently also acquired a Collard and Collard upright similarly decorated and attributed on stylistic grounds to Bevan[7] (fig. 4).

In the Victoria and Albert may be seen a highly interesting piano made by Robert Wornum in 1868/9 for the Museum's first Director, Sir Henry Cole.[8] Keenly interested in music, Cole hardly deserved Sir Michael Costa's cutting accusation that he "knew nothing about music and never should";[9] on the contrary, perusal of his manuscript diaries reveals a good critical sense and above all real enjoyment of music. It was surely some-

thing more than self-interest that caused him to work enthusiastically for the foundation in 1873 of the National Training School for Music, later (1882) to become the Royal College of Music; furthermore his wife delighted in music and was an accomplished pianist. Their joint initials are carved on the openwork candle-slides of the piano.

Apart from its unusual down-striking action, the piano is of a decorative interest that at first sight may be all too easily overlooked, so muted is the style and execution. Apollo and a swan on the lid, and musical instruments (some of them evidently inspired by examples in the Museum's own collection) round the sides (fig. 5), form the main decorative ingredients; the illusory effect of inlay or marquetry is achieved by a typically Victorian process known as xylatechnigraphy. This is a technique of staining wood while retaining the natural grain, lending itself to subdued rather than strong colours; it seems to have been fairly popular during the late 1860s and early '70s, for at the 1871 International Exhibition in London, at which this piano was shown, other furniture decorated by the same process was also to be seen. The artist responsible for the piano, James Gamble (1835–1911), had been a pupil of Alfred Stevens and assistant to Godfrey Sykes, and had done a considerable amount of decorative work at the then South Kensington Museum (later the Victoria and Albert) on both the interior and exterior of the building. The piano was presented to the Museum in 1913 by Sir Henry Cole's son, Alan.

The re-introduction of simply-designed painted furniture, a feature of the reform movement headed by William Morris, is particularly linked with the names of his associates, Philip Webb and Ford Madox Brown. Simplicity, however, was hardly the outstanding characteristic of a grand piano that Madox Brown designed in 1873, the sides decorated with scenes from the Wagnerian legend of *Lohengrin* and the keyboard ends and upper portions of the legs carved to represent swans (fig. 6). At first sight it seems almost incredible that Madox Brown, whose furniture designs in general are noted for their clean, uncluttered lines, should have planned such a ponderous instrument. On the other hand, the style is undoubtedly suited to the subject matter of the decoration, the idea for which must surely have come in the first instance from Madox Brown's

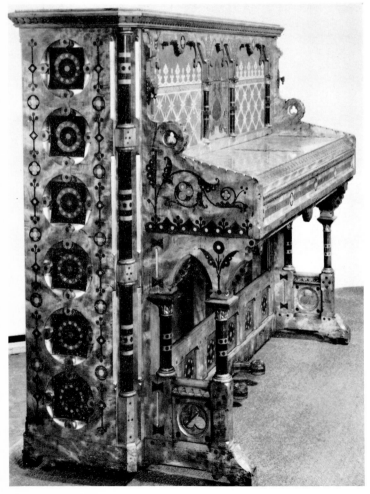

4. Collard upright attributed to Charles Bevan, Victoria and Albert Museum, Room 120 (W.6/1968).

5. Wornum grand with decorations by James Gamble, for Sir Henry Cole; side view of case. Victoria and Albert Museum, Musical Instruments Gallery (W.11/1913).

son-in-law, Francis Hueffer (Franz Hüffer). This German-born music critic and writer had come to London in 1869, where in 1872 he married Madox Brown's younger daughter Catherine; while still in Germany he had become one of the earliest and most ardent of Wagnerites, later communicating his enthusiasm to his English relations, including his father-in-law. The impulse for designing the piano cannot have come from an actual performance of the opera, which did not receive its first hearing at Covent Garden until 1875 (when it was sung in Italian!). It is sad to have to relate that, according to Hueffer himself, the *Lohengrin* piano never got beyond the design stage owing to the expense that would have been involved in making it (it was to have incorporated ebony and ivory inlay). Not only would it have ranked as a highly individual instrument, but a certain negative interest would also have attached to it as being perhaps the most uncharacteristic object ever to be designed by a close associate of the Pre-Raphaelites.[10]

The decorative treatment of the conventional nineteenth-century grand piano reached its apogee in two resplendent instruments associated with Sir Lawrence Alma Tadema. The ornamentation of the first and most famous of these was in fact conceived and for the most part executed by G. E. Fox, perhaps best known for his decorative work at Warwick Castle. The piano was in a "Byzantine" style emphasized by the massive columns of rosewood and ivory which, with their capitals, formed the legs, by the character and richness of the ornament, and by the enormous throne-like seat designed *en suite*, whose back was painted by Alma Tadema himself with a typical scene of Roman figures dancing to a flute-player (fig. 7). The main carcase was of oak, but this was totally concealed beneath geometrical inlay of ebony, tortoiseshell, mother-of-pearl, mahogany, ebony, gilding, brass and ivory. The latter was used notably in a drop-like frieze running round the bottom edge of the case and inspired by decoration in the church of St. Sophia at Constantinople. Instead of painting the inside lid, Alma Tadema affixed to it large sheets of parchment, on which the various musicians who visited the house were invited to sign their names; the artist and his wife were renowned for their musical evenings,

6. Madox Brown's design for the *Lohengrin* piano. From *The Artist*, XXII, 1898.

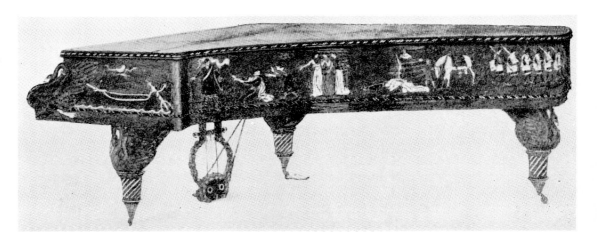

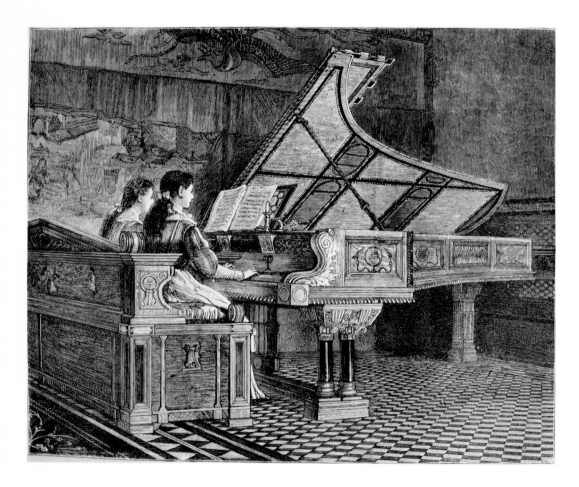

7. The Alma Tadema "Byzantine" grand. From *The Graphic*, XX, 1879.

and among those who signed were Tschaikowsky, Clara Schumann, Paderewski, Saint-Saëns, Joachim and Melba. Later the Neapolitan sculptor, Giambattista Amendola (whose portrait busts of Alma Tadema and his wife were exhibited at the Royal Academy in 1879) was commissioned to provide a silver plaque in high relief representing Orpheus, and this was set into the case at its narrow end.

Originally the piano stood in the Alma Tadema home, Townshend House near Regent's Park, in a "Byzantine" room also designed by Fox; this room, with gold walls and ceiling and lit by windows glazed with Mexican onyx, contained nothing but the piano and some seats. When in 1887 the artist moved to 34 Grove End Road, the instrument then stood on a shallow platform in the main studio. Constructed by Messrs. Broadwood, it was completed in 1878 and rapidly became celebrated; references to "the grand piano, of which all the world has heard"[11] occur frequently in the fashionable magazines of the late nineteenth century.

It was shown at the 1885 International Inventions Exhibition, and was still making headlines as late as 1936, when its appearance at an exhibition of pianos held at Maple's store in Tottenham Court Road elicited the following tribute: "So successfully has he recaptured the atmosphere of Ancient Rome that one is almost tempted to imagine that it is the actual instrument on which Nero played while Rome burnt. Or was that perhaps a fiddle?"[12]

This exhibition was probably the piano's last public appearance. At the sale of Alma Tadema's effects on 9 June, 1913 (he died on 25 June, 1912) it was withdrawn at £1,500, to be finally sold at Christie's on 22 July, 1920, for £441; at the same time the seat was sold to the same bidder for £115.10.0. By 1927 piano and seat had been acquired by Maple's, on whose premises they remained until destroyed in an air raid during the 1939–45 war – a sad end to a magnificent instrument.[13]

The second Alma Tadema piano (a Steinway) was

designed as part of a commission from the American connoisseur Henry G. Marquand, for the complete furnishing in Grecian style of the music room in his new house on Madison Avenue, New York. No limit was put on the cost, and the decorative work was carried out by Johnstone, Norman and Company. Begun about 1884, the piano itself was completed in 1887 and was placed on view for a time at the firm's New Bond Street premises before being despatched to the United States, most of the other furniture having already preceded it. This was an even more costly and exotic instrument than the Byzantine grand, and for a full description of it the reader is referred to *The Building News*, volume LII,

1887; this account concludes with the still valid statement that "We have before seen costly and beautifully-painted pianoforte cases to which our leading painters have contributed their art; but this one . . . surpasses them in architectural character and in thoroughness of decorative design". The chief feature was a painting by E. J. Poynter of the inside of the keyboard cover, depicting a "Pompeian garden scene" with minstrels. The piano, whose total cost is said to have been in the region of £7,000, happily has been preserved; it was exhibited at the Metropolitan Museum of Art, New York, in 1957 and now stands in the foyer of the Martin Beck Theater in the same city.[14]

8. Priestly miniature upright painted by Burne-Jones. Victoria and Albert Museum, Room 119 (W.43/1926).

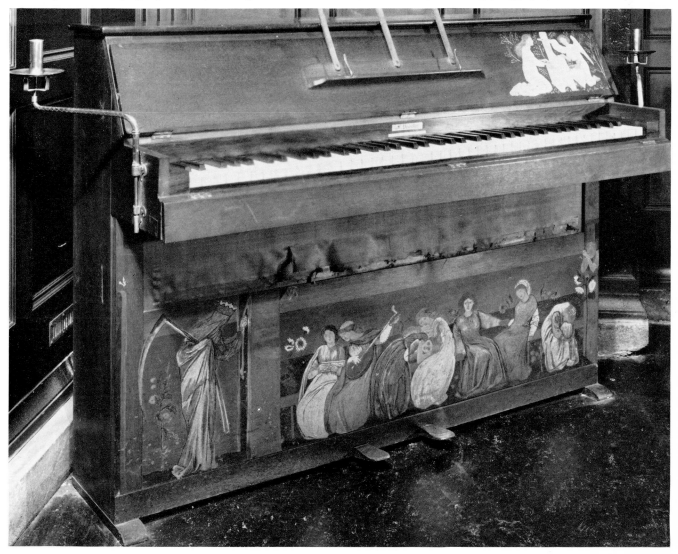

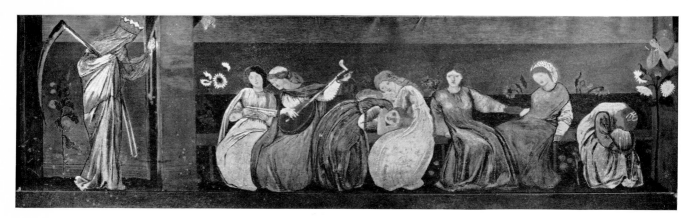

9. Detail of lower panel of the Priestly upright: Death at the garden gate.

The widespread impression that all nineteenth-century pianos from about 1850 onwards tend to be bulky, even elephantine objects, is nevertheless a mistaken one. It is not generally realized that the modern miniature upright piano had a prototype as early as 1811, when Robert Wornum produced a "cottage" piano or "pianino" measuring only three feet six inches in height. Some thirty years later Priestly of Berners Street brought out a similar version about six inches lower, and one of these was presented to Edward Burne-Jones at the time of his marriage in 1860 by his aunt, Mrs. Catherwood. He had already seen and admired one in the house of Ford Madox Brown (not at that time a Wagnerite). The case, of unpolished American walnut, was left absolutely plain so that Burne-Jones could decorate it according to his fancy. This he did, restricting his work to the inside of the keyboard cover and the front panel under the keyboard (fig. 8). On the former he painted, in one corner only, two white-clad figures (one personifying Love) with a portable organ; this foreshadows his full-scale painting "Chant d'Amour", of which the large-scale oil version (1868–77) is now in the Metropolitan Museum of Art, New York, the small watercolour version (1865) in the Boston Museum of Fine Arts. On the lower panel appears a row of girls sitting in a garden enjoying music and another looking out from a window, but with the figure of Death, crowned and carrying a scythe, ringing a bell at the garden gate (fig. 9). A pen-and-ink drawing on the same theme, though with minor variations, exists in the National Gallery of Victoria, Melbourne; it has been dated at 1860 and is clearly a study for the piano (fig. 10). No precise development of this oddly disturbing little scene has so far been traced in Burne-Jones's later

work, but perhaps it may have led to his painting "The Hours", which also features a row of seated female figures, and for which (although not painted until 1870–3) studies are said to date from as early as 1865 – only five years or so after the painting of the piano. The garden scene glows sombrely in browns and gold, Burne-Jones having used a red-hot poker to enrich the colouring while the paint was still wet.

After many years in the artist's household, the piano eventually came to the Victoria and Albert Museum.[15] Unassuming as it is, we may well accord it the distinction of being the first nineteenth-century keyboard instrument to signalize renewed interest in a more restrained and appropriate style of decoration. It was moreover swiftly followed by the decoration of a second small upright designed by the artist George Pryce Boyce, for himself. Here Burne-Jones's work consisted in painting six female figures in a landscape, on the panel over the keyboard. A design for this, dated 1861, was shown at the Burlington Fine Art Club exhibition of Burne-Jones's work in 1899, and another (though showing only four figures) is preserved in the Fitzwilliam Museum, Cambridge. The piano was sold with Boyce's other effects on 5 May, 1897, and went to the United States.[16]

But it was not until at least ten to fifteen years later that Burne-Jones turned his attention to the actual design of piano cases as distinct from their decoration. The generally awkward size and shape of the contemporary grand piano was a problem that from about 1870 onwards increasingly attracted the notice of the more enlightened art journals, though it seems not to have interested a wider public until the 1890s. In the following extract from Broadwood's illustrated catalogue of

1895 entitled *Album of Artistic Pianofortes* Burne-Jones is shown to have been in the van of progress in this field, whilst in the same extract are set out some of the highly important modifications that resulted from his work: "Attention has lately been drawn in the Art World to what certain critics deem the 'inelegant' shape of the conventional Grand. Repeatedly has it been advanced that the outlines of the precursor of the pianoforte – namely the harpsichord – are more to be commended. It is therefore noteworthy that long before this question was generally discussed, Sir Edward Burne-Jones, Bart., had in various ways adapted to the Broadwood horizontal pianoforte the admired harpsichord shape, for the proportions of which it was found that the Broadwood instruments – almost alone amongst those of modern types – were peculiarly harmonious. Of Sir Edward Burne-Jones's design, the chief characteristics are: the substitution of a harpsichord tressel-stand for the usual rounded legs; the small end to the piano tapers in an acute angle (with which angle the internal iron-work has been made to conform) instead of being curved; and there is a rectangular instead of a rounded lid to the keyboard."[17]

This account omits one other highly significant feature of the new design – the re-shaping of the curved side into the older and more graceful outline common to both harpsichords and early pianos of the Shudi/Broadwood era. It is said that Burne-Jones, suddenly inspired, drew this curve entirely freehand in his studio, and that only afterwards was it found to conform almost exactly with that of the earlier instruments.[18]

Thus Burne-Jones demonstrated his belief that the appearance of the nineteenth-century piano could best be improved by making it look as much like an eighteenth-century harpsichord as possible, even to the extent of reverting to such details as the sharply-angled end and the six-legged trestle support. This belief also coloured his attitude to case decoration, in which his approach was again a conscious return to the practice of former times and is notable for a much greater emphasis on painted ornament at the expense of the costly inlay favoured by the Alma Tadema school of thought. Indeed, it was apparently a Van der Meulen painting on a seventeenth-century Ruckers harpsichord that inspired the decoration of the first grand piano with which Burne-Jones put his new ideas into practice.[19]

This, the famed "Orpheus" piano commissioned by his friend and patron, William Graham, M.P., takes its name from the story of Orpheus which is enacted in a series of scenes painted within eleven roundels and a rectangle on the oaken sides of the instrument. These scenes were first sketched by Burne-Jones, then drawn onto the case by pupils, and finally completed by the artist. But the chief glory of the piano – as indeed of so many keyboard instruments of the pre-pianoforte era – is the inside lid which, on being raised, is seen to be painted overall with an enchanting scene of Mother Earth surrounded by her children (fig. 11).

Mother Earth is young, and a beauty in the true Burne-Jones tradition (though no model has been traced). She sits by the roots of an enormous vine, serenely untroubled by the varied activities of the twenty-one chubby babies, some well-behaved, some mischievous,

10. Pen-and-ink study for the Priestly upright. National Gallery of Victoria, Melbourne, Australia.

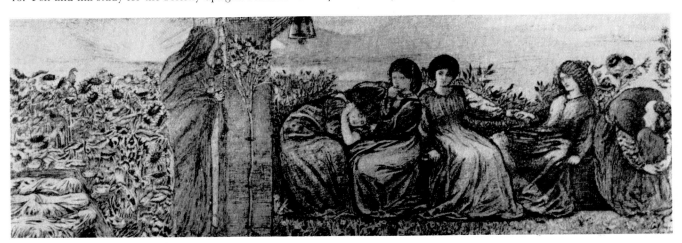

that play among the thick tendrils. The bad children are immediately distinguishable from the good by their Puck-like, pointed little ears and also by what can only be described as a look of infant cunning in their faces. (The whole question of Burne-Jones's curiously ambivalent attitude to babies as subjects for art is a highly interesting one and deserves close study.) Although irreverent comparisons might be drawn between this scene and that of an infant-school teacher in the midst of her charges, there can be no denying the mastery of the design. The outer surface of the lid shows a reclining, Dante-like poet receiving inspiration from Music, a half-length winged and semi-angelic figure within a roundel; again, much space is filled with the branches of a large tree or plant, and there also appears a quotation from Dante's *Vita Nuova*, beginning with the lines "Fresca rosa novella, piacente primavera". In all this there is clearly to be perceived what a French writer has called "une résurrection de l'esprit même du Moyen Âge et de la Renaissance, des siècles aimés entre tous par M. Burne-Jones".[20]

The complete lid was painted on both sides by Burne-Jones himself, and a number of preliminary sketches

for it exist, notably at the Victoria and Albert Museum in the forms of a small-scale incomplete cartoon in coloured chalks and some drawings in a sketchbook; the latter also show the development of the ideas for the Orpheus roundels (figs. 12–14).[21] Other related designs for the roundels are preserved at the Fitzwilliam Museum, Cambridge.[22]

It seems that the Orpheus story was not a sudden inspiration on the part of the artist but evolved from a series of drawings originating as book illustration and dating from some years earlier; an entry in his diary for 1872 runs simply "Designed the story of Orpheus"[23] – the piano, of course, not being commissioned until six or seven years later. It is noteworthy that in fact much of Burne-Jones's finest work was done in the form of illustrative series, more especially the "Cupid and Psyche" drawings of 1866, the illustrations to Morris's translation of the *Aeneid*, the painted "Briar Rose" series, and the 1897 Kelmscott Press edition of Chaucer.[24] In addition to the decorations on the Orpheus piano already described, naturalistic rose petals are painted on the soundboard (again in imitation of the old Flemish tradition), which, together with the ironwork,

11. Inside lid of the "Orpheus" piano: Mother Earth and her children. From a wood engraving.

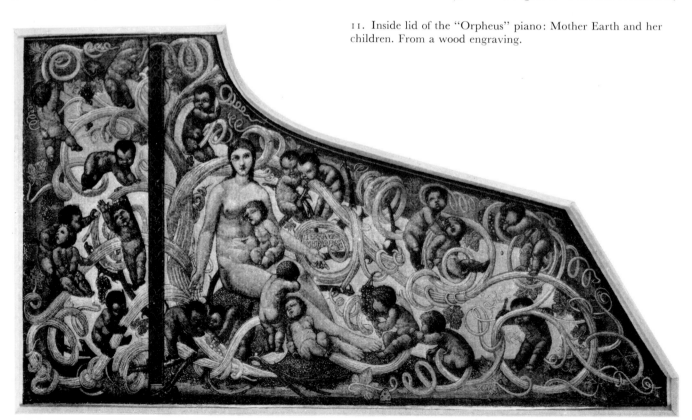

is gilded. The basic colours of the exterior case are olive green and brown, while the roundels, though not strictly painted in grisaille as is sometimes claimed, are nevertheless in muted tones of brown, grey and white. Inside the lid, however, all is light, the predominant colours being the flesh tints of the children and their mother and, above all, the wonderful blue of the vine tendrils and grape clusters. The intentionally vivid contrast between these colours and those of the outside case, while still striking, must have been even more so when the paint was fresh.

Although William Graham may originally have commissioned the piano for his wife, who was an accomplished pianist and had studied with Liszt, Mendelssohn and Hallé, it seems more likely that it was intended for his daughter Frances, later Lady Horner. This probability is strengthened by the fact that the quotation from Dante painted on the outer lid begins with a florid initial F, and to identify the owner of the piano in this way would have been characteristic of Burne-Jones, who was always especially fond of Frances Graham. The piano is still owned by her descendants. It was shown at the 1885 International Inventions Exhibition and again at the 1933 Burne-Jones Centenary Exhibition.[25] It is said that in designing the Orpheus piano Burne-Jones was considerably influenced by William Morris. Certainly the new-style instrument, of which the Orpheus piano was the prototype, was enthusiastically propagated by Broadwood in co-operation with Morris and Company. The Orpheus piano itself was a Broadwood, and in the firm's 1895 catalogue, *Album of Artistic Pianofortes*, we are informed that "instruments made to this style are kept in stock in oak fumé, or oak stained green in imitation of malachite. They can be . . . decorated, if wished, with Italian gesso-work".[26]

The idea of green-stained furniture almost certainly originated with Madox Brown, and Morris is reputed to have coloured thus an otherwise plain grand piano for Burne-Jones himself. The instrument boasted green instead of black sharps and was presented by the Burne-Jones family to the Royal College of Music.[27]

The chief exponent of gesso-work on the Burne-Jones/

12. Cartoon in chalks by Burne-Jones for the inside lid of the "Orpheus" piano. Victoria and Albert Museum, Room 118 (E.690/1896).

13. Drawing by Burne-Jones of an idea for the outside lid of the "Orpheus" piano. From his sketchbook in the Victoria and Albert Museum, Dept. of Prints and Drawings (E.7/1955).

14. Drawing by Burne-Jones of the exterior of the "Orpheus" piano, listing the proposed subjects for the paintings on the sides, and showing the angled end. From the same sketchbook as illustration no. 13.

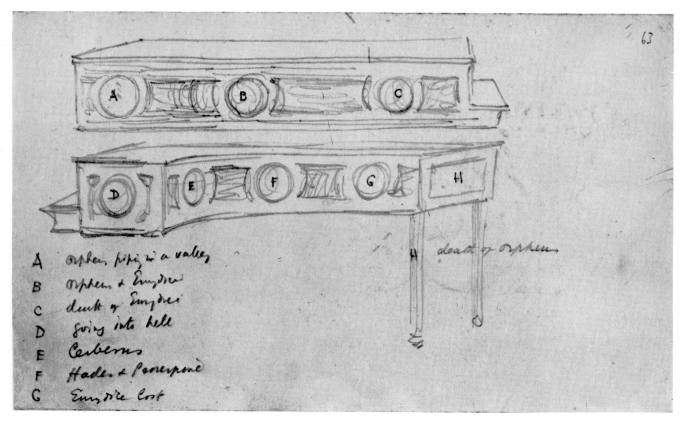

Morris/Broadwood pianos was Kate Faulkner (d.1898), who worked for Morris and Company from the firm's earliest days (when it was known as Morris, Marshall, Faulkner and Company, the Faulkner being her brother Charles). Her first piano would seem to have been the one in the Birmingham City Museum and Art Gallery, and was another commission from William Graham (fig. 15). The design is bold, consisting (on the outer case) of large raised gilt roses and their foliage, amongst which green butterflies play; inside, more naturalistic foliage, gilt but not in relief, is set off against a now faded background of crimson. This background has been a means of identifying the piano with contemporary accounts that confirm its date as 1881 and also show that it was in all probability both the first piano to be adorned by Kate Faulkner, and the first semi-commercial Burne-Jones model.[28]

If therefore, as now seems certain, the piano at Birmingham was Kate Faulkner's first attempt, it is perhaps not surprising that the gesso roses look rather large and full-blown. She was more successful with a later commission dating from 1883 and supplied to Alexander Ionides for the drawing-room of his house, 1 Holland Park. "Groups of spring flowers in raised and silvered gesso adorn the top and sides of this case, the outline of which is by Sir Edward Burne-Jones, R.A., the surface decorations being designed and carried out by Miss Kate Faulkner. Varying tints of coloured silver upon a groundwork of Celadon Green produce a very fine effect."[29] The piano now stands in the William Morris Room (the former Green Dining Room) in the Victoria and Albert Museum.[30] Visitors may be puzzled by the reference to the green ground, for no trace of this is now to be seen on the outer case (fig. 16), despite constant references to it by contemporary writers of the 1880s and '90s who use phrases such as "a deep rich green".[31] The fact is that the stain or dye used was evidently of a fugitive nature and with the passage of time has faded away so completely that but for the contemporary accounts one would be tempted to disbelieve that it had ever been coloured green at all. However, some traces of staining do remain inside the lid of the piano, though even here it has paled. For his green stain Madox Brown is said to have used oxide of chromium,[32] but it is not possible to say what was used for the Ionides piano.

Despite a generally favourable reception at the 1888 Arts and Crafts Exhibition, the piano was not without its critics. "It may be art, but it would look horrid in a

15. Broadwood grand with gesso decorations by Kate Faulkner. Birmingham City Museum and Art Gallery.

drawing-room", tartly exclaimed one lady visitor to the Exhibition.[33] Plainly she had never been to 1 Holland Park.

In a letter to Kate Faulkner dated 7 February, 1883, Philip Webb apparently refers to her work on the Ionides piano, though he does not specifically mention the instrument: "I rather think, Kate, that you are in want of me to tell you candidly, as I always do, what I think of your work; for I feel sure that, from long continued strain in doing so great a labour, you are not able yourself alone to make out what it is really like. . . . It seems to me that such work as raising patterns with gesso must be disappointing to you, as to do it perfectly one would have to be brought up to it, and work at it in a traditional manner; but I felt satisfied, and more so, in the way you had done it." There is a hint, in the final words of this passage, that Webb himself may have been concerned in creating the designs on the Ionides piano.[34] He certainly collaborated with Kate Faulkner some ten years later in decorating another Broadwood grand for W. K. d'Arcy, partly with geometrical motifs

16. Outside lid of the Ionides Broadwood grand with gesso decorations by Kate Faulkner. Victoria and Albert Museum, William Morris Room (off Room 13: W.23/1927).

and partly with a naturalistic pattern of vines. A four-line quotation from Morris's poem *The Roots of the Mountains* was also inscribed round the base of the case, and it is in a letter to Morris that Webb makes what is almost certainly a reference to this piano in the words: "The piano case goes steadily on, but the colouring asks for wary artfulness" (18 September, 1893).[35]

For a number of years the Victoria and Albert Museum housed on loan another fine piano produced by the Morris and Broadwood partnership and commissioned by J. Sanderson of Bullers Wood, Chislehurst. The decoration, part inlay and part marquetry, is an especially beautiful design of stylized foliage and birds, but it is not possible to say which particular artist was associated with it. The piano was withdrawn from loan by its owner in 1946 and sold; it remains in private hands.

At the other extreme the same Museum has a Broadwood of 1882 with decorations designed by Alfred Waterhouse in an idiom so restrained as almost to escape notice. The decorations take the form of floral patterns in boxwood and mother-of-pearl round the edge of the lid and on the long side and end of the instrument; apart from these the basswood case is otherwise plain and unadorned. The piano departs from the Burne-Jones style in having a rounded end, though the trestle stand is retained.[36]

Not all decoration on Burne-Jones models was carried out under the aegis of Morris and Company. T. G. Jackson applied a luxuriantly elaborate scheme of mixed painted and inlaid embellishment to a Broadwood commissioned by Athelstan Riley for his house at Kensington Court, the inlay-work being executed by C. H. Bessant. The exterior of the ebonized case bore floral designs inlaid in pearwood, satinwood and mother-of-pearl, interspersed with painted cartouches showing music quotations from works by Byrd, Gibbons, Purcell, Bach, Handel and Arne. In contrast, the inside lid was lacquered in vermilion and covered with a gesso pattern of gold laurel boughs. In its style and richness this piano was more akin to the Alma Tadema type, and like the famous Byzantine grand it too perished during the 1939–45 war.[37]

Reform of the upright piano dates from the 1870s, if one excepts the pianinos and cottage models that first appeared early in the nineteenth century, and as with the horizontal grand the efforts of designers were directed primarily towards lightening the total impression of the case, especially the front legs supporting the projecting keyboard. Two interesting designs in the Prints and Drawings Department of the Victoria and Albert Museum are those by Owen Jones, for a plain black upright with an openwork front backed by a green panel (probably of silk), and by J. D. Crace, for an extremely plain upright designed for a Mr. Dugdale and dated 1871.[38]

While presumably neither of these two designs was published, one by E. W. Godwin appeared in *The Building News* for 1874; although to some extent not practical (and therefore probably never executed), it showed the general direction in which designers' thoughts were moving. The wood of this piano was to have been polished white deal, the decoration consisting of cedar panels with ebony mouldings, plus four panels of stamped leather set in the upper part of the case.[39] Here are to be seen elements of the Anglo-Japanese style in furniture and decoration that Godwin himself initiated during the 1870s; a more commercial adaptation of that style is embodied in an upright made in 1878 by Shoolbred and Company (the mechanism itself bearing the Collard stamp) to the design of H. W. Batley, and at present on loan to the Victoria and Albert Museum. The mahogany case is set with relief panels of carved boxwood, and the much lighter effect of the front supports is noticeable. A similar design also by Batley appeared in *The Building News* for 1885.[40]

It is noteworthy that in 1877 *The Building News* organized a competition for the design of a cottage piano, and in 1894 *The Studio* followed suit with a similar competition.[41] Both produced results which, though foreign to our modern conception of a well-designed upright piano, nevertheless showed that reform was generally felt to be desirable and necessary. *The Studio* also makes periodic references to painted or worked piano-fronts, and these items appear not infrequently in the catalogues of the various Arts and Crafts Exhibitions.[42]

It was under the influence of the Arts and Crafts movement in the 1890s that the first significant attempts to improve the total design of the upright piano were made. At the movement's Exhibition of 1893 Walter Cave showed an upright in a perfectly plain oak case, the front legs of which were carried upwards to form candle-holders.[43] This became a highly successful commercial model and was sold by Bechstein under the name of the "Mediaeval English Upright Grand".[44] At the 1903 Exhibition C. A. Voysey showed a similar design, and in some quarters was wrongly credited as the originator of the candle-holder idea.[45]

Then in 1896 Hugh Baillie Scott showed the first of his "Manxman" uprights, the curious name due to his own Manx origins. In this, perhaps the most striking design for an upright piano of any produced before or since, the whole of the case from the keyboard upwards took on the appearance of a cupboard with two large hinged doors and a folding lid, all of which opened up to reveal the keyboard, music-rest and candle-holders. The case was of oak stained green, the large metal hinges being an important decorative feature. The makers were Broadwood, who thus once again led the way in the production of advanced models.[46] Examples of the Manxman still appear from time to time on the second-hand market. The dark colouring of the original model did not necessarily indicate a preference for such restraint on the part of Baillie Scott, who in *The Studio* of 1902 published a design for a music room containing a blue-painted horizontal grand with circles of painted decoration on its sides and gay chequered banding along the top and bottom edges.[47]

No discussion of late nineteenth-century pianos would be complete without some reference to the work in this field of C. R. Ashbee. For upright design Ashbee seems to have looked no further than Baillie Scott's Manxman for inspiration, since he made use of exactly the same form, though decorating it in a characteristically personal manner for Mr. Peter Jones[48] (figs. 17, 18). Better known is the impressive horizontal grand which he designed as a wedding present for his wife in 1898 and which is now at Toynbee Hall. It appeared at the seventh Arts and Crafts Exhibition in 1903.[49] In shape it is – most unusually – almost square, the lid being hinged in the centre, and the oak case has handpainted satinwood panels on the lid and over the keyboard. The form is not unique, since it was copied in 1902 by T. Myddleton Shallcross in a similar instrument made to his design by Broadwood and with painted decoration by F. C. Varley.[50]

The Ashbee grand is to some extent spoiled by the rather unsightly forest of legs beneath, though no doubt its heavy frame required extra support. A multiplicity of turned baluster-type legs was used less justifiably by

17, 18. Two views of an upright in the style of H. Baillie Scott's "Manxman", designed by C. R. Ashbee for Mr. Peter Jones. Victoria and Albert Museum Library Photograph Collection.

W. A. Forsyth in a wainscot-panelled Bechstein grand of about 1910, in which the ancient idea of an entirely separate trestle frame was apparently reintroduced. E. L. Lutyens produced a model similar in the panelling of the case and the style of the legs, but the latter were fewer in number (thirteen in all) and were moreover an integral part of the case itself. This instrument was a prizewinner at the Paris Exhibition of 1900 and attracted considerable attention.[51]

In a letter to his future wife, dated 2 March, 1897, Lutyens writes of the furnishing of their home, asking "What about a piano? This I shall design when the time comes – small, square, and refined, and the colour inside gorgeous. I shall try to get Guthrie of the Glasgow School to paint whispers – I almost prefer his painting in this sort of decoration to E. Burne-Jones".[52]

No piano by Lutyens answering to this description has been found. But for Marshcourt, Hampshire, which he built in 1901 in his own interpretation of the Tudor style, he provided a plain piano case resting on a separate yet highly individual seven-legged trestle frame.[53] In the same year his individuality was further marked by the publication of a design for a plain oak-cased grand with enormous metal candleholders and resting upon a circular drum-like stand with five sturdy-looking columnar legs. At least one actual model was executed from this design.[54]

Lutyens's Paris Exhibition grand was shown on their premises by Messrs. Broadwood (who had made it) to visiting members of the Architectural Association on 9 March, 1901. At the same time the visitors saw models designed respectively by A. C. Blomfield (case of

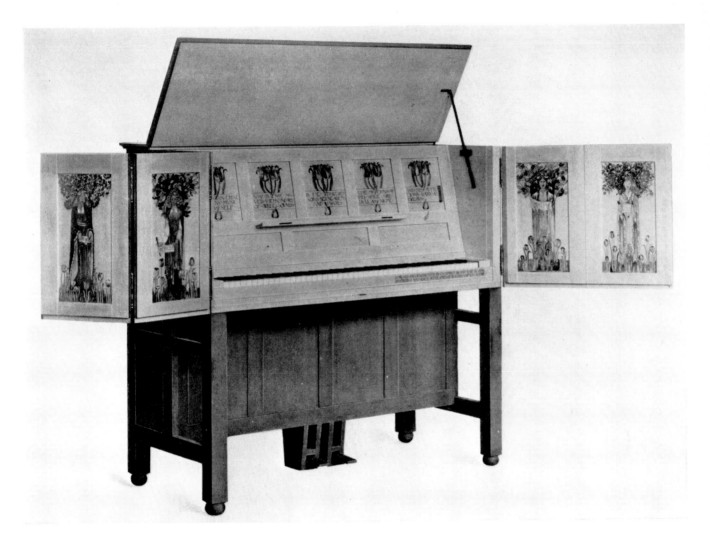

Spanish mahogany with inlay of coloured woods; in a vaguely neo-classic style, the legs like fluted pilasters), G. Ogilvy (a reinterpretation in oak and inlay of the Manxman upright) and C. C. Allom (neo-classical style with Sheraton-type inlay of coloured woods). Three of Baillie Scott's own Manxman models were also on show.[55]

Throughout these pages the name of Broadwood has constantly recurred, and with good reason. From the days of its first associations with Burne-Jones no firm had done more to spread the idea of reformed piano design. It is true that by 1900 other firms were producing pianos in a wide variety of different styles; in 1904, for instance, Erard made the following claim: "Messrs. Erard have made a study of English and French styles of furniture, and have produced pianos en suite to match all periods – Sheraton, Chippendale, Adam, Georgian, Elizabethan, Louis XIII, Louis XIV, Louis XV, Empire, Renaissance, Art Nouveau, etc."[56] This, however, was merely an extension of the Victorian *penchant* for pianos in Elizabethan or Gothic styles; it was not by any means the same thing as genuine reform. But the enthusiasm for reform vanished abruptly in 1914. Pianos in the various reformed styles had never been cheap and most were made to special commission; after 1918 few people still had money enough to be able to hire artists of the calibre of Burne-Jones to decorate pianos, or to afford costly inlay of the Alma Tadema type. Above all, tastes had changed. The last grand piano whose form and decoration both stemmed directly from the influence of Burne-Jones was designed in 1911 by R. S. Lorimer and painted by Phoebe

Traquair (d.1936), who used transparent oil paints on a gilt ground; the various subjects included scenes and passages from the *Song of Solomon*, an illustration of a Rossetti sonnet, figures of Pan, Psyche and Eros, and arboreal arabesques. Appropriately enough, the piano was exhibited at the Victoria and Albert Museum in 1952.[57]

With this instrument a chapter in the history of the modern pianoforte apparently closed. The harpsichord-style case, with its trestle stand and sharply-angled end, fell out of favour and has not been revived. As for decoration, there was for many years a decided reaction against any tendency to regard a piano case as a substitute for an artist's canvas; indeed we nowadays on occasion accept the "non-case" of transparent material that paradoxically envelops yet at the same time entirely reveals the instrument's mechanism, laying bare its innermost secrets in a manner that Burne-Jones would most certainly have found extremely repugnant. Yet the tradition of the painted case never entirely died out, and its survival was at least partly due to renewed interest in the older keyboard instruments. It was to be expected that Burne-Jones, with his obvious dedication to reviving the spirit if not the exact style of traditional case decoration, should have become associated with Arnold Dolmetsch, who was the first to re-awaken public interest in the keyboard instruments of the pre-piano era. For his own daughter Margaret, later Mrs. Mackail, Burne-Jones decorated an 1897 Dolmetsch clavichord; the exterior was painted a deep red and bore a Latin poem in white lettering, plus (framed in a laurel wreath) the slightly painful pun "Clavis Cordium". There was also an appropriate picture of St. Margaret with her attendant dragon, whilst inside on the soundboard Burne-Jones painted a white-clad, flower-gathering maiden against a background of floral arabesques.[58]

On the subject of case decoration Dolmetsch himself had firm ideas, some of which were noted in an article published in *The Studio*, 1900. Burne-Jones painted other instruments for him, and there is evidence in Dolmetsch's MS letters that he did not always approve of that artist's schemes of decoration. Better suited to Dolmetsch's personal tastes was the work of Helen Coombe (i.e. Mrs. Fry), while he himself decorated a grand piano which is still preserved in the collection at Haslemere.[59]

Over the years well-known artists have continued to apply their talents in this field. Two examples will suffice here. In 1917–18 Roger Fry decorated the case of a Dolmetsch wing-shaped spinet with abstract patterns in bright colours on the outside, and on the inside lid a reclining female nude. A 1938 clavichord by Goff and Cobb was similarly painted overall, in that exquisite style he made so peculiarly his own, by Rex Whistler.[60] No doubt the reader will be able to supply similar examples from personal experience. But the point is that these are the older instruments, rightful heirs to the ancient tradition of case embellishment; they are not pianos. So far as the piano was concerned, it seemed for over fifty years as though the Orpheus piano might never have been created.

Now, however, the wheel has come full circle and brightly decorated piano cases are in vogue again. In 1969 a leading London department store held an exhibition of some thirty pianos, horizontal grands and uprights, their cases gaily painted in contemporary styles and colours by specially-commissioned modern artists and their students. (Today it is even possible for a purchaser to paint his own piano, using a numbered design as his guide.) The visual impact of these modern cases, though initially startling, is often very exhilarating, the more so if it is recognized that they represent an entirely contemporary interpretation of a tradition having its roots in Burne-Jones's experiments with his little Priestly upright, and which itself was a re-interpretation of a tradition much older than the pianoforte.

Notes

At the conclusion of this article I would like to thank all those colleagues, friends and owners of pianos who have assisted me in my research.

1. The piano is now on exhibition at Old Deerfield Village, Massachussetts, U.S.A. For a description see W. Dale, *Tschudi, the Harpsichord Maker*, 1913, pp. 76–82. See also P. B. James, *Early Keyboard Instruments from their Beginnings to the Year 1820*, 1930, p. 142 and pl. LXII; K. Purcell, "The Design of Grand Pianos", *The House and its Equipment* (ed. L. Weaver), 1911, p. 61.

2. Victoria and Albert Museum, R. Russell, *Catalogue of Musical Instruments*, I, 1968, p. 60, cat. no. 30, and pp. 74–75. See also the same Museum, *Musical Instruments as Works of Art*, 1968, fig. 63b. Some authorities in fact believe that this piano is of English manufacture despite the signature of Florez: see The Galpin Society, *Journal*, XXIII, 1970, pp. 147, 149.

3. *The Works in Architecture of Robert and James Adam*, I, 1778, no. v, pl. VIII. Adam's original designs for the harpsichord, as well as for a square piano, are preserved in the Soane Museum, London. Both instruments were intended for the Empress Catherine of Russia. For references to chamber organs see M. Wilson, *The English Chamber Organ 1650–1850*, 1968.

4. R. Ackermann, *Repository of Arts* [etc.], 3.s., VIII, 1826, plates facing pp. 58, 245; P. and M. A. Nicholson, *The Practical Cabinet-Maker, Upholsterer and Complete Decorator*, 1826, pls. 51, 52. The Pugin Departmental nos. are E.1588–1601/1912.
For a modern reference to a Neo-classical piano of c.1780 see *Antiques*, XLII, 1942, p. 202. For a design for a Gothic drawing-room complete with Gothic upright see J. C. Loudon, *An Encyclopaedia of Cottage, Farm and Villa Architecture and Furniture*, 1857, p.1096. The same work also contains a strange idea for a piano concocted by E. B. Lamb, pp. 1290–1.

5. *Official Descriptive and Illustrated Catalogue of the Great Exhibition 1851*, pp. 467–8, Class X, cat. nos. 496, 518, 500. The Dimoline is no. 489. The extensive literature connected with the 1851 Exhibition contains a number of references to the various pianos, but none are particularly illuminating. For a fine coloured illustration of the side and lid surface of the Broadwood designed by Barry, see M. D. Wyatt, *Industrial Arts of the Nineteenth Century at the Great Exhibition 1851*, II, 1853, pl. 83.

6. The Salt piano remains in private hands. See J. B. Atkinson, 'Gothic Furniture: Recent Revivals', *The Art Journal*, n.s., VI, 1867, p. 26; L. O. J. Boynton, "High Victorian Furniture: the Example of Marsh and Jones of Leeds", *Furniture History*, III, pp. 59, 60, 63n; *The Building News and Engineering Journal*, XIV, 1867, pp. 158, 160, 161. The Salt piano is also illustrated in S. Jervis, *Victorian Furniture*, 1968, p. 65.

7. Acquired after the publication of Russell's catalogue; Museum no. W.6/1968. Departmental no. of the tracing and details is E.16/1915, nos. 603 and 606 in vol. 95.B.28. A contemporary photograph of a curious upright in reformed Gothic style is also to be found in the Department of Prints and Drawings, in an album of cuttings, etc., 93.A.111, p. 17.

8. V. and A. Museum, R. Russell, *op. cit.*, pp. 64–5, cat. no. 38.

9. MS diary (in V. and A. Library), entry for 27 November, 1875.

10. Sources for the Lohengrin piano are: F. M. Hueffer, *Ford Madox Brown: A Record of his Life and Work*, 1896, p. 282; anon., "Madox Brown's Designs for Furniture", *The Artist*, XXII, 1898, pp. 44–51; M. Archer, "Pre-Raphaelite Painted Furniture", *Country Life*, CXXXVII, 1965, p. 721. A design for the piano was shown at the Grafton Galleries, *Works of Ford Madox Brown*, 1897, p. 49, cat. no. 188.

11. M. Haweis, *Beautiful Houses*, 1882, p. 28.

12. *The Architectural Review*, LXXX, 1936, p. 185. The "Byzantine" grand has been widely noticed, but the principal sources are: *The Graphic*, XX, 1879, p. 147; *The Building News and Engineering Journal*, XLIII, 1882, p. 260; M. Haweis, *op. cit.*, pp. 28, 29; International Inventions Exhibition, *Guide to the Loan Collection ... of Musical Instruments*, 1885, p. 2; W. Dale, *Brief Descriptions of ... Pianos shown in the Loan Collection of the ... Exhibition*, 1885, p. 36; *The Art Annual*, 1887, p. 31. An intimate glimpse of the piano in use at a typical Alma Tadema musical soirée is afforded by H. Henschel, *When Soft Voices Die*, 1944, pp. 100–1, and Alma Tadema painted George Henschel, the singer, sitting at the piano's keyboard. In fact, he painted the piano a number of times; the most complete view of it is in "The Artist's Studio", shown at the Nicholson Gallery's 1943 exhibition *Artists at Work*. A good modern illustration of the instrument is to be found in the 1913 sale catalogue.

13. Information per Mr. Banthorpe of Maples, 1970.

14. *The Art Journal*, 1885, p. 290; *The Furniture Gazette*, XXIV, 1886, p. 37 and XXV, 1887, p. 190; *The British Architect*, XXVIII, 1887, p. 6; *The Building News*, LII, i, 1887, pp. 792–3; New York, Metropolitan Museum of Art, *Bulletin*, n.s., XVI, 1957–8, p. 110 (illus. showing the piano *in situ* in Marquand's music room).

15. V. and A. Museum, R. Russell, *op. cit.*, pp. 65–6, cat. no. 41. See also G. Burne-Jones, *Memorials of Edward Burne-Jones*, I, 1904, p. 207; A. Thirkell, *Three Houses*, 1931, p. 101. For the preliminary study see Melbourne, National Gallery of Victoria, *Bulletin*, II, 1960, p. 26. For the painting "The Hours" see M. Bell, *Sir Edward Burne-Jones: A Record and Review*, 4 ed., 1898, p. 35. There are studies for this picture in the Birmingham City Art Gallery and Museum, and the picture itself is at Sheffield (City Art Galleries).

16. London, Old Water Colour Society, *Annual*, XIX, 1941, p. 66; Burlington Fine Arts Club Exhibition, *Drawings and Studies by Sir Edward Burne-Jones, Bart.*, 1899, p. 7, cat. no. 20. An indistinct illustration of the piano appears in *The Architectural Review*, V, 1898/9, p. 151. It is curious that despite his interest in musical instruments Boyce took no lessons in keyboard playing until 1874. Alma Tadema painted an 1874 Broadwood pianino with figures of "Merry Music" and "Serious Music", together with a few bars of "Summer is i-cumen in" on the inside lid; this is briefly described in the 1913 sale catalogue (lot no. 303) and mentioned in W. Dale, *op. cit.*, p. 36 and by M. Haweis, *op. cit.*, pp. 24–5 (where, presumably mistakenly, it is attributed to Mrs. Alma Tadema).

17. John Broadwood and Sons, *Album of Artistic Pianofortes*, 1895, pp. 16–17.

18. W. Dale, 'The Artistic Treatment of the Exterior of the Pianoforte', *Journal of the Royal Society of Arts*, LV, 1906–7, p. 366.

19. W. Dale, *op. cit.*, pp. 365–6.

20. P. Leprieur, 'Artistes Contemporains: Burne-Jones, Décorateur et Ornemaniste', *Gazette des Beaux-Arts*, VIII, 1892, p. 388.

21. Department of Prints and Drawings: E.690/1920 (cartoon) and E.7/1955 (sketchbook).

22. Three were shown at the Tate Gallery, *Centenary Exhibition of Paintings and Drawings by Sir Edward Burne-Jones, Bart., 1833–1898*, 1933, pp. 19, 20, 22, cat. nos. 60, 66, 80. Ten (including four of the above) and two additional drawings were shown at the B.F.A.C. Exhibition, 1899, pp. 13, 14, 17, 18, cat. nos. 50–59, 76, 87. It is interesting to note how often Burne-Jones used the roundel form for designs and illustrations, quite apart from those relating to the "Orpheus" piano.

23. G. Burne-Jones, *op. cit.*, II, p. 30.

24. The Cupid and Psyche drawings were intended for an unpublished edition of Morris's poem *Earthly Paradise*. Over 40 of the drawings were actually engraved on wood and from the blocks a number of copies were printed and circulated privately. From the drawings evolved the painted series (begun 1872) for Lord Carlisle's house at Palace Green, Kensington.

25. International Inventions Exhibition, *Guide*, p. 49; Tate Gallery, *Centenary Exhibition* catalogue, p. 11, cat. no. 3. The date 1879 appears twice on the piano (including the inside lid) and the Broadwood label gives 1880. This instrument, like the "Byzantine" grand, has been frequently written up, but see especially *The Artist*, I, 1880, pp. 210–11; W. Dale, *Brief Description of . . . Pianos* [etc.], p. 37; M. Bell, *op. cit.*, p. 91. A. Thirkell, *op. cit.*, p. 101, confirms that the piano was for Frances Graham.

26. John Broadwood and Sons, *op. cit.*, p. 16. For Morris's influence see W. Dale, "The Artistic Treatment of . . . the Pianoforte", *op. cit.*, p. 368.

27. *The Artist*, I, 1880, p. 211; W. Dale, *op. cit.*, p. 368; A. Thirkell, *op. cit.*, p. 102. The College authorities have not been able to trace this instrument.

28. *The Building News*, XL, 1881, p. 504; *The Furniture Gazette*, XV, 1881, p. 308. The piano is sometimes said to have been given by Graham to his daughter Amy as a wedding present, but as she married in 1874 (even before the "Orpheus" piano itself had been designed) this can hardly be so. On the other hand, she married Kenneth Augustus Muir Mackenzie (later Lord Muir Mackenzie), and W. Dale (*op. cit.*, p. 368) refers to a piano made for him; therefore it may well be that the piano was in fact commissioned not by Graham but by his son-in-law. It later passed to the Mackenzies' daughter Dorothea, wife of the celebrated pianist Mark Hambourg.
The situation as regards pianos commissioned by William Graham is further complicated by the presence, in Christie's sale catalogue of his effects (April, 1886) of lot 165: "A grand piano . . . constructed for Mr. Graham, on the same model as the piano painted by Mr. Burne-Jones which was exhibited at the International Exhibition of Musical Instruments, 1885. The decorations of the Case were designed and executed by Miss Kate Faulkner". This piano corresponds to no other so far traced.

29. John Broadwood and Sons, *op. cit.*, p. 59.

30. V. and A. Museum, R. Russell, *op. cit.*, p. 65, cat. no. 39.

31. *The Art Journal*, 1893, p. 141. See also *The Studio*, XII, 1898, p. 107.

32. R. Watkinson, *Pre-Raphaelite Art and Design*, 1970, p. 150.

33. *The Builder*, LV, ii, 1888, pp. 241–3. See also Arts and Crafts Exhibition Society, *Catalogue of the First Exhibition*, 1888, p. 142, cat. no. 266a. For an illustration of the piano *in situ* in the Ionides drawing-room, see *The Studio*, XII, 1898, p. 103.

34. V. and A. Museum, Library MSS, *Letters from Philip Webb to William Morris* [and others], 1884–96. There are other references either to this or to another piano in letters dated 7 December, 1884, and 28 March, 1885. See also W. R. Lethaby, *Philip Webb and his Work*, 1935, earlier published as a series of articles in *The Builder*, CXXIX, 1925. The theory of Webb's participation in the Ionides piano project is often discounted on the grounds that in the 1888 Arts and Crafts Exhibition catalogue Kate Faulkner appears as sole designer, but I do not find this necessarily conclusive.

35. V. and A. Museum, Library MSS, *op. cit.* This piano has not been found but is illustrated both in John Broadwood and Sons, *op. cit.*, p. 52, and in W.R. Lethaby, 'Philip Webb and his Work' in *The Builder*, CXXIX, 1925, pp. 672–3. Lethaby's informant was under the impression that the piano was a commission from A. Ionides, but Broadwood's catalogue shows that he was mistaken.

36. V. and A. Museum, R. Russell, *op. cit.*, p. 65, cat. no. 40; illustrated in S. Jervis, *op. cit.*, p. 74.

37. Information from Mr. S. Broadwood; *The Building News*, LXIV, 1893, p. 52; T. G. Jackson (ed. B. H. Jackson), *Recollections of T. G. Jackson*, 1950, pp. 216–7.

38. Departmental nos. 8363.B. (Jones), E.1908/1912 (Crace).

39. *The Building News*, XXVI, 1874, pp. 19, 54, 81, 105.

40. *The Building News*, XLVIII, 1885, p. 925. It is interesting to note that Batley's ideas seem to have been anticipated to some extent by the commercial manufacturer William Whitely; see *The Furniture Gazette*, IX, 1878, p. 112 and plate facing; see also the same, V, 1876, plate facing p. 178 (anonymous design). For an interesting survey of commercial models, both horizontal and upright, shown at the 1885 International Inventions Exhibition, see *The Furniture Gazette*, XXIII, 1885, pp. 309–11. For two extraordinary variations on the theme of the upright piano see *The Building News*, XXV, 1873, pp. 452, 461 (design by H. H. Statham), and *The Furniture Gazette*, XIII, 1880, pl. II in March 6 no. (anon. design, no significant text). A pleasant and relatively plain upright Collard designed by J. G. Burns for the music saloon of the S.S. *Umbria* is shown and described in *The Building News*, XLVII, 1884, p. 661.

41. *The Building News*, XXXII, 1877, pp. 278, 343; *The Studio*, II, 1894, pp. 225–8.

42. See e.g. *The Studio*, XVII, 1899, p. 262 and XXVIII, 1903, p. 181.

43. Arts and Crafts Exhibition Society, *Catalogue of the Fourth Exhibition*, 1893, p. 43, cat. no. 240; *The Building News*, LXV, 1893, pp. 507, 509 [525]; *The Studio*, II, 1894, pp. 11, 18.

44. *The Studio*, XVII, 1899, p. 286 (illus. only) and XVIII, 1900, p. 179. Among the more fanciful names given to semi-commercial models at this time, that of the "Valkyrie" upright grand (inevitably recalling the *Lohengrin*) must take pride of place; an otherwise unassuming and rather pleasant-looking instrument in Art Nouveau style, it was designed by L. Wyburd and made by Hopkinson. For an illustration see *The Studio*, XXVI, 1902, p. 133.

45. *The Builder*, LXXXIV, 1903, p. 57. But this idea also appears in embryo in one of Wm. Whitely's models, *op. cit.*, illus. no. 2 on plate facing p. 112.

46. Arts and Crafts Exhibition Society, *Catalogue of the Fifth Exhibition*, 1896, p. 124, cat. no. 513; *The Artist*, XVIII (Extra Number), 1896, pp. 36–8 and XXI, 1898, p. 65; *The Cabinet Maker and Art Furnisher*, XVII, 1896, p. 121; *The Studio*, IX, 1897, p. 282 and X, 1897, pp. 154–5. At the 1896 Arts and Crafts Exhibition W. Cave showed a second design, cat. no 537, also referred to in most of the above-quoted references.

47. *The Studio*, XXVI, 1902, p. 117.

48. Illustrated in *Der Moderne Stil*, VI, 1904, pl. 60. Another version by Ashbee of the same form is illustrated in S. Nowell-Smith (ed.), *Edwardian England 1901–1914*, 1964, pl. XLVII(b).

49. Arts and Crafts Exhibition Society, *Catalogue of the Seventh Exhibition*, 1903, cat. no. 494; *The Builder*, LXXXIV, 1903, p. 57; *The Studio*, XXIX, 1903, pp. 207–8.

50. *The Studio*, XXIV, 1902, pp. 135–6.

51. Both illustrated in K. Purcell, "The Design of Grand Pianos", *op. cit.*, p. 64. Additional illustrations of the Lutyens are in *The Builder*, LXXX, 1901, pl. IV after p. 292; L. Weaver, *Houses and Gardens by E. L. Lutyens*, 1913, p. 314. The piano is now at Oakley Park, Shropshire, and is illustrated *in situ* in *Country Life*, CXIX, 1956, p. 428.

52. C. Hussey, "The Life of Sir Edwin Lutyens", *The Lutyens Memorial*, I, 1950, p. 65.

53. L. Weaver, *op. cit.*, p. 314.

54. For the design see *The Builder*, LXXX, 1901, p. 627; for the instrument see S. Nowell-Smith, *op. cit.*, pl. XLVII(a).

55. *The Builder*, LXXX, 1901, p. 292 and following plates.

56. W. S. Sparrow (ed.), *The British Home of Today* [etc.], 1904, p. XX.

57. V. and A. Museum, *Exhibition of Victorian and Edwardian Decorative Arts*, 1952, p. 111, cat. no. U5; K. Purcell, "The Design of Grand Pianos", *op. cit.*, pp. 63, 65. The decoration has undergone some alteration since originally painted.

58. *The Easter Art Annual* (The Art Journal), 1900, pp. 24 (illus.) and 26, and plate facing p. 24; A. Thirkell, *op. cit.*, p. 102.

59. *The Studio*, XIX, 1900, pp. 191–4; see also *The Artist*, XVIII, 1896, p. 35. At the fifth Arts and Crafts Exhibition, 1896, a Dolmetsch harpsichord with decorations by Helen Coombe was shown (cat. no. 178) and at the sixth Exhibition, 1899, both Mrs. Mackail's clavichord and Dolmetsch's own piano were shown (pp. 94, 128). At the eleventh Exhibition in 1916 could be seen two Dolmetsch clavichords painted by Major the Hon. Neville Lytton (cat. nos. 321a and b). For information on Dolmetsch's private feelings about Burne-Jones I am indebted to Miss Margaret Campbell.

60. For Fry's spinet see the Courtauld Institute of Art, *Galleries Catalogue*, 1960, Catalogue of the Fry Collection, Room VII, p. 6, cat. no. 37 (where it is described as a virginals); for Whistler's clavichord see the Arts Council, *A Memorial Exhibition: Rex Whistler 1905–1944* (at the V. and A. Museum), 1960, p. 29, cat. no. 125. There is an illustration of the Fry spinet in R. Clemencic, *Old Musical Instruments*, 1968, p. 118.

NOTE: The Bullers Wood piano (see p. 146) was recently sold for the second time, on this occasion at Sotheby's Belgravia rooms on 27 October 1971. The piano and its matching stool together realised £2,300.

Index